The Triangle
of Representation

The Triangle of Representation

Christopher Prendergast

COLUMBIA UNIVERSITY PRESS NEW YORK

Columbia University Press

Publishers Since 1893

New York Chichester, West Sussex

Copyright © 2000 Columbia University Press

All rights reserved

Library of Congress Cataloging-in-Publication Data

Prendergast, Christopher.

The triangle of representation / Christopher Prendergast.

p. cm.

Includes bibliographical references and index.

ISBN 0–231–12090–7 (cloth : alk. paper)

ISBN 0–231–12091–5 (pbk. : alk. paper)

1. Representation (Philosophy) 2. Culture. I. Title.

B105.R4 P74 2000

110—dc21 00-022651

Printed in the United States of America

Designed by Audrey Smith

c 10 9 8 7 6 5 4 3 2 1

p 10 9 8 7 6 5 4 3 2 1

For Gita and Clea

Contents

Preface

Entering the prison house of Representation (in the rhetorically vivid though existentially gloomy metaphor with which certain commentators have sought to represent "representation") can sometimes resemble taking on a life sentence. There are profound theoretical reasons why this might be so, and some of these are described in the following pages. But there can also be more contingently personal ones. In my own case, I first encountered the problematic of representation in a sustained way in connection with an attempt to think through a number of arguments centered on the category of *mimesis* (*The Order of Mimesis*, 1986), and since then, despite the sense of having had my say, however incompletely, it has actively and stubbornly continued to seek me out across a whole range of reencounters. The first encounter was essentially with a concept in ruins, carpet bombed by the formidable arsenals of contemporary critical theory. At the time, this relentless, and necessary, assault on the more naive and disingenuous mythologies of representational thinking struck me as in some ways trapped in naïvetés of its own, in particular the paradox (a form of which is in fact supplied by one of the princes of the new critical temper, Jacques Derrida, but which in other contexts went entirely unexamined) whereby to speak of representation in this way was itself

to represent. The heady atmosphere generated by that uncomfortable aporia has never quite evaporated and has seemed to require the constant renewal of a different, and more judicious, kind of reflexive turning back on the concept, something more sensitive to complexity and ambiguity than the catchphrases ("against" representation or, in even more naive register, "beyond" representation) that, like so many camp followers, have pitched camp in the debris left by the scorched-earth policy.

Since the moment of devastation, the debates have of course moved on, most notably into the confrontational spaces of the politics of representation, occupied by the splendidly insubordinate rejection of all master representations and the raucously democratic demand that neglected voices and narratives be given *droit de cité* in the postimperial and multicultural agon of the late twentieth century. In many ways, however, these have been debates more about occupancy of the category of representation than its theoretical grounds, and, beyond the urgencies of the whom, what, where, and when of representation, the grand theoretical questions remain open: how to understand the meaning of representation, and, perhaps above all, how to evaluate representations (according to what criteria: true/false, good/bad, strong/weak?). The following collection of essays may be read in large measure as testimony to the fact that, at least in the present author's case, these questions refuse to leave us. One of the objectives here is clarificatory, namely, to engage more closely and more carefully with different incarnations of the concept of representation across various disciplines, for the cross-disciplinary dimension (here, literary theory, art history, philosophy, politics, and the social sciences) is itself an index of the difficulty of gaining stable purchase on the concept, since its meanings and values shift considerably as we cross the boundaries from one discipline to another. If its flexibility is part of its enduring intellectual fascination, it is also a source of potentially disabling confusion, as we try to negotiate a fluid map of both family resemblances and radical differences. But far more important than the strictly clarificatory endeavor is maintaining a dialogue with the continuing challenge of the historically recent assault on the concept of representation. Its problematical fate in the swirl of the post-Nietzschean tide of critique has left us entirely uncertain as to what place, if any, the concept might now usefully have in our thinking. The different texts gathered here add up (although that is perhaps not quite the right metaphor) to a series of experimental shots at further exploration of these matters.

Gaining some elementary purchase on the concept is the brief of the

opening chapter. It is thus largely expository, devoted to discriminating the meanings of the term "representation" and the general form of some of the arguments these have generated in contemporary thought, especially those based on the triangular model of the representational prison house memorably sketched by Michel Foucault and Roland Barthes (and from which this book derives its main title). But it also touches on an issue that leads into many of the subsequent essays: the thorny issue of foundations and truth values in the analysis and evaluation of representations. In our current antifoundationalist mood, according to which representations are characteristically held to spring from and manifest the contingencies and conflicts of psychological and social power, this issue has tended to disappear or to have been expressly banished from the arena of discussion. It remains, however, obstinately resistant to banishment.

The first chapter broadly delineates what is at stake here. The following three chapters take up the question of foundations in greater detail by way of themes and problems in Marxist cultural theory, notably in the version of it that has come to be called, after Raymond Williams, cultural materialism. The first considers the attempt to construct a materialist art history in connection with representations of the city in nineteenth-century French painting made by T. J. Clark in his pioneering book *The Painting of Modern Life* (a book heavily indebted to the thinking of Raymond Williams), where a complex range of argument appears to settle, but to settle uneasily, in the notion of a founding category in the determination of pictorial representation. The next chapter considers the role of foundations in the more explicitly formulated theoretical program of cultural materialism in the writings of Williams himself and in particular what this can be taken to entail against the background of Williams's vigorous repudiation of the standard form of foundational thinking in classical Marxism, the base-superstructure model of explanation. What it might entail, especially for intelligible notions of history, is also a concern of the chapter on New Historicism, where, in a debate both within and against Marxism conducted by Stephen Greenblatt, culture is conceived as a circulation of representations without foundation or fixable origin.

The fifth chapter, on Paul de Man, looks at another way of representing the past, this time a personal one embedded in a wider history: that of responses to de Man's wartime journalism in occupied Belgium and its alleged relations to his later commitments to deconstruction. This essay connects more obliquely to discussion of the category of representation, but this is in large measure because its theme is obliquity of representa-

tion itself: the notion, much touted at the time of the de Man affair, of representation as mask or disguise in relation to certain modes of discourse or kinds of speech acts and, more specifically, the notion of disguised representation as either concealment or confession of an otherwise unavowable secret. Such a description of course smacks of a psychoanalytical approach to questions of representation, and so I should make immediately clear that this as such is not my concern at all. It is rather with the intellectual and ethical implications of going down this interpretative road, at least in connection with a past like de Man's; my conclusion is that these implications are pretty bleak.

The sixth chapter reviews and evaluates the work of Edward Said on the question "How does one *represent* other cultures?" Not only is the question Said's own, so also are the italics, thus signaling the paramount importance for Said of representation in the formulation of his question (though a full account would presumably require that equal emphasis be given to all its principal terms). Said's how-to is primarily historical: in *Orientalism*, how the West has represented the East from the eighteenth century onward, and, in *Culture and Imperialism*, how imperialist discourses have represented its objects of conquest. But the how-to also operates at a more general epistemological level, in terms familiar to cultural anthropology and the philosophy of the social sciences: what, if any, are the grounds of intercultural understanding in a world of uneven access to intellectual power and authority? The first part of the chapter assesses Said's contribution to this debate. The second part, however, turns to the more specific question of literature and Said's way with the representational economy of literary texts in the articulation of the imperialist dream.

The following two chapters take us respectively to another contentious space and another way with foundations; the distinction between representation and embodiment. In the first, I consider some aspects of Walter Benjamin's thinking, in terms of the notoriously slippery relation in German between *Vorstellung* and *Darstellung* (often, though controversially, translated as "representation" and "presentation"), a relation active in German aesthetic theory since the romantics that is mapped onto a preoccupation with the differences between allegory and symbol. In the case of Benjamin I trace this through his work on Baudelaire and the doctrine of *correspondances*, in an alignment with other nineteenth-century figures (in particular Joseph de Maistre), with a view to showing how the relevant theories of linguistic and literary significa-

tion are freighted with (often alarming) political consequence and impli-
cation. The next chapter reviews a number of developments in recent
accounts of literary realism post-Auerbach, with a focus on the surpris-
ing resurrection of embodied and embodying conceptions of art and
writing in certain contemporary approaches, notably the connection
between the body and embodiment in the theoretical essays of Hélène
Cixous and her curious imagining of a form of writing that would be
based on the notionally embodied immediacies of a kind of painting.

This fantasized grounding of literary writing in visual analogies in
turn leads to the last three chapters, which are concerned more with rep-
resentation in terms of certain transactions and translations across the
boundaries of medium, genre, and language. The first examines links
between visuality and narrative in the theory and practice of history
painting, specifically, what happens to and with the canonical notion of
the moment of representation in early-nineteenth-century French histo-
ry painting. In the next chapter I move from early-nineteenth-century
painting to experimental art and writing of early high modernism and
the place of metaphor in the work of Proust and Matisse, where
metaphorical representation denotes not just the familiar theme of
metaphor as foundational for Proust's literary practice and (though less
familiarly) for Matisse's fauve paintings but also the idea of painting and
literature as metaphorical representations of each other. The sense of
meta-phor as a carrying-across also implicates the subject matter of the
concluding chapter, translation of the interlingual kind, again with the
example of Proust (as an account of some of the issues raised by the
appearance of the revised Kilmartin translation of Proust that appeared
some years ago). This last essay (originally written as a review of
Kilmartin) also opens onto the perspective of future work in my role as
editor of a new English translation of Proust and the project of an accom-
panying book on aspects of translation both of and in Proust.

Acknowledgments

Versions of some of the chapters of this book have appeared previously: in *French Studies, Paragraph, London Review of Books, Critique,* and *Substance*; in *Cultural Materialism: On Raymond Williams,* edited by Christopher Prendergast (Minnesota University Press, 1995), *Intellectuals,* edited by Bruce Robbins (Minnesota University Press, 1990), and *De Spiegel van Stendhal,* edited by Barend van Heusden and Els Jongeneel (Groningen, 1998). Where relevant, I am grateful to the respective publishers for permission to reprint. Heartfelt thanks to my copyeditor, Sarah St. Onge, for her hawkeyed scrutiny of the manuscript, and to my editor at Columbia University Press, Jennifer Crewe, for her unfailing patience and generosity in seeing this book through to publication.

The Triangle
of Representation

1

The Triangle of Representation

Wherever it is that we may have found ourselves camping out in the battlefields of Theory, we will doubtless have encountered, whether as friend or foe, the concept of representation. In one of the now numerous guides to literary theory, not only does the entry for representation come first in the volume, the entry itself makes the claim—by way of the example of Aristotle's *Poetics*—that representation is both historically and conceptually foundational for our thinking about literature and culture.[1] The claim rests on a plausible translation of *mimesis* as representation,[2] linked to Aristotle's view of literary fictions as mediating an intelligible relation of man to the world by virtue of a rational and teleological structure inhabiting both the world and our fictional images of it (broadly, Aristotle's entelechic argument that art completes what is to be found potentially in nature).

This philosophical confidence in the power and authority of representation is of course long gone. In our so-called postmodern times, we are more likely to be seduced by the claim that what matters to us, existentially and historically, is unrepresentable (for example, the Holocaust and the notorious assertion that after Auschwitz poetry is no longer possible). This claim is entirely false. Everything is representable. This is not

the same as saying that the *concept* of representation is a cultural universal, that it belongs to, or more strictly matters to, all times and places (though to say that not all cultures have the concept of representation does not mean that they do not have representations). As a concept supplying a regulatory matrix of thought, representation, notwithstanding its ancient lineage, is an essentially modern invention, one of the master concepts of modernity underpinning the emergence of what Heidegger called the Age of the World Picture, based on the epistemological subject/object split of the scientific outlook: the knowing subject who observes ("enframes" is Heidegger's term) the world-out-there in order to make it over into an object of representation. "Observation" here is a strongly loaded term, indicating not only empirical observation but also the primacy accorded to a relation of looking, and this priority given to the visual and vision (Heidegger calls it the age of the world *picture*) as the very ground of apprehending and understanding the world is quite fundamental. I shall have occasion to return to this visual analogy at various junctures.

But for those of us who live inescapably in a culture of representation, these historical considerations scarcely affect the relevant argument. In such a culture, there is no such thing as the unrepresentable. What presumably is meant when we say that something is unrepresentable is that any given (or conceivable) representation is inadequate to what it seeks to represent, thus invoking, if only negatively, the model of *adequatio* and an associated correspondence theory of truth. It is not that representation as such is impossible; it is rather that it fails in its task, thus falling under a negative valuation or, more radically, under prohibition (as in the case of iconoclasm and the interdiction of graven images). An alternative view, much favored by antifoundationalist thinkers, has been to invoke *adequatio* (or its converse) on pragmatic grounds: a representation is adequate to some purpose or other, and human purposes can vary according to needs and interests in ways entirely irrelevant to the epistemological concerns of a correspondence theory of truth. A corollary of this alternative view is *mise en abîme*: the contingent origins and partial dimensions of a representation are or should be—there is here some uneasy sliding between the descriptive and the prescriptive[3]—marked in the representation itself, rather than merely suppressed in the reach for a correspondence between the representation and the truth of the (or a) world.

These are the dominant tones of reflection on representation today. The injection of *mise en abîme* and self-reflection, however, raises a diffi-

culty that is written deep into the premises of discussion but rarely spot-
ted or acknowledged, a difficulty so acute indeed as potentially to derail
the whole project of inquiry even before it has left the station. *Mise en
abîme* is not only a marker of honesty (signaling the contingency and par-
tiality of a representation); it is also held to declare the truth of represen-
tation (its nature, as in all cases, contingent and partial). Here is the epis-
temological sting in the tail, circling back at the metalevel to the very
point of departure it sought to transcend: the question of the truth val-
ues of representation (it is another version of the famed paradox of the
Cretan Liar). This difficulty has been eloquently addressed by Jacques
Derrida in a paper titled (in its English translation) "Sending: On
Representation."[4] The difficulty is this: in the very act of talking about
representation, in trying to define representation, one effectively begs the
question. Assuming you can talk about representation is the same as
assuming you can represent representation; to talk about it is to represent
it. This is true at the most basic level of all: the naming of the object of
inquiry. For the word "representation" and its cognates in other languages
(*représentation, Vorstellung*, etc.) are themselves representations of represen-
tation. The question then arises (it is very much Derrida's question) as to
whether there is a general form of representation for Representation, just
as in Wittgenstein there is a question as to whether there is a general form
of Proposition that could represent all propositions, both actual and pos-
sible. This opens onto the perspective of an infinite regress or an unbreak-
able circle: if you can represent Representation, how do you represent the
representation of Representation and so on?

 This is a theoretical problem to do with a relation between metalan-
guage and object language. It is not one I propose to dwell on, since it
can rapidly lead us into logical quicksands from which we are unlikely to
escape with our sanity intact. It does however point to a real practical dif-
ficulty: the project of representing Representation, defining an essence of
Representation, presumes that one can subjugate the varieties of repre-
sentation to, as Derrida puts it in "Sending: On Representation," the
"identity of an invariant meaning." Yet the concept of representation
behaves in a whole variety of different ways according to context, intel-
lectual discipline, and object of inquiry. It plays an important role in dis-
ciplines as diverse as literary studies, philosophy, psychology, and anthro-
pology and in theoretical approaches as diverse as structuralism, semiotics,
Marxism, and psychoanalysis. To show something of this diversity of use,
let me present just two examples (bearing in mind that the category of

the example is itself a mode of representation, with an attendant range of very tricky epistemological difficulties). In psychoanalysis, representation is an important term in the theory of the unconscious (Freud's German uses two words, *Repräsentation* and *Vorstellung*, which complicates the issue further). Freud speaks of object representations that are linked to desire and fantasy, to a whole topology of transformations governed by a principle of *distortion*; object representations are the material of the processes of primary and secondary revision in the dream work, the work of the unconscious in at once expressing and disguising unavowable desires. In literary studies, on the other hand, the term "representation" tends, at least in its classical nineteenth-century guises, to function in an exactly opposite way: it is not linked to the principle of distortion but on the contrary to the idea of a fully accurate or faithful reflection of reality.

This radical divergence of meaning and use suggests something of the difficulty in talking about representation in general. It is against that somewhat unstable background that I want in this introductory chapter to do essentially three things of a largely expository kind: first, to outline and discriminate some of the basic meanings of the term; second, to sketch some of the principal arguments that attach to those meanings, with particular reference to two figures: Jean-Jacques Rousseau, of all the modern philosophers the one most hostile to representation, and, in the field of inquiry more immediately relevant to contemporary literary theory, Roland Barthes; third, to consider some of the consequences of both the meanings and arguments in question (notably the consequences for what we might call the politics of representation).

The term "representation" has a complex semantic history (where the English term is concerned, a very useful account of that history is to be found in Raymond Williams's *Keywords*). But we can discriminate two basic meanings, although the discrimination is problematic by virtue of areas of overlap and confusion between the two. First, there is the sense of represent as re-present, to make present again, in two interrelated ways, spatial and temporal: spatially present (in the sense of the German *darstellen*, "to put before," "to put there") and present in the related temporal sense of the present moment (to present there and *now*). This meaning has an ancient lineage, deriving in part from the Latin *repraesentare* as "bringing to presence again," usually understood as the literal reappearance of an absent person or object but also carrying the sense of making present again by means of a simulacrum and thus aligning the concept of

representation with notions of illusion. Representation as the illusory re-presenting of the once-present object connects with a theme that in one way or another runs back to Plato's's censuring of the imitative arts as a kind of disreputable exercise in magic, confusing the senses and the mind with false simulacra.

The second basic meaning of represent is that of standing for: a present term "b" stands in for an absent term "a." The familiar example is the linguistic one, the linguistic sign as a phonic or graphic representation that stands for something else (an object, a concept, etc.). Representation in this sense thus rests on a principle of *substitution*. The substitution can take the form of a simulacrum, thus curling back into the definition of represent as making present, but it is not reducible to it. There can be only one kind of simulacrum, namely, the copy that produces the illusion of presence (Plato's *phantasma*), whereas there can be many kinds of substitution whereby one thing can stand for or indicate another. In this wider sense of representation as standing for, representation can be said in theory to cover the whole field of culture (that is, all semiotic systems from traffic lights to wedding rituals).[5]

These two basic meanings—making present again and standing for—can be further specified in terms of a number of different contexts of use, two of which I want to emphasize here. The first has to do with the arts, the notion of certain kinds of artistic works as representations (for example, the notion that characters in novels stand for real people or certain kinds of human experience in the world). The second is political, representation in the sense of a political system (such as modern parliamentary democracy) in which certain persons stand for other persons as their representatives, a sort of making present of the political subject through a process of standing for that subject. As with the idea of artistic representation, so the idea of political representation can oscillate between the two primary meanings, making present and standing for. In the history of political thought, representation can sometimes signify an act of delegation that does not entail claims to a relation of likeness between represented and representing. On the other hand, John Adams's theory of representation explicitly emphasizes a relation of likeness (interestingly modeled on the analogy of the portrait): a representative legislature "should be an exact portrait, in miniature, of the people at large, as it should think, feel, reason and act like them."[6] The political context is further complicated by the convergence of notions of representation on notions of embodiment, as in the older, theologically supported ideas of

kingship (the doctrine of the king's two bodies, held to be analogous to the Eucharist). These two contexts of use—the artistic and the political—occupy much of the space of the semantic history of the term "representation" in both English and French. Although the artistic and political senses must be distinguished, there is, as Williams stressed, an important "degree of possible overlap between representative and representation in their political and artistic senses," which probably rests on "a deep common cultural assumption," most particularly through the meaning of representation as "standing for others or other things."[7]

From this constellation of meanings and contexts of use, I want now to turn to a range of arguments about representation, in particular two arguments, one historical, the other contemporary. The historical argument reflects a key moment in the emergence and definition of representation as an issue and problem for thought. This is roughly the period of European thought stretching from the late eighteenth to the early nineteenth centuries, which, where the problematic of representation is concerned, is marked by two names in particular: Rousseau and Hegel (both of these figures being, for instance, key figures in Derrida's reflection on representation). Rousseau's example is the one that concerns me here (Hegel I shall mention only in passing). The more contemporary argument involves a model of representation in the theoretical writings of Roland Barthes, notably the influential essay "Diderot, Brecht, Eisenstein," which I shall use as a benchmark text for a discussion of what has happened to the idea of representation in modern critical theory.

The importance of Rousseau in these terms is, first, that he plays with both meanings of representation (as making present and as standing for) and, second, that he does so across a range of intellectual concerns that include both the artistic and the political. Rousseau's thought can be fairly characterized as a thoroughgoing critique and rejection of the idea of representation. On the political front, the principal text is of course *Du contrat social*, which among other things is full-scale assault on the idea of representative democracy. In Rousseau's system, there can be no authentic polity in which one person is allowed to represent, in the sense of standing-for, another person. To be a citizen is to participate directly in government; sovereignty is inalienable; thus the authentic polity is one based exclusively on presence rather than on representation, the presence of the citizen as a speaking and voting agent. Notoriously, Rousseau then has to confront the problem of how to have participatory rather than rep-

resentative democracy in a large, complex modern society; his model is the small city-state of antiquity, whose scale and forms are alien to the utterly different conditions of social and political modernity. Faced with these intractable difficulties, Rousseau's argument gets tied up in knots; in one plausible reading of *Du contrat social*, the alternative to the degraded form of representative democracy comes out as a version of dictatorship.

The logical paradoxes of Rousseau's political theory are not my concern here. More to the point is a relation between Rousseau's political writings and some of his other writings, notably those on culture and the arts. Rousseau's attack on representation in the name of unmediated presence is also one of the great themes of his famous intervention on the theater in the *Lettre à D'Alembert sur les spectacles*. The theater is a crucial example, in that one of the meanings of the French *représentation* is of course "theatrical performance." The theater, according to Rousseau, is a place of simulacra, a place of mask, artifice, and illusion, of substitutes for the real thing. It is both simulacrum and substitution in that it furnishes us with alibis for dealing with the challenges of face-to-face relationships in real life; thus the emotions of pity and fear we feel for fictional characters on a stage is a mechanism for evading the responsibility of using those emotions in an ethically creative way in the outside world.

Rousseau's rejection of representation is therefore entirely motivated by a commitment to the idea and the ideal of presence: political presence in a participatory democracy and human presence in face-to-face social and personal relationships, free of artifice and deception, fully "transparent," to use one of Rousseau's key terms. The objection is not to the contingent defects of a given representation but to the very principle of representation as such. To represent is to enter the sphere of alienated human relationships. This is what makes Rousseau at once exemplary and problematic for contemporary thought (it explains in large measure why Rousseau's example is so important for Derrida's *Grammatology*).

Current critical theory tends to start from the premise that representation is indeed alienation (in this sense it is Rousseauist) but refuses the other side of Rousseau's thinking: that the alienating effects of representation can be counteracted by an appeal to the principle of presence. If we are alienated by representation, we are also constructed by representation. There is no outside representation, no original condition of nonmediated, undivided being that we can recover on the far side of representation. Longing for unmediated presence rests on a nostalgic myth, a

longing for something that does not exist, that never existed at all, other than as a fantasy object for what Hegel called the unhappy consciousness of modernity. Hegel of course is another pivotal figure in the relevant story. It is Hegel who speaks in the opening pages of *The Phenomenology of Spirit* of the desire of philosophy to get beyond representation to the world itself, to the presence of the world, from the mediate to the immediate, the nonmediated (to a "simple immediacy," "a knowledge of the immediate or of what simply is"). One of his terms for this dream of philosophy is *Darstellung* (as it will also be for Marx), often translated as "presentation," in explicit opposition to "representation" (*Vorstellung*).[8] Hegel's sad recognition, however, is that the mediated lies everywhere in our path. In the ancient world, art temporarily found a solution to the division of subject and object, but that solution is no longer available to us. The end of history, the ultimate metaphysical *Aufhebung*, might bring a new, uniquely Hegelian resolution, but only after a prolonged and strenuous voyage through the badlands of representation.

Contemporary theory is broadly on the side of Hegel here, minus the grand utopian projection, engaging critically with the concept of representation without nostalgia for some allegedly lost and recoverable moment of unmediated presence to the world (although there are some versions of contemporary critique of representation where in fact these nostalgias resurface in one guise or another).[9] Generally speaking, however, contemporary theory has tackled representation on the terrain of representation itself (which is of course why Derrida makes such a fuss about the metalanguage/object-language problem and the potential bad faith of representing representation in the form of a critique of representation; at every point we risk having the rug pulled out from under our feet). Divested of the prospect of a comfortable landing on the ground of presence, critical theory accordingly works less from the first than the second of the two meanings of representation described earlier: the sense of standing for rather than the sense of making present again (generating the illusion of presence).

To this relation of standing for, representation as the process whereby one thing substitutes for another, a further question is brought, and this really is the key question for modern critical theory: if representation is the process whereby "a" stands for "b" (where "a" and "b" can be terms in a linguistic system, a literary system, or a political system), by what *authority* does it do so? The question then is a question about authority in representation, linked to the view that representation, though

inevitable (no human culture is conceivable without representations), is not only alienating but also oppressive. The principal set of claims concerns a relation between representation and *power*; if it is through representations that we speak, if it is representations that speak us (fundamentally the representation or system of representation called language), what can we do with and about that fact?

One of the things we can do—one of the things that contemporary theory has done exceptionally well—is to analyze the properties, rules, and modes of functioning of systems of representation, with a view to uncovering their assumptions, describing their origins, and above all unmasking the processes whereby those origins are concealed in the interests of parading the human choices and conventions on which they are based as not human choices and conventions at all but as if they were natural, permanent, and unalterable, made to the specifications of eternity. Representations have a strong in-built tendency to self-naturalization, to offering themselves as if what they represented was the definitive truth of the matter. If it is impossible to define representation, it is certainly true that representation is strongly invested in definitions; representations define worlds, subjectivities, identities, and so on. Examining this relation of representation and power can take many forms, but it overridingly involves another displacement or shift of emphasis. In traditional accounts of representation the focus is on the *represented*, whereas in contemporary theory the focus is as much on the process of *representing*, the question of who does the representing, who delimits and controls the field of representation; in brief, there is a displacement from the object of representation to the subject of representation.

Heidegger's account of the place of representation as a master category of modern thought, it will be recalled, turns on the division of subject and object in determining the field of knowledge. Heidegger describes (represents) this as an act of picturing, the framing of reality on the analogy of a picture. This division of subject and object, carried by the force of a visual analogy, is also the ground on which the idea of representation has been theorized in contemporary French thought, notably in the work of Foucault and Barthes. In *Les Mots et les choses* Foucault takes a famous painting by Velázquez (the painting of the painter painting the royal family) as a reflexive allegory of representation in general. It is no accident that the example is from the sphere of painting and that it includes the subject as well as the object of the representation. Foucault calls it the triangle of representation.

The image of the triangle is also to be found in the account of representation I want to consider here in more detail: namely, Barthes's sketch of what he calls an "Organon of Representation" in the essay "Diderot, Brecht, Eisenstein."

> Representation is not defined directly by imitation: even if one gets rid of notions of the "real," of the "vraisemblable," or the "copy," there will still be representation for so long as a subject (author, reader, spectator, or voyeur) casts his gaze toward a horizon on which he cuts out the base of a triangle, his eye (or mind) forming the apex. The "Organon of Representation" . . . will have as its dual foundation the sovereignty of the act of cutting-out [*découpage*] and the unity of the subject of that action.[10]

In this account, the field of representation is construed as a field of vision shaped like a triangle. At the apex of the triangle there is a subject of vision, a centered and unified subject who as it were cuts out (*découpe*), delimits, and controls the field. The geometric metaphor evokes a formal rather than a substantival model of representation, directed less to objects than to relations. It designates an activity of mapping the world in terms of relations of proportionality, such that the field of representation corresponds to a perceived structure of the represented field. The model is then, once again, grounded on a visual analogy. Artistically, this recalls the model of classical perspective in which the subject of vision is positioned as a subject of mastery (classical perspective being indeed one of the founding aesthetic forms of what Heidegger calls the Age of the World Picture). But it also resonates into areas of political thought, in particular the metaphorical view proposed by Mirabeau of democratic representation as a mapped and mapping space built on relations of proportionality: "A representative body is for the nation what a map drawn to scale is for the physical configuration of its land; in part or in whole the copy must always have the same proportions as the original."[11]

The political dimension thus brings us squarely back to questions of power in the issue of representation. This indeed is where, at least in the tradition of classical political theory, the issue of representation begins and, ultimately, divides. In later democratic thought (for example, that of Mill), representation is linked to talking and thus to reflection (the assembly as that which reflects all shades of opinion). In the earlier, Hobbesian

tradition, however, representation is linked rather to acting and hence to authority, the authority vested in the ruler to govern.[12] Representation in this context is more a matter of the mapper than of the map, the cartographer-ruler, precisely at the apex, not unlike perhaps the subject in Barthes's triangle. For Barthes, the image of the triangle of representation is expressly designed to highlight a whole economy of authority and hierarchy, a relation of power in which the subject of representation commands the systems of knowledge and belief within which the world is interpreted and the relevant interpretations socially validated.

This displacement of attention from the object of representation to the subject of representation is probably the most significant general move of contemporary critical theory vis-à-vis the category of representation. The focus of more detailed inquiry will thus be on the origins and constitution of this subject. Here I will limit myself schematically to three aspects of its general character. First, the subject is not necessarily or even normally an individual (in the case of works of art, let us say an author). It designates rather a set of subject positions, generally articulated in a transindividual fashion, in an ideology, a tradition, or set of conventions, often connected to a dominant set of interests (a social group, a ruling class, which has privileged access to the cultural resources of a society). This does not mean that representations can be separated from individual intentions, still less (as in some of the cruder versions of the death-of-the-author thesis) that there are no such things as intentions. The focus here is rather on the ways in which intentions are formed, organized, and expressed within determinate social and historical settings.

Second, there is the relation between the subject of representation and the process of naturalization (an important concept in both semiotics and Marxist theory of ideology), the process whereby particular cultural constructions of the world are made to appear as if they were in accordance with nature, permanently and unalterably valid. While the subject positions in question are transindividual, they are not transcendental or universal; they are socially and culturally produced and so a fortiori are the representations they generate. But the characteristic ideological move of power is to mask that relativity, in the gesture whereby culture and history are made over into an image of the natural.

Third, there is the notion of the representational field as a field to be policed and the subject of representation as a kind of policing agent. In the "Diderot, Brecht, Eisenstein" paper, Barthes refers to this through the figure of the Law ("cette Loi qui regarde, cadre, centre, énonce . . .'"). The

law of representation is that which legislates how we are to see ourselves, what positions in the symbolic order we are called on to occupy.

This has much in common with Althusser's reflections on representation and ideology as that which fixes and frames identities within the social order, specifically, Althusser's famous notion of interpellation according to which representation "hails us" as subjects, issues a kind of command to enter into a given subject position. It also has much in common with the terms of feminist critique of representation as geared to the creation of essentializing, stereotyped definitions of gender identity, where the idea or metaphor of the Law is specifically assimilated to the law of patriarchy, representation as the reproduction of the terms of patriarchy for naming and classifying reality. Whether the center of gravity is in Marxism, feminism, or somewhere else, the more general point about this notion of representation as having, so to speak, legislating and legalizing functions, in particular legislating identities, circumscribing the area of the normative and the normal, is that representation is not simply passive reflection of ways of looking at the world but itself an active force in the social construction of reality.[13]

Within this body of thought, then, questions of representation are also questions of politics (in a broad sense of the term and moreover not necessarily congruent with what we would routinely think of as democracy). Construed as such, however, this approach generates further questions, which, it is fair to say, the more influential forms of contemporary critical theory have not satisfactorily addressed and which remain pressingly on the agenda of discussion. The first is this: Is representation intrinsically and always alienating, oppressive, and violent, as distinct from particular, contingent representations that can be challenged and changed? Is representation like this all the way down? And, if so, what then would be the consequences, notably of course for a politics of representation?

In certain moods this indeed seems to be the claim of Barthes and others: that representation as such is irreducibly oppressive. For example, in some of his writings Barthes argued that oppression is intrinsic to the most fundamental representational system of all, our most basic medium for constructing the world and transacting with one another, namely, language. The predicative structures and operations of language impose attributes and identities that are not of our own choosing, a view the most notorious version of which is Barthes's claim in his introductory lecture at the Collège de France that language is fascist, imprisoning us in

the frame of its own terms: the syntax of the sentence is like a sentence in the juridical sense, incarceration in what Nietzsche called the prison house of language.[14]

If we take this view seriously, we then have to ask on what grounds we can contest representations. Is there any space from which the authority of representation can be challenged? Is there an outside or a beyond–representation (as in Rousseau's dream of presence and transparency)? The answer here tends to be that there is no beyond or, if there is, it would be the domain of babbling insanity (as in the arguments of Lacan and his followers to the effect that if the representations that constitute the symbolic order are intrinsically alienating, they are nevertheless in some form or other essential to the creation of subjectivity and intersubjectivity).[15] If then we are locked into representation as the very condition of human culture, of being human, and if representation is tied to oppression, what do we do with our wish to be able to say that some representations are better than others or more truthful than others? This is a very real difficulty, to which there are no straightforward solutions. What would be the grounds and the measure of such judgments? Would they not imply a point beyond the play and conflict of representations? Or is it just a matter of preferences on the battlefield of representations or, in the pragmatist argument, that there are certain things we can *do* with representations and that this is the criterion of their value?

In this connection, if we cannot get outside representation as such, what we can try to do—it is one of the lessons of modern theory—is to weaken the relation between representation and power by questioning all *master* representations. This is the great theme of the philosopher Lyotard, his rejection in *La condition postmoderne* of all master narratives. The implied injunction here is not to pursue the illusory Rousseauist goal of a space beyond representation but rather to proliferate and multiply representations, to construct a diversified agon of representations, dominated by no single voice but in which multiple voices speak and clash. This has many further consequences. Here I will mention just two. First, insofar as representation as standing for can also mean speaking for, it can involve not only the notion of the political representative but also the notion of the representative intellectual, who speaks for or on behalf of others. The notion of the representative intellectual (in a tradition running from Voltaire through Matthew Arnold to Sartre) is one that has become increasingly an object of suspicion. The other has to do, relatedly, with the implications of the critique of representation for what we

now call multiculturalism, the terms on which cultures represent one another to themselves. This relation between power and representation is at the heart of Edward Said's account, in *Orientalism*, of the discourses through which the West has historically constructed the East as its Other. Multiculturalism is a critical response to these kinds of master representations, an attempt to substitute the dialogue of multiple articulations of the world for the monologue of power.

Nevertheless, a problem remains: if master representations are to be contested by means of counterrepresentations, are we not committed at some point in all this to the principle of the truth values of representations? If not, in the name of what do we speak? The question of truth remains obstinately before us. In recent critical theory, this question has suffered considerable neglect, more or less liquidated in the relativities of antifoundationalism. But this is too easy. In the first place, the liquidation is, as I showed earlier, impossibly paradoxical: if what is claimed regarding the relativity of representations is held to be true of representation, this is self-defeating, and it has to be said that those who have most vociferously occupied the relativist position have often signally failed to follow through on how that position then stands in relation to their own argument. If there is no exteriority to representation, if we are always inside it, this does not preclude the possibility that some forms of representation are especially well equipped to deal with the category of truth, because, if that were not the case, it is unclear how we could even continue talking coherently about representation at all.

In philosophy such considerations typically arise in the context of realist epistemologies and causal theories of knowledge (our representations are reliable to the extent that they are caused by properties of the world) and are thus closely linked to a view of philosophy as justification of the natural sciences.[16] But there are also other areas where the issue of truth arises, which have little to do with the hegemony of science. In political theory, for example, there is a rich tradition of debate as to when and how a representation (of others by representatives) constitutes a true representation. Burke, for instance, argued that a true representation is what represents the interests of a person or group, but where "interest" does not have to be tested by consulting the conscious wishes of the represented constituency. This rests on a view of interest as objective, thus not requiring empirical verification in the form of consultation; its practical consequence is the legitimizing of a political elite authorized to rule on the grounds that only it can rationally determine what an interest is. The

counterargument (it is Mill's view) has it that determining a true interest is inseparable from the consultation of wishes, even though wishes can visibly compromise or damage what is conducive to welfare. Rousseau was alert to these paradoxes and contradictions, which is why he abandoned the concept of representation altogether, though his own solution in the self-confirming metaphysical notion of the General Will was no solution at all. What underlies these reflections is that, however glossed, the question of truth will not go away.

This is also a matter for literary theory or perhaps what is better called theory of fictions. Here too the issue cannot conceivably be understood in terms of a simple positivism or reductive version of the correspondence theory (without returning to those naive nineteenth-century versions of realism that sought to construe fiction on the analogy with science). In the case of literature, representations are best seen as forces at work in a cultural force field; in that sense, they are irreducibly bound up with power. Literary fictions do not simply portray or reflect the world. They elicit, precisely by way of their fictional modes of representation, *attitudes* to the world that enable—or disable—forms of understanding. This is one of the most important things that literature does.[17] The forms of understanding that the persuasive energies of literature make available are not of course simply or primarily conceptual and cognitive. They demand complex forms of attention and processes that are often obscure but bring a greater degree of clarity to our engagement with the world than those normally on offer in the structures of everyday preunderstanding. They do this, if only heuristically (that is, by means of hypothetical fictions), either by revealing connections between what to ordinary consciousness is disconnected or, conversely, by revealing a lack of connection (of the sort we often ardently desire in order to sustain the illusion of the world as a comfortably habitable place).[18] The plots of the nineteenth-century novel are an illustration of the first kind and the plots of tragedy an illustration of the second kind, a distinction that Bernard Williams has specified in the contrast between "dense fictions" and "stark fictions."[19]

This view has the interesting property of highlighting the rhetorical functions of literature, but in a manner that divorces them from the rhetoricism that has been so prevalent in contemporary literary studies. It does so by restoring rhetoric to considerations of understanding (what here I call rhetoricism has, on the contrary, focused on the rhetorical aspects of literary discourse with the express purpose of undermining any

claim by literature to truth values). Since rhetoricism often goes by way of Nietzsche (the notorious equation of truth with an army of metaphors and metonymies), perhaps we should heed Williams's injunction to return to what Nietzsche importantly said about art and truth (specifically trag- ic art and truth): "When later he [Nietzsche] said that we have art so that we do not perish from the truth, he did not mean that we use art in order to escape from the truth: he meant that we have art so that we can both grasp the truth and not perish from it."[20]

2

Blurred Identities

REPRESENTING MODERN LIFE

In 1877 a critic in *Le Télégraphe* sketched, half jokingly, half prophetically, a scenario for the impressionist novel, according to which the identity of all its characters and actions would be undecidable. These of course are the distinctive tones of what we call modernity, and modernity, both as development in the later nineteenth century and as *problem* bequeathed to us (for whom the "undecidable" has assumed almost sacrosanct status), is the central concern of a most remarkable book, T. J. Clark's *The Painting of Modern Life*.[1] Although its main focus is on nineteenth-century French painting of the period, it engages critically with the emergence of a whole cultural formation, many of whose terms are still with us, and from now on it will only be by ignoring this book, or by playing down its importance, that we shall be able to continue to treat the idea of the modern with the innocence to which we have grown accustomed.

It is difficult to gain purchase on the book's immensely complex and subtly shaded argument. But a serviceable, if crude, point of departure might be by way of the somewhat overexposed question: what was the famous impressionist *blur* all about? Contemporary critics lampooned it as a scandalous dereliction of representational duty. The impressionists themselves commonly defended it on cognitive and epistemological

grounds, as the attempt to capture the immediacies of perception prior to their entry into an order of representation commanded by reason and habit. Some attempts were made (notably by Laforgue) to link it to the mobile energies of the unconscious. Later avantgardiste versions have stressed its function as a means of displacing attention away from a determinate signified toward the painterly signifier, the textured materiality of the picture surface as a constellation of pigments and brushstrokes organized on a flat two-dimensional space.

Tim Clark takes into account all these approaches, only to declare them radically inadequate to an explanation of the complex cultural configuration to which the impressionists belonged. "Belonging," however, is a term that begs questions. The indistinctness of impressionist painting concerns an uncertainty as to what or who belongs where in the shifting landscape of the later nineteenth century. Not knowing, or not wanting to know, what belongs where, what constitute criteria of identity and difference, can of course be mapped in cognitive or epistemological terms. Equally we can convert the picture surfaces of Manet, Monet, and Pissarro into currency with which to book a pleasure trip on the flight of the signifier. But such conversions are purchased at the price of a major devaluation: positioned suitably close up, we can decompose Pissarro's *Coin de village, effet d'hiver*, Monet's *Le train dans la neige à Argenteuil*, or Manet's *Argenteuil, les canotiers* into masses, shapes, and layers or, as Clark puts it, into "metaphors for paint and painting," but only if we bypass forms of indeterminacy that pressingly engage the less myopic gaze. What, for example, do we make of the woman in *Argenteuil, les canotiers*? Does she belong to the picture's setting, or is she from elsewhere (on an outing from Paris, for example)? Why is her look so vacant, detached from both her surroundings and the attentions of the man seated beside her? Why does her *endimanché* attire look so fussily out of place against the background of river and boats (although this is no semirural arcadia: on the far side of the river we see, in yet another "blur," the smoke of factory chimneys blending with the clouds)? Is this the appropriate class of person to be found among the boats of Argenteuil, occupying, however ambiguously, the place of leisure? And, if this is one of the characteristic faces of modernity, why are there so many indeterminacies in its representation? It is not a question of evacuating the picture's representational content but of examining the meaning of our difficulty in gaining a secure interpretative purchase on it. Why are we as uneasy in looking at this picture as the woman appears to be in the pic-

ture? Nothing—neither viewer nor subject—appears to be in its proper place.

These unsettling mixes are the stuff of Clark's account of modernity. Modernity here is not seen as merely an aesthetic phenomenon. Modernity is not only modern art, it is also modern art caught in a complex set of transactions (at once metaphorical and literal) with modern *life*; and modern life, at least in the capital, is posed essentially as a set of increasingly ambiguous, or self-ambiguating, social forms of life. This kind of alignment of the artistic and the social disturbs more than one critical orthodoxy. If it grounds the heady flight of the signifier, it also challenges, head on, many of the assumptions and procedures of conventional art history. Like Clark's previous books, this inquiry into French painting of the later nineteenth century is conducted in terms that the established art historical milieu characteristically refuses or indeed does not even recognize, apart perhaps from its scrupulously documented scholarship. But scholarship here serves in large measure the enterprise of rescuing art history from Art History. Along with those other agents provocateurs of the discipline, Clark's insistence is that the history of painting cannot be read independently of social history or the history of social representations of reality (although exactly what notion of history is active here raises a problem to which I shall return). But the provocation to the protocols of so-called normal art historical discourse runs deep: the network of interrelated practices and representations under consideration is held to be inseparable from the maneuver of ideology (defined, perhaps somewhat cursorily in the opening pages along with the other key terms of Clark's conceptual framing of his topic, as naturalization of the given or assumed forms of the social world). The involvement of later-nineteenth-century painting in ideology and its attempts (and failures) to escape or marginalize its relation to ideological ways of looking at, and masking, modern social realities form the basic theme of the book.

In *The Absolute Bourgeois* and *Image of the People* Clark articulated these sorts of question primarily in political terms related to the experience of the 1848 revolutions. How did artists engage with revolution, understanding this in the precise sense, entirely appropriate to 1848, of representation of the interests of the proletariat? Clark's answer to this question proved attractively, and fiercely, unpredictable: the heroes of that story were not the writers and painters manipulating the received forms of republican and socialist rhetoric and imagery; they were the quirky and

iconoclastic figures of Courbet and, more surprisingly although also more problematically, Baudelaire (it is straining the evidence somewhat to promote, as in the final analysis Clark does, an image of Baudelaire as the champion of proletarian violence). But the main thrust of the argument in the earlier books was that Courbet and Baudelaire engaged with crucial political issues in ways that were enigmatic, oblique, and incomplete, as the only possible terms of resistance in an artistic and intellectual world where the terms of frontal contestation had been appropriated and domesticated.

In *The Painting of Modern Life* things have changed considerably. Notions of the oblique, the enigmatic, and the marginal have become explicitly the categories of painterly representation to be subjected to close, and often quite relentless, critical scrutiny. The focus of the book is class and its representations, but not class in visible, if confused, conflict on the barricades of 1848. Here, we are in the world of the Second Empire and the Third Republic, the world of Haussmann's Paris, of mobile speculative capital and shifting social allegiances. It is a world still haunted by the specter of revolution but that has also learnt to displace and defuse that anxiety by the production of a new leisure and pleasure culture within which class relations and identities, at least in certain spaces and under certain conditions, have become "blurred," no longer amenable to clear demarcation and interpretation. Class is of course notoriously difficult to define: is it a heuristic fiction or an objective reality, a determinate entity or semiotic construct, a matter of substance or a matter of signs? Clark's own text circles ambivalently around this question, and, although the substantivist view (broadly, the Marxist account of class as a determinate relation to the means of production) is vital to much of his case, his methodological preliminaries leave a great deal hanging in the air.

But if class is a problem *for* Clark's argument, it is also a problem *in* that argument. Insofar as the question "substance or sign?" arises, the origins of the question arguably lie in specific economic and social developments in the later nineteenth century, for, assuming that class is real, then how is it to be displayed or represented other than by means of signs? If a person belongs to a class, how do you tell which class he or she belongs to? Clark argues that the earlier nineteenth century gave confident answers to these questions (though this not only simplifies but overlooks the anxieties about taxonomy in, say, late Balzac). In the second half of the nineteenth century, however, there appears a certain confusion concerning

the legibility of the social world. Clark adduces some causal explanations for these changing social perceptions: broadly, new modes of production and consumption, new forms of work and leisure, centered on such phenomena as the *grand magasin* (generating the syndrome of impulse buying), and *grande confection* (making available a range of cheapish clothes with which the clerk could dress up as the gentleman); the creation of a whole new leisure industry coupled with the expansion of public transport, permitting mass urban access to the *banlieue* and the countryside; above all, the key social development entailed by these transformations, the emergence of a new class, the *petite bourgeoisie*, originating in the working class but with aspirations to bourgeoisie, a class uncertain of its own social position, at once confronted with but also actively cultivating its own sense of rootlessness and marginality. The consequence is the appearance in an otherwise stratified population of an atmosphere of fluidity and provisionality, especially in certain public places such as the *grands boulevards*, the race tracks, the café-concert, the regatta, the Sunday promenade at Argenteuil, so many sites of pleasure that were also sites of ambiguous mixes and effaced origins, where class seems to be simultaneously both absent and present.

How to map and represent that fluidity, as well as what it masks, is, according to Clark, the main problem faced (or evaded) by the impressionist painters. At the level of the sign, these developments were real enough (the *commis* really did imitate the gentleman), and the call for a return to the secure social taxonomies of the past was but the anxious reflex of an essentially reactionary nostalgia. On the other hand, the complacent registration of the new fluidities and ambiguities carried its own dangers: the promotion of a spectacular fiction (precisely, a spectacle for ideological consumption), according to which class no longer mattered or indeed no longer effectively existed. If class identity proves uncertain, then it is but a step to saying that modern society is a classless society or at least that what is significant about modernity takes place at the margin of class. We thus have a new kind of *fix* that took the shape of a social unfixing, broadly, the fix by which modern capital ensured its success while appearing to keep its hands clean, or at least invisible.

Questions of visibility and invisibility, clear seeing and "blurred" seeing, are also questions for painting. How then did the impressionists deal, or refuse to deal, with them? Clark gives his own answer to these question over four long and intricate chapters plus a conclusion. The first rehearses the

Haussmannization of Paris and concentrates pictorially on Manet's *Exposition Universelle de 1867.* The second considers the implications for the urban social order of the spread of prostitution in Paris, largely in terms of a reading of the problematic readability of Manet's *Olympia.* The third takes us to the environs of Paris (Argenteuil, Asnières, Genevilliers) in terms both of the spread of industrialization from Paris to the banlieue and of the developing forms of petit-bourgeois leisure culture; the main focus here is on the landscape paintings of Monet (who gets a particularly hard press), but there is also a look at Seurat's *Une Baignade à Asnières* that prefigures the key role of Seurat in the later stages of Clark's argument. In chapter 4 the text returns to Paris and the culture of the café-concert, with particular reference to Degas and to what is perhaps Manet's most unusual picture, *Un Bar aux Folies-Bergère.* The final chapter draws conclusions (some of them surprising and certainly controversial) and gears them to an account of what for Clark is clearly the great painting of the period, Seurat's *Un Dimanche après-midi à l'île de La Grande Jatte* (although what the criteria of greatness can plausibly be in this account is a major issue that I shall take up toward the end of this chapter).

For purposes of summary I shall concentrate more on the first chapter of his book, since this sets both the scene and the terms for much of what is to follow. The changing forms and perceptions of urban space entailed by the Haussmannization of Paris supply the essential figures of modernity. It is here that the great ideological fix produced by the myth of social unfixity takes place. Clark rehearses, with a mixture of sympathy and exasperated skepticism, the received versions of Haussmannization, of which the most favored (at least on the Left) has been that the essential purpose was to rationalize and regiment the layout of the city with a view to controlling future insurrection. Clark does not dispute these motivations, but his explanation goes beyond considerations of individual perceptions and intentions to more generalized and insidious modes of appropriation and control. Haussmann (and his enemies) may have thought the objective was to produce a coherent and stratified identity for modern Paris, a clearly readable system of boundaries and demarcations with everything in its proper place, a city without surprise. But the notion of surprise (of chance encounter, random purchase, quick money, provisional pleasure) was exactly what the speculative ideologies of modern urban capitalism prized most. And if the consciously perceived purpose of Haussmannization was to produce an instantly legible form for the city, the actual result was the converse: the city became a space of

growing illegibility, as a consequence and reflection of the interests of
modern capital in masking its own opaquely mobile operations: for the
city to belong to capital, it had to be perceived as belonging to no one in
particular, as a "free field of signs and exhibits" in which everything was,
in theory, permanently up for grabs to everyone.

This is the great myth of modernity: the image of the city as a place
of confusion and mixture beyond the powers of social control and intel-
ligible representation, an agglomeration of marginal spaces, improvised
life styles, and fast transactions, like an anonymous swirling masked ball
(figured in Manet's *Un bal masqué à l'Opéra*). The city, we might say,
becomes the privileged site of the shifter, in the sense both of a mobile
population and a medley of experiences perceived as a sequence of
unconnected deictics (*"this* ball, *this* bar, *this picnic; this* balcony, *this* walk
outside the Great Exhibition, *this* rest with a novel by the railings, *this*
prostitute's bedroom, . . . *this* café-concert," my italics). For the painter, the
problem is, then, the following: the city can no longer be portrayed in
terms of a coherent image without falling into a form of bad faith;
Haussmann's Paris presents itself as spectacle, but a spectacle that is
incomplete, characterized by a lack of workable "forms of visualization."
Manet ironizes the difficulty in his *Exposition Universelle de 1867* by liter-
ally giving us spectacle (Paris viewed by a group of strollers from the
heights of the Butte de Chaillot, specially reconstructed by Haussmann
for the purpose). The painting is comedy, pantomime, a parodic echo of
the totalizing energies of Balzac's panoramic views. Centered on an
absence of significant relation, a disconnectedness between viewers and
city and between viewers themselves, this is Paris seen, but seen non-
committally, with indifference, as a place that doesn't add up, that doesn't
mean anything anymore. On the other hand, this very way of seeing car-
ries its own dangers. The comedy risks turning into a certain compla-
cency whereby the surface of modernity is recorded as a natural state of
affairs, as if innocently free of significant forms of division, conflict, and
control, and correspondingly coverted into a kind of "touristic entertain-
ment" (the terms of Clark's description of Monet's two versions of *Le
Boulevard des Capucines*, later amplified into a fully fledged attack on the
leisured idiom of Monet's representation of the leisured life in the
Argenteuil pictures).

The essential movement of the book, however, consists in a series of
returns to the puzzling work of Manet and the contexts of its reception.
The two most exciting chapters are built around extended analyses of

Manet's two most controversial pictures, *Olympia* and *Un Bar aux Folies-Bergère*. Clark's excavation of the copious critical record shows that what shocked was not the pictures' realism (which, however shocking, would at least have supplied a framework for recognition) but their apparent *unreadability*: in the case of the *Bar*, how to read the famous mirror and its play of presences and absences, its reflections all askew or nonexistent; in the case of *Olympia*, how to make sense of that provocatively resistant naked body, strictly nonrecuperable into the conventions and expectations of High Art. In both cases, Clark's explanation turns yet again on questions of class in its more opaque (or opacified) transactions. The *Bar* explodes the great fiction of the culture of the café-concert as a place of informal and relaxed mingling of social groups (although the elements of that mingling were a source of considerable alarm to the Parisian authorities). In the *Bar* the reflected image of the man addressing the girl behind the counter is not matched by a corresponding image of the man in the foreground addressing the girl over the counter: instead of presence, absence; instead of the man in the picture, the viewer outside the picture confronted with the girl's impenetrably passive gaze. But the substitution doesn't work; it is visually and spatially illogical; we cannot be where the man "is," for that does not match the relationship between the reflection of the girl and the man in the mirror. What we have is a relation of conflict and cancellation between image and reflection: in the latter an amiable, relaxed exchange (possibly between client and prostitute); in the former a transaction between girl and the viewer, except that it is exactly *transaction* that has become impossible. The inert resistance of the girl's face to communication and exchange eludes taxonomies, produces uncertainty, and introduces an uneasiness of class relations into that uncertainty from the point of view of the viewing subject (himself).

The *Olympia* also introduces class by way of a male/female relations and more specifically by way of its deadpan equivocation of two major categories, one social, one painterly: the Courtesan and the Nude. For the male viewer (the view presupposed by Clark's argument), the category of the *courtisane* is entirely comfortable, a stereotype situated beyond class at the margin of society, participating in a theatrical charade in which her class is simply classy, an amiable yet wholly transparent fiction (its transparency was presumably part of the client's pleasure). Manet's picture "blurs" the division between the safe margin and dangerous middle of the social order by making of his prostitute the focus of an uncertainty in perception. Where does she come from, what are her origins, what is the

social context of the body/money transaction? Clark's claim is that these questions are inscribed in the actual painting of Olympia's nakedness; what the client buys is the body (and not the theatrical props), and the body comes from the streets, the *faubourg* (whence the recurring references in the contemporary accounts to Olympia's body as "greasy," "unwashed," "deformed"). What the picture says is that Olympia is working class and hence that the prostitute is a point of contact between social classes otherwise held to be hierarchically separate. This crossing of class and body, social and sexual identity, further implicates the aesthetic category of the Nude, by way of a set of questions addressed to the most notorious feature of *Olympia*, the position of her left hand. That left hand serves to remind us of what is characteristically absent in representations and appreciations of the Nude. For the female body to be converted into an object of aesthetic attention something has to be missing (normally the representation of pudenda and genitalia). Clark, however, takes "missing" in another sense, and here the argument takes an oddly Lacanian turn. What the classical Nude picture implies is the missing phallus and thus the constitution of female identity (as "lack") by reference to the male. Olympia's flexed hand over her crotch touches a primal male fear, the fear that here we have a body that is not (un)sexed in the right way; beneath the hand there might be the phallus in some hideous distortion of sex, and if this seems far-fetched, we only have to look—as Clark does—at what the contemporary cartoons made of that left hand. There are of course other possible readings, less dependent on a commitment to rather specific sorts of psychoanalytical categories. But the general point is that Olympia's body refuses to play the game (either of sex or of art) and in that refusal forces issues of sexuality and class, origin and identity, into an exposure of those various forms of bad faith interested in keeping those issues buried or "blurred."

Crucial to this account of Manet, however, is Clark's insistence that the pictures themselves never insist. And this raises what, for Clark, is the problem of Manet and, for me, is the problem of Clark. I shall devote the rest of this chapter to these problems, in terms both of Clark's account of Manet in particular and his concluding reflections on the phenomenon of impressionism as a whole. *Olympia*, Clark suggests, is organized as a "broken circuit of signs" providing no point of definite purchase and as such refusing to give the terms of an attitude. Like the boldly impassive gaze of its subject, it is a picture that keeps the viewer out, by means of a

carefully managed performance in pure deadpan. But for Clark Manet's ambiguous deadpan is itself ideologically ambiguous: it can be read either as ironic disruption of social and sexual taxonomies or as itself complicit in the myth of the fluid and indeterminate nature of modern social life. Prior to his analysis of *Olympia*, Clark remarks that one question that needs to be answered in respect of the painting is "whether the price of [its] success was too high." In immediate context it is not clear what this means (Clark's text has its own, often inscrutable ambiguities), but I take this to refer to a cost incurred by Manet's equivocal relation to the mix of equivocated reality and equivocating mythology deemed by Clark to be at the heart of modernity. Does Manet's work not only record but also endorse modernity by privileging "blur," thereby screening off from vision what, beyond equivocation, was actually there to be seen in the social landscape? Does the work blur the issues because, in the last analysis, it cannot—or will not—face *the* issue?

Clark appears to believe that this is so. In the last pages of the *Bar* chapter, Manet's work is compared with the café pictures of Degas. Degas's enterprise is seen as a failed attempt to design a visual repertoire (a "physiognomy") for the notation of distinct identities. Under the pressure of modernity, however, the enterprise breaks down, and into the gap of that failure steps Manet's famous deadpan, as at once an affront to protocols of legibility and a form of acquiescence, a capitulation to "blankness" whereby a genuine "margin of error" with regard to codes of social recognition in the modern world is converted into the fiction of "an overall loosening of class ties." Manet's work then has its ideological "limits," and a fortiori so do nearly all the other impressionists, with one major exception. The exception is Seurat and his great painting *Un Dimanche après-midi à l'île de La Grande Jatte*. This picture is the matter of Clark's concluding chapter and is singled out as unique in the impressionist corpus for the "adequacy" of its representation of class relations in the specific context of the modern leisure culture: the different classes are there, distinct yet not entirely so, together yet apart, occupying common ground yet having nothing in common. The painting thus simultaneously discloses both the surface fluidities and the controlling hierarchies of modern life, a combination unavailable elsewhere in the impressionist repertoire.

In this respect (as in so many others), the *Grande Jatte* is a very great achievement, and we are clearly invited by Clark to admire it as such. Yet "achievement," as both descriptive and evaluative category, is exactly the

major problematical category of Clark's argument as a whole. Clark quite rightly points out that what we admire in painting is not essentially the business of art history, that art history is not art criticism, that indeed it is one of the tasks of art history to uncover the determining choices and interests that go into the making of a critical canon (with respect to impressionism, these interests of course include those of the art market). Nevertheless, Clark's account is not evaluatively neutral, although his text displays considerable unease in this area, and if I have introduced the question of evaluation, it is because this unease bears very directly on the more precarious features of the general structure of his argument. For instance, in the first chapter, tucked away in a footnote, there is a remark to the effect that aesthetic considerations are not the same as ideological ones, illustrated by the claim that Caillebotte's *Le Pont de l'Europe*, though less subservient to ideology than Degas's *Place de la Concorde*, is the "lesser" of the two pictures, more "rehearsal" than "performance." This seems an entirely unobjectionable—indeed commonplace—distinction between subject matter and technical skill. It does, however, produce some rather arbitrarily tendentious readings: it is surely just as plausible to say of the subject of Degas's *Place de la Concorde* that Vicomte Lepic's blanking out of the Parisian history that produced him is to be read as critical commentary rather than ideological "subservience" on the part of the artist. Similarly, it might make sense to say of the blurred figures of a working-class woman in the foreground of Nittis's *Place des Pyramides* that it represents "class as *repoussoir*," but it would make just as much sense to say that it is a subversion of *repoussoir*, drawing attention away from the leisured elegance in the center toward the labor at the bottom of the canvas. This kind of question presents itself with even greater force in the long chapter on Monet's Argenteuil paintings. What, for example, are we to make of *Le Convoi du chemin de fer*, which features smoke belching out from train and factory chimney across the countryside? Is it, as Clark suggests, a complacent image of "industry as landscape . . . with three small strollers in the foreground twirling parasols and taking in the sights"? Or is it an ironic representation of the strollers' attempt to convert the dissonant scene into "landscape"? More important, however, is that the subject matter/technique distinction is not really the one that matters. On the contrary, Clark's book is everywhere informed by judgments that bring together both ideological and aesthetic considerations, forming in a way its own alternative canon. The great painters of his story are Seurat and, though less securely, Manet, and they are great because of the rela-

tion in their work between subject matter and technique, vision and per-
formance. Where Caillebotte is "thoughtful" but not particularly skillful
and Degas very skillful but not particularly thoughtful, Seurat is both: his
picture is great because its emancipation from the given ideologies is
inseparable from its complex painterly performance with matter, medi-
um, and convention.

What makes that judgment possible is what, after much delay, is finally
declared in the concluding chapter: the notion of adequacy. It is around
this notion that both the aesthetics and the epistemology of Clark's
account come together, but they do so in a way that is itself deeply uncer-
tain, indeed to the point of placing serious intellectual strain on the whole
argument. And—if I may briefly adopt the sermonizing tone that awk-
wardly surfaces from time to time in Clark's text—we had better attend to
the consequences of this convergence, not only for the purpose of review-
ing this book but also in order to explore further how to take up a criti-
cal position concerning impressionism and modernity in terms that are
not just a disguised restatement of a neo-Stalinist doctrine. "Adequacy"
here means representational adequacy to the realities of class and includes
what, on Clark's account, impressionism typically excludes or masks,
structures of division and control that the fluid, indeterminate semiotics of
the social surface often tend to conceal or equivocate; more bluntly, what
is excluded or repressed is the point of view of the proletariat.

Adequacy is of course an epistemologically very tricky criterion, and
its operation in Clark's text is such as to produce its own kind of episte-
mological "blur." In the sophisticated, if sketchy theoretical preamble of
the introductory chapter, the argument insists that it is dealing with a
field of representations, often in conflict with each other but not
reducible to a "base" of "brute facticity" or to what, in a later chapter, is
described as an ultimate "(founding) reality" (the parentheses are Clark's),
against which representations can be read off and checked. Clark appears
to have no time for that kind of naive base/superstructure model of inter-
pretation. What, then, can the notion of adequacy conceivably mean?
Does it mean that, on the battlefield of representations, one simply has to
take sides, as a matter of moral and political choice ("society is a battle-
field of representations," Clark writes in chapter 1)? But the concluding
chapter makes plain that it is not just a matter of preferences and alle-
giances. Seurat is great because his forms are "in some sense more truth-
ful than others," and that otherwise hesitant "sense" turns out to be noth-
ing other than "the founding categories of social experience."

The term "founding" here is finally released from its earlier suspension in parentheses and rejoins one of the inaugural—and founding—assertions of the opening pages: "It makes sense to say that representations are continually subject to the test of a reality more basic than themselves—the test of social practice." There is after all an ultimate historical and social ground, and if the impressionists could not or would not see it, we can. History and its class structure turn out to be transparent after all. Questions of foundation, reference, and determination are thus crucial for Clark. They are not so crudely, in the form of some Marxist equivalent of Dr. Johnson's kicking of the proverbial stone. For example, "founding category" is not the same as "founding reality" or referent. The epistemological claim that, within a given field of representations, one set of categories "founds" the others is quite different from a demand for a simple referential grounding (the belief that "we have poked through the texture of signs and conventions to the bedrock of matter and action upon it"). This opens the interesting prospect of a possible way beyond simple base/superstructure models, recasting the concept of the base by putting representation itself *into* the base, seeing the base as a stratified system of representation ("a hierarchy of representations" is how Clark puts it), in which the notion of base is nevertheless retained in the sense that some representations are more "basic" than others, are determining representations, with determination then understood as the action of one representation on another within the stratified complex.

This way of thinking recalls the more inventive moments of Raymond Williams's way with base/superstructure thinking. On the other hand, it also steers perilously close to Lukács's worst moments with modernism, that awful berating of the modern from an assumed position of epistemic superiority giving special access to the truth of History and Class and hence enabling him to consign the avant-garde to the trash can as but the symptomatic expression of the cul-de-sac of bourgeois culture. Clark's book, immensely more sophisticated and self-questioning in its analysis of modernity, seems in its conclusions to come close to adopting a similar stance. But how close remains uncertain. How we make sense of that uncertainty is perhaps as troublesome as dealing with the uncertainties in the pictorial mode of which this book itself tries to make (uncertain) sense. Clark is clearly right to argue that our acquired reverence for semantic indeterminacy requires ideological unpacking, and it would be a contradiction in terms to expect that exercise to be conducted in a spirit of ecumenical politesse. There is nevertheless more than a whiff of

Stalinist gunpowder in some of Clark's shots across the bows of modernism. But rhetorical cannon fire cannot do service for deliberative argument; either there is a "founding category" tied to some strongly anchored notions of reality and truth, or there isn't, and whichever it is needs to be made clear, since this bears decisively on the book's substantive claims. As it stands, the book is in fact at its active best when circling ambiguously around the phenomenon of modernist ambiguity, sending us back, for instance, to the best in Manet in ways that change, perhaps inalterably, how we shall look at these pictures in the future.

In this respect, we might say that the dialectic of Clark's book reverses the impressionist perspective from which "blur" is produced: close up to the picture surface it discloses properties and relations that from the more distant moralizing perspective are often scarcely seen at all. I have to concede, however, that its author might wish to reject that dissociation of the two dimensions of his text and to claim moreover that a preference for the former is a "liberal" retreat from the sterner demands of its argument. But one cannot have it both ways. Clark lacerates those nineteenth-century critics who felt "sure of the answers" to the questions posed by these disorientating pictures. He is at his least convincing when he too, though in a different interpretative idiom, is sure of his own answers, and at his most stimulating when he is not. That, however, is merely a local judgment. Even though it is left hanging in the air, the broader issue—the relation between representation and foundation—is the one he courageously raises at exactly the moment everyone else seems to be walking away from it, into a hazy "blur" of their own making.

3

Foundations and Beginnings

RAYMOND WILLIAMS AND THE GROUNDS
OF CULTURAL THEORY

People have often commented on the quietly authoritative voice we so often hear in the writings of Raymond Williams. But alongside the directness and confidence of address, we should also remember the many hesitancies and uncertainties, along with the constant reaching for complexity. The endlessly backtracking and self-qualifying style (what Robin Blackburn has called Williams's "characteristic mode of piling qualification upon complexity") tells of a strategy not merely of ordinary intellectual scrupulousness but also of active unsettlement of terms and positions (from a man many of whose existential and political preferences were for settled forms of life against the huge disruptions of modernity). We need only look again at the opening paragraph of *Marxism and Literature*:

> At the very centre of a major area of modern thought and practice, which it is habitually used to describe, there is a concept, "culture," which in itself, through variation and complication, embodies not only the issues but the contradictions through which it has developed. The concept at once fuses and confuses the radically different experiences and tenden-

cies of its formation. It is then impossible to carry through any serious analysis without reaching towards a consciousness of the concept itself: a consciousness that must be, as we shall see, historical. This hesitation, before what seems the richness of developed theory and the fullness of achieved practice, has the awkwardness, even the gaucherie, of any radical doubt. It is, literally, a moment of crisis: a jolt in experience, a break in the sense of history; forcing us back from so much that seemed positive and available—all the ready insertions into a crucial argument, all the accessible entries into immediate practice. Yet the insight cannot be sealed over. When the most basic concepts—the concepts, as it is said, from which we begin—are suddenly seen to be not concepts but problems, not analytic problems either but historical movements that are still unresolved, there is no sense in listening to their sonorous summons or their resounding clashes. We have only, if we can, to recover the substance from which their forms were cast.[1]

There is much that is going on here, but the particular feature of the passage I wish to emphasize, as characteristic of Williams's whole intellectual and political style, is the self-destabilizing work of its vocabulary: the typical movement away from formed "concept" back to open "problem," the acceptance of the "awkwardness," the "gaucherie" of "radical doubt," the openness to "the moment of crisis," "the jolt in experience," and the corresponding refusal of "ready insertions," notably into the very concept to which most of a working life had already been devoted and that this opening paragraph both reapproaches and reproblematizes, namely, the concept of "culture."

"Culture," its meanings, formations, and politics, is of course what the work is famously about, from the early soundings in *Culture and Society* to the later development of the notion of "cultural materialism," and the accompanying run of definitions of culture as the creation of "meanings and values," as a "whole way of life," and finally, in the formulations of cultural materialism, as a "constitutive human process" inseparable from the totality of "social material activity." The range of definitions signals a particular commitment: the continuing effort to wrest the idea of culture from its historical and ideological specialization to the arts or the notion of *Bildung* and to move the theory and analysis of culture beyond a

restricted concern with representations back into the sphere of social practices. More precisely, it is the attempt to close the gap between representations and practices by posing the former as themselves forms of social practice, at once produced and producing within the movements of history and material life.

This large view of the significance of culture, along with the exploratory hesitations as to its definition and analysis, point to a mind in search of grounds, but a search whose outcome is not given or presumed in advance. And it is of grounds that I want to speak here, the grounds of cultural theory, where "grounds" means many things but in particular a relation between intellectual foundations and a certain narrative of beginnings, a relation that, to my knowledge, has not been traced out in previous writings on Williams but is already signaled in the paragraph from *Marxism and Literature*, in the conflation of "basic concepts" with "the concepts, as it is said, from which we begin."

A concern with grounds and foundations is an important structural feature of Williams's work as a whole ("ground," interestingly, is also a recurring term in the opening pages of Arnold's *Culture and Anarchy*). In one of the interviews published in the collection *Politics and Letters*, for example, Williams speaks of "an absolutely founding presumption of materialism." The context of this claim to an absolutely founding presumption is in fact that of a relatively uninteresting, even unnecessary argument about ontology versus epistemology, in which, characterizing the moment of structuralism and semiology as a time of "rabid idealism," Williams asserts that "the natural world exists whether anyone signifies it or not." The substantive argument is not for the moment the issue (its target is in fact a man of straw, confirming that, in its major negative forms, the relation with structuralism constituted one of the few intellectual disaster areas of Williams's work). My present point bears, however, less on substance and more on rhetoric: the extent to which Williams's claim illustrates the presence in his writings of what David Simpson has rightly called a "foundational rhetoric." It is often a strong rhetoric, as instanced here by the adverb "absolutely" (the words "absolutely" and "absolute" appear in a similar connection elsewhere). In these antifoundationalist times, this sort of thing strikes an oddly disconcerting note. We must however attend to it; it will take us to many of the questions currently relevant to the interpretation and reception of his work, above all in connection with the category of culture.

The characterization of culture in Williams's writings recurringly

attracts three adjectives from his own lexicon of favored keywords, all of which work together in the theoretical enterprise of generalizing the notion of production out from its classical restriction to economy into the manifold domains of social life: "primary," "active," and "whole." To these three adjectives correspond three negative emphases (on what culture is not), which together generate the terms of Williams's path-breaking critique of entrenched ways of thinking about culture. First, culture is not secondary, a delayed effect of a prior determining instance but is itself prior, or primary. Second, it is not passive, a mere superstructural reflection but itself an active force in the social construction of reality (or, more accurately, it is to be grasped as at once producing and produced within the complex and mobile totality of social process); as he puts it in *Marxism and Literature*: "Cultural work and activity are not . . . a superstructure . . . they are among the most basic processes of the formation itself." Third, and above all, it is not separated from the rest of social life (as in the standard specialization of culture to the arts) but has to be seen in terms of a principle of wholeness. Much of Williams's work must be understood as an abiding, in some circumstances even obstinate resistance to the categories of separation and specialization, which (like system and abstraction)[2] are commonly posed as the categories of an instrumental capitalist rationality, consecrating an entire new order of the division of labor and hence of social relations.

The general argument spread out across these diverse sources is shaped more or less consistently from the three major negative emphases in the account of culture I have mentioned. Of the three, it is especially the third that calls for close inspection. The first two of course have their own problems, in particular the theoretical implications of the generalized extension of the category of production for the question of causality (which, as Williams's interlocutors in the *Politics and Letters* interviews stressed, would seem to require some conceptually differentiated hierarchy of relations, or levels, of determination). There are, second, the related implications, and political consequences, for the notion of class, since, if—to take the famous example from "Base and Superstructure in Marxist Cultural Theory"—the notion of production applies equally to the maker of the piano and the player of the piano, the logic of such a view, taken to an extreme, could seriously compromise the theory of the class basis of social formation to which Williams elsewhere in his work is strongly committed. Nevertheless, whatever these difficulties, it is unlikely that one would nowadays wish to quarrel with a conception of culture

that emphasizes its significance as both primary and active, at least where such an emphasis is designed essentially to highlight the role of cultural production in the general process of the social construction of reality.

The major problems, however, arise with the various meanings that attach to the third founding term, the term "whole." We need to remember here that this is more than an emphasis; it is also an insistence against a reified, systems-analysis language of separable levels or a postmodern vocabulary of plural fragmentation, an unbending insistence on wholeness or connectedness ("connection" is another highly valorized keyword; both the fictional and nonfictional work could be interestingly charted in terms of the vicissitudes of this one word). Culture accordingly is understood within the notions of "indissoluble totality," "whole indissoluble practice," "the wholeness of history," and so on.[3] The phrasing resonates in multiple directions, back to and across many sources: the tradition of English cultural critique described in *Culture and Society*, the varying forms of Marxist theory, including the form, associated in particular with Althusser, we call structuralist Marxism and, from there, principally in terms of the question of language, to the ideas of Saussure and Volosinov. Thus, despite the rapprochement with semiotics in the later definition of culture as "signifying practices" and the related association of cultural materialism with "historical semiotics," semiotics and structuralism (at least of the kind that come out of Saussure) fail the test of "wholeness"; in the language of "system," "function," and so forth used to talk about language, they divide speaker from medium ("the connected aspects of a single process" are "divided and dissociated") and so, like all formalisms, fall into the trap of "objectivism" and end by offering a "reified account" of human communication (these are the terms of the chapter on language in *Marxism and Literature*). Similarly, Marxism, in its classical association with base/superstructure models of explanation, not only gets culture wrong (by failing to see it as primary, active, and so on); worse, by violating the principle of wholeness, by separating and specializing culture as a category apart from the base of economic activity, the latter in turn seen as "the most important sphere of 'production,' " it is also "at some important points a prisoner of the social order which it is offering to analyze," paradoxically complicit in the technorationality of modern capitalist modes of human socialization that propose as normal and basic—foundational—the model of performance-orientated, nature-mastering *Homo economicus*.[4]

My concern here is not with the details of these arguments but with

their general form, in particular the way they rest on some appeal to a ground. The relevant model or figure is not, however, spatial (as in the hierarchical figure of "a fixed and definite spatial relationship" that Williams says governs the base/superstructure model). The location of the ground is less spatial than temporal, a site in a story of beginnings, of how it is at the start, prior to the distorting effects of specialization and separation. Here, for example—to stay with *Marxism and Literature*—is the idiom of grounds and foundations in particularly active guise. The general thrust of his approach, Williams tells us, is to reject "the two-stage model . . . in which there is *first* material social life and *then*, at some temporal or spatial distance, consciousness and 'its' products" (Williams's emphasis); again, "consciousness is seen *from the beginning* as part of the human material social process," my emphasis); or, again, language "is involved *from the beginning* in all other human social and material activity" (my emphasis). Finally, consider this sentence from "Base and Superstructure in Marxist Cultural Theory": "If we have the broad sense of productive forces, we look at the whole question of the base differently, and we are then less tempted to dismiss as superstructural, and in that sense as merely secondary, certain vital productive social forces, which are in the broad sense, *from the beginning*, basic" (my emphasis).

The italicized terms tell the story, and it *is* a story, the foundational gesture as a whole fable of beginnings, origins, and priorities. More accurately, there are two stories, complementary but not fully compatible. The first has it that there is no single beginning (as in the rejection of a certain Marxist insistence on labor, or a particular concept of labor, as "the single effective origin"). There is, as Williams says, "no single effective origin." Origins rather are multiple and, in that multiplicity, phenomena and practices coextensive. This, however, is not the originary multiplicity of deconstruction, the paradoxically antiontological ontology of being-as-*différance*, dispersed, heterogeneous, and nonidentical from the word go. Nor is it, as in the structural anthropology of Lévi-Strauss and then the related concepts of culture in Lacanian notions of the symbolic order, a question of the foundation of culture on an original, allegedly traumatic experience of separation from nature. Williams on psychoanalytical theory generally is a very curious saga of salutary skepticism, missed opportunity, and potential affinity, particularly—in that last connection—with psychoanalytical theories of the construction of the subject in the intersubjective realm of the social and the linguistic, though any acknowledg-

ment of those possible affinities appears to remain fairly decisively blocked by virtue of a deep resistance in Williams to the Lacanian view of the constitutively divided nature of subjectivity. Division, like separation, specialization, and so on, is another of Williams's quasi-organicist bêtes noires, associated almost exclusively with the social division of labor under capitalism, and this has important consequences for the theory of culture as a theory that takes little account of the view of culture as separation from nature, a kind of tear in the fabric of life and consciousness that is at some deep level entirely irreparable (one reason why incidentally it could be claimed that, although he wrote a quite wonderfully suggestive book on modern tragedy, Williams never had any genuinely highly developed sense of the tragic as a category of thought and a mode of experience and indeed was arguably suspicious of it as a category on political grounds similar to those of Brecht, Sartre, and Barthes).

But let us return to the story of beginnings and origins in Williams's account of culture. In that account, it is not that at the beginning things are aboriginally divided but that they are simultaneously coextensive and interacting. The argument is not just that culture is there at the beginning (itself primary) but also that at the beginning, before separation and specialization, culture is whole or part of a whole process, once again connected; instead of the notion of a "single effective origin," writes Williams, "the real emphasis should be on connected practice." On the other hand, cutting across this story of the originally multiple and coextensive, there is another story, which speaks more of priorities, indeed even of absolute priorities. In the *Politics and Letters* interviews Williams repeats both the view of the interconnected wholeness of social process and the buttressing adverb "absolutely": "I am absolutely unwilling to concede to any predetermined class of objects an unworked priority." Yet when it is a question of contrasting the allegedly reified formalist notion of system with the more active notion of process, Williams can also write unhesitatingly that "here [in the idea of social process], as a matter of *absolute priority*, men relate and continue to relate *before* any system which is their product can as a matter of practical rather than abstract consciousness be grasped or exercise its determination" (my emphasis). The quarrel with the language of system and abstraction thus yields another fable of origins, in which this time there is an ultimate grounding, or absolute priority, reaching back beyond abstraction into the lived, primordial domain of experience and feeling. System is thus not only a category of a (contested) mode of thought that thinks in terms of "first" and

"second"; insofar as it corresponds to something in reality, it is itself what comes second, after some kind of primary relating, which would then carry the weight of the loaded vocabulary of experience, feeling, and emotion. Interestingly, the term "absolute," along with "primary," turns up again, in *Towards 2000*, in an account of emotion as that which "has an absolute and primary significance." It also translates importantly into William's account of the novel, specifically Emily Brontë's *Wuthering Heights*, where the significance of the Cathy-Heathcliff relationship—significant for the terms in which Williams will theorize the "structure of feeling"—lies in the fact that it is the "kind of relationship" that is "there and absolute before anything else can be said." In short, if everything is there at the beginning, it would seem that some things are more at the beginning than others.

This double narrative of beginnings is thus shadowed by a degree of internal contradiction and a good deal else besides. As such it furnishes a useful, because intrinsically unstable and hence potentially fertile, point of departure for an enterprise concerned as much with prospects for as retrospects on Williams's work. For it would be fair to say that many of the fundamental intellectual questions surrounding Williams's account of culture, and especially its elaboration as cultural materialism, turn on the status of his fables of beginning and priority. What then is their status? Is their purpose to support claims of an empirically historical kind, to do with what actually came first? Are they instead logical fictions, like Rousseau's "state of nature," an analytical presupposition or a heuristic device without which we cannot make sense of the actual social order? Does "beginning" therefore refer less to real history than to the procedures involved in how we set about thinking of the social (on one page of *Marxism and Literature*, where the vocabulary of beginnings is particularly dense, the text shifts from what appear to be statements about actual beginnings in social processes to beginning moves in how we think about those processes, statements about "what begins as a mode of analysis"). Or, finally, are they fables constructed simply as a function of moral and emotional preferences, what Williams wants to believe because of the consequences of not so believing? Wholeness for instance, in a great deal of the writing, is clearly not just a theoretical postulate or descriptive term, and it is significant that, in the relevant pool of collocationary terms, Williams generally preferred the word "wholeness" to the more analytically freighted "totality." The reason seems to have been that the former also had certain affective and ethical resonances, thus knotting the

Williams's text in ways that make it extremely difficult to disentangle analysis and values (through precisely that gesture of separation to which Williams was so strongly opposed).

This mixing of descriptions and judgments ("judgment is inevitable," says Williams in *Politics and Letters*), the logico-analytical and the appraisive, around the idea of a primary and grounding wholeness of process tells of a more general way of looking at the world, whereby culture is not just the area of the production of meanings and values within the total social formation but is itself privileged as a meaning and a value; culture is a good with which to oppose the antihuman values of economism and productionism and a social order based on a radical division of function and faculty. In this context, the emphasis on wholeness, continuous connected practice, and so forth reveals the continuing and probably unexpungeable traces in Williams's own thought of the tradition explored in *Culture and Society*, in particular the paradoxical Arnoldian-Leavisite view of culture as distinct (from "society") in that it makes whole what has been divided and atomized. It is therefore not surprising that, as with all such fables, the validity of this view is presumed rather than demonstrated. Or if grounds are given for the assertion of a ground, it is usually based on the self-validating authority of experience: the proof that things are connected is that people, in their ordinary lives, know them to be so. But then not all people know this; indeed it is precisely a feature of experience in modern times ("my own time," says Williams) that it is constituted by and within a divided social order in such a way as "to block any awareness of the unity of this process [the indissolubility of the whole social-material process]." Williams ruefully concludes, in the *Politics and Letters* interviews: "I can see that my appeals to experience [in those earlier definitions] to *found* this unity was problematic" (my emphasis). Once again we have the language of foundations, but this time as an openly confessed problem.

Yet if Williams concedes that there is no "absolutely" reliable court of appeal for the assertion of foundation, the assertion itself nevertheless still stands. Indeed standing, simply standing there, is probably what in the final analysis Williams's foundationalist rhetoric adds up to. Certainly it could not *with*stand for very long the corrosive skeptical examinations of contemporary antifoundationalism. But then scarcely anything could withstand that, including—in a wonderfully circular paradox—itself (it is worth recalling here what Fredric Jameson said, in *Postmodernism*, regarding "the tendency of 'foundations' to return via some extreme form of

the return of the repressed within the most anti-foundational outlooks"). This presumably is why Williams does not so much argue the grounding move as simply make and assume that move (and perhaps also why, in the *Politics and Letters* interviews, while making various concessions to his interlocutors on this and other matters, he nevertheless led them such a song and dance). In the final analysis, we are tacitly invited to take it or leave it, to stand there with him or to walk away (for, after all, if we are to place our trust in anything, experience would seem the best bet). The difficulty is that if we accept the invitation to stand there with him, it is still unclear as to whether where we stand, in the arguments about culture, is more a place of the residual than of the emergent, a place that, despite all the resistances and qualifications, remains demarcated and informed by the old Leavisite notions of the organic community.

This aspect of Williams's thinking has been much discussed in the past and indeed has always been at the forefront of debate about his work. The truth of the matter is that the place in question is probably best seen as a combination of the residual and the emergent, at once disabling and enabling, boxing us in and nevertheless allowing us to move on. It is not therefore a question of posing and deciding the issue as an either/or choice, either one thing or the other. The challenge of the work is that it is both, though, as both and as challenge, it does not as a consequence offer the comfortable inhabiting of a do-nothing aporia. Ken Hirschkop has rightly said that the most enabling thing about Williams for us is that "he literally taught many of us how to think about culture and politics together." We cannot, however, disentangle this from what, on certain assumptions, must also appear disabling. Or to put this in a more upbeat way, Williams puts us on the spot, in various senses of the term, challenging us to move on but without the illusion that we can do so effortlessly, in a free-floating euphoria of emancipation.

At the level of general theory, one possibility might be to retain the indispensable emphasis on connection while detaching it from the more holistic and value-laden notion of wholeness, thus permitting a way of thinking about the social that is more compatible with a sense of the fluid, heterogeneous, and fragmentary character of social formations. Indeed, in theoretical terms, this is precisely the drift of Williams's recasting and extension of Gramsci's notion of hegemony; whatever problems we might have here with the cluster of related ideas of experience, the lived, structure of feeling, and so on, what is valuable about this recasting is the way it takes ideology down into the sphere of the subjective, not as

homogeneous dominant discourse but as heterogeneous and multiple, endlessly subject to appropriations and transformations, opening fissures in the classically hegemonic as the space of the antihegemonic, and coming out finally in the immensely flexible model of historical inquiry built around the terms "dominant," "residual," and "emergent." In terms of practical analyses, we see the benefits of this in much of the later work. A great deal of the latter, notably the short book *Culture*, moves toward just this view; by consistently approaching "totality" ("the whole social order") from the notion of "complex real processes," the argument both demands and engenders as crucial to the actual analytical program of a "sociology of culture" a strongly maintained attention, alongside the continuing stress on the connected, to the concrete and differential specificity of cultural practices.

The general point, however, is that to go forward with Williams we have to carry a lot of baggage, even as we jettison some of it; the question then is how we carry it and what we do with it. Or, to switch metaphors, is it the case that there is in Williams's argument, around questions of grounds and foundations, a kind of blur at the heart of the argument or rather at its own *fons et origo*, its own initiating moment, and thus that in standing with Williams we stand on a ground that in fact isn't one in any properly conceptualizable sense other than as an enabling fiction? Is the ground an example of what the philosophers call a "fuzzy concept"? And, if so, would we do best here to adopt the upbeat Wittgensteinian view of the fuzzy concept as both inevitable and necessary to meaningful human projects? Would that in turn mean that one was putting forward here an essentially pragmatist justification for Williams's fable of beginnings and origins: that it helps us get something done?

This would of course be a point of connection between cultural theory and cultural politics in Williams's thought, in particular what is entailed by Hirschkop's claim. What, for example, in terms of cultural politics, happens to the category of grounds when it is pragmatically transferred to the weighty matter of Williams's attitude to the famous "project of modernity" (an attitude that for some is entirely incompatible with any plausible commitment to the emergent)? Insofar as, following Weber, modernity is to be understood as the rationalized order of the systematic "differentiation of the spheres" producing, again in Weber's terms, "specialists without spirit and sensualists without heart," Williams mobilized what remained of his Leavisite-Lawrentian sympathies in support of a position of resolute opposition. This, however, comes through

in a variety of not necessarily equivalent guises and perhaps nowhere at once more strongly and more problematically than in the late inquiries into the related concept of modernism (as a series of essays published posthumously under the title *The Politics of Modernism: Against the New Conformists*).

This a vexed area for all of us. The new conformists are those initiating and completing the process whereby the phenomenon of the twentieth-century diasporic, deracinated, cosmopolitan writer, characteristically migrating or exiled to the great metropolitan centers of the capitalist and imperialist West, is packaged as a selective and marketable ideology of modern*ism*. It is significant that modernity gets addressed here primarily via the question of literature, as another point of resistance in Williams's thought to the pressure to specialize generated by and within the modern itself. This in turn gives a context for Williams's long engagement with literature as both critic and writer. Just as Williams refuses the specializing movement that restricts culture to the arts, so he is root-and-branch opposed to the specialization of literature to a separable and autonomous function (as distinct—radically distinct—from posing literature as a set of *specific* practices). From *The Long Revolution* to *Keywords* and other works, Williams returns again and again to the fact, and its demonstration, that the concept of literature is not a given or a constant but has a history, precisely a history of increasing specialization from writing in general to printed texts to fiction and works of imagination (the latter definition being essentially a nineteenth-century invention).

What I want to take here from this alignment of modernity, modernism, and literature is a convergence of historical separations, the late separation of the concept of literature from a wider formation, and the separation of the (avant-garde) writer from rooted location and community. Against those late specializations and separations, Williams's argument is again an argument for seeing or making things whole and again, in the conduct of the argument, an embedding of analysis in a value language. What seems to count most for Williams is, relatedly, an aesthetic of integration and a culture of (relative) settlement, as modes of life and practice in which connections are to be found or can be made. These are the connections that supply another version of the ground: a grounding of literary representations in grounded forms of social life. This is one reason why Williams returns time and again in his writings on literature to the idea of realism and a certain tradition of the novel. Here he is very

close to Lukács (especially in his book *The English Novel from Dickens to Lawrence*), preferring to the art of dispersal and fragmentation promoted by the sanctioned versions of modernism an art that connects, especially forms that join, as mutually necessary for the intelligibility of each other, individual experience and social formation. His own novels are themselves—sometimes in a perhaps excessively demonstrative mode—geared to just this aesthetic, in their very plots and structures always relating consciousness and experience back to origins ("beginnings") in community and change in collectively lived history.

Yet in the case of his own novels it is now impossible for us to overlook the limitations and blind spots of the insistence on connection as both social and aesthetic category. Consider, for example, the obvious patriarchal sense of the formula in the novel *Volunteers*: "changed but connecting, father to son." We might find ourselves correspondingly suspicious of any attack on cosmopolitan modernism in the name of rootedness against the rootless, especially when the former starts to attract disturbing appeals to the category of the natural (the ratified version of the avant-garde, writes Williams, derives from the loss of a "naturalized continuity with a persistent social settlement" and, in an extremely puzzling formulation, works "to naturalize the thesis of the *non*-natural status of language"). To my mind (the matter is controversial), there is an uncomfortably strained quality in much of the writing of *The Politics of Modernism*, above all in the closing pages of the essay "When Was Modernism?" Here we see Williams deep in the characteristic effort of making difficult discriminations, but the difficulty often shifts from tension to tenseness, a barely concealed hostility, informed by what, at its worst, we have to call prejudice. Thus when modern literary cosmopolitanism is represented in terms of the experience of "endless border-crossing," we suddenly feel the sharp edge of scarcely contained aggression surface in the writing: "The whole commotion is finally and crucially interpreted and ratified by the City of Emigrés and Exiles itself, New York" (this from the man who wrote the novel *Border Country* and described his own life as an endless renegotiation of borders).[5]

Here, frankly, alarm bells start to ring, and we are perforce obliged to think of other, deeply uncongenial forms of the attack on the cosmopolitan. Nevertheless, it would of course be fatuous to see Williams as an antitechnological pastoralist or agrarian antimodernist, a kind of Heidegger of the left.[6] In the critique of a certain modernism, we have to remember the guiding political perspective, above all the argued claim

that the marketed selective tradition of modernism Williams is anxious to contest rests on the centrality of Western metropolitan culture to the consolidation of empire and the globalization of capital (in this connection it is important to reemphasize the last chapters of *The Country and the City*). It is above all in these terms, with their reach, however incomplete, into the history of empire and modern capitalism, that the project of modernity is sketched as negative picture, rather than as a recipe for taking refuge in fantasy constructions of the premodern. As the demolition job on the sentimental fictions of "knowable community" in *The Country and the City* shows, whatever Williams meant by "settlement," it had nothing to do with the imaginary social orders discussed in relation to some of the novels of George Eliot or with the connoted class narrative behind the denotative opening sentence of Jane Austen's *Sense and Sensibility* ("The family of Dashwood had been long settled in Sussex") and still less of course with what Arnold called, in pages expressly written to denounce working-class militancy (the "Hyde Park rough"), "that profound sense of settled order and security, without which a society like ours cannot grow and live at all."[7]

On modernity Williams is probably close in spirit to much of the point of view of Habermas in at least the following respect: there is full recognition of the damage done to the life world by the instrumental rationalities coming out of the Enlightenment, but this in no way makes Williams an enemy of the Enlightenment *tout court*. On the contrary, we need remind ourselves here only of Williams's very strong stance on the importance and value of the natural sciences, notably in the essay on Timpanaro in *Problems in Materialism and Culture* (indeed such is Williams's enthusiasm for natural science, once freed from its fantasies of technomastery, that in *Politics and Letters* he even confessed to the dream of a form of literary study linked to the procedures of natural science: "if I had one single ambition in literary studies it would be to rejoin them with experimental science").

If then, indeed even in somewhat surprising guises, Williams gives short shrift to reactionary forms of premodern nostalgia, could we usefully situate him in relation to any of the recognized terms of the postmodern? Given that the latter is quite radically and determinedly antifoundationalist, this would seem most implausible, though to whose disadvantage, intellectual and political, is by no means obvious. Williams himself hardly uses the word "postmodern"—and on the occasions when he does it is not with any evident enthusiasm (he does not appear to have

shared Jameson's view that "for good or ill, we cannot *not* use it")—and would probably have felt about many of its manifestations what Cornel West once said in response to a question about the future of rap: that it would end up "where most American postmodern products end up: highly packaged, regulated, distributed, circulated and consumed." Where, in its left versions, postmodernism means the politics of new social movements, Williams gave his strong support, on the tacit assumption, however, that postmodern also meant postcapitalist. In *Towards 2000*, he wrote of the need for "a new kind of socialist movement" based on "a wide range of needs and interests." But he was also quick to add, as part of that account, a claim for the gathering of these diverse needs and interests in "a new definition of the general interest." The idea of the general interest, like its neighbor, the idea of a "common culture," is the political correlative of the analytico-ethical stress on the virtues of wholeness; it engages principles of solidarity and community and seeks, in the formulation from *Resources of Hope*, the "creation of a condition in which the people as a whole participate in the articulation of meanings and values."

Reference to the general interest has tended to disappear from left discourse, partly from the pressure of the multiculturalist case and partly, and relatedly, because of the hijacking of the idea by the political right, especially in the United States. Yet if it is true that the left has ceded the terrain in question in part because the right has been so adept at commandeering it, this could well be a mistake. Williams almost certainly thought it was a mistake, and much of his lesson is that, beyond short-term considerations of tactical moves and positions, in the longer-range view it is essential to reclaim it. Similarly, he had little interest in a pluralized postmodernity that comes out as multicultural consumer spectacle. The argument in Williams is always that a cultural politics cannot be just a politics of cultural difference and cultural rights (though the latter are of course, for Williams, crucial in contexts of social inequality, discrimination, blockage of access to resources, and all the other impediments to the creation of a truly democratic culture). There still remains, however, the difficult question of cultural clash (as notoriously in the Rushdie affair). Here there are not many plausible choices. We can opt for fashionable adaptations of Lyotard's incommensurability thesis as one version of the postmodern (but this idea is ultimately a liberal idea in the sense of posing the social order on the model of the agon, akin to the competitive relations of the marketplace). Or, as Williams encourages us to do, we can

try to think of the politics of culture in terms of the idea of a fully human culture, where the emergent in cultural theory would be the attempt to think the conditions, the grounds, of the emergence of a common culture, but without—as Williams always stressed—losing sight of the relations of power and subordination that at once block, and so imperatively require, that very project.

4

Circulating Representations

New Historicism, like all the other isms of our time, has rapidly become a catchword, a label, under which the heterogeneous is repackaged and marketed as the more or less homogeneous. The intellectual reality of New Historicisms in fact discloses a variety of sins or virtues or a mix of both depending on one's point of view (the points of view themselves of course vary in that from its inception to the present New Historicism has been an object of fierce and continuing controversy). For example, in the very fine book by Graham Bradshaw on Shakespeare,[1] we find, convincingly demonstrated, fundamental differences, at least in the case of Shakespearean interpretation, between American New Historicism (as instantiated by the work of Stephen Greenblatt) and British New Historicism (as instantiated by the work of Jonathan Dollimore and Alan Sinfield). Bradshaw, quite rightly in my view, sustains a respectful dialogue with Greenblatt (whose work he simultaneously admires and disagrees with), while reserving for the British scholars a disdain verging on contempt for their willful dogmatism, polemical straw men, and, above all and paradoxically, their radical inability to think in a genuinely historical way at the very moment they speak in the name of History, for instance, by ripping speeches out of dramatic context as if they were embodiments

of Shakespeare's own views and thus perpetrating the gravest error of all: namely, systematic disregard of the elementary point that any historicizing of Shakespeare must attend to the generic and structural realities of what Bradshaw calls "dramatic thinking." Dramatic thinking is a particular modality of thought (just as poetic and philosophical thinking are), a perspectival mode in which a dramatic speech is relativized not simply to a point of view (that of the speaking character) but also to its place in the temporal unfolding of the play. How the generic and structural temporalities of dramatic thinking relate to the conditions of a wider history is exactly the task at hand. To short-circuit that inquiry in a crude reduction of texts to symptomatic ideology is a travesty of anything that New Historicism might productively be.

It is not my intention to comment here on the details of Shakespearean scholarship. I point to this example simply to indicate that New Historicism, in presupposition, scope, and quality, is not one single thing, and so we have to be clear what precisely it is we are talking about. For myself, I want to talk about Greenblatt, not, however, the Greenblatt of the Shakespeare books but rather in terms of what in retrospect has come to be seen as one of the programmatic, founding texts of the New Historicist endeavor, namely, Greenblatt's essay "Towards a Poetics of Culture."[2] As its title indicates, this essay is a strategic intervention in a debate about cultural theory and politics in the context of the so-called return of historical method in literary studies. I want to talk about the essay on two fronts: first, with a view to characterizing some of its principal features, claims, and arguments; second, to comment on it, in the form of some questions and problems to do with the kind of historical inquiry this version of what Greenblatt designates as cultural poetics both outlines and recommends: in short, a return to first texts and first questions

One such question that has much exercised New Historicists concerns the category of historical context, and it is there that I want to begin. What sort of intellectual endeavor is represented by the deployment of this category, and in particular what are we doing, or think we are doing, when we take a text and, as we say, put it into a context? Literally, context, con-text, means another text or body of texts that goes "with" (*con*) the text under scrutiny. The term "text" in the term "context" can be understood in a variety of senses: as something written (thus taking us into the sphere nowadays known as intertextuality) or, more broadly, as something in language or articulable in language (practices, beliefs, horizons of meaning, and so on, the sort of thing that Gadamer talks about

and that informs certain projects of both historical and anthropological inquiry). But it also extends beyond the literal sense of the term to the nonlinguistic, the whole sphere of material and social life, such that, in one very influential model of text and context (the base/superstructure model of classical Marxism), context can include economy, the sphere of economic determinations pressing on the cultural sphere, the medium of which being ideology (though ideology of course takes us back to questions of language and text).

Context is supposed to supply a double principle of intelligibility: hermeneutic (to do with how we interpret the meanings of a text) and explanatory (to do with the conditions of the coming-into-being, or the production, of a text). Perhaps the most eloquent spokesman of this double use of the category of context, at least in the English-speaking world, has been Quentin Skinner. Skinner takes a canonical text such as Machiavelli's *The Prince* and deploys a notion of context for the purpose of both interpretation (what the text means, generally specified in terms of the allegedly recoverable intentions of its author) and explanation (its production, its appearance as a practical response to a particular, historically circumscribed sociopolitical universe). However, in both these applications—hermeneutic and explanatory—context is famously unstable, and even Skinner's attempts to stabilize it as a tool of inquiry come up against these instabilities. In the hermeneutic register, the best-known illustration of this is Wittgenstein's in the *Philosophical Investigations*: the example of the word "slab." The meaning of the utterance of this word, argues Wittgenstein, is contextually variable: it can be an imperative (the stonemason calling out "slab!" to his apprentice, meaning "bring me the slab"); a warning (the slab is about to fall on you); or an instance of definition (saying "slab" while pointing to one, as an exercise in ostensive definition). Context, in this view, is intimately bound up with what Austen called speech acts and is comprehensible, so Wittgenstein argues, only by virtue of participation in the language games and shared forms of life that make up the relevant culture. An equivalent of this in sociolinguistics is the so-called conversation postulate, a principle designating the tacit compacts and presuppositions—the context—without which intelligible exchange is not possible (the force of this principle is evident when it is willfully violated, as, for instance, in the dramatic dialogues of Samuel Beckett, which play havoc with the normal circuits of communication and exchange.[3]

Derrida has given an even more radical inflection to this view of the

instability of context, arguing that, where written texts as well as speech are concerned, context can never settle, even provisionally, the question of meaning. What is the context that will help you determine the meaning of a word? Is it the expression in which it appears, the sentence, the paragraph, the chapter, the whole book, other books, all books, and so on, in an expansion that finally takes the form of an impossible circle (a version of the hermeneutic circle). Take, for example, the case already mentioned of Quentin Skinner's work on Machiavelli. Skinner's method has been described by one of his disciples (James Tully) in the following way: "Step one is to situate the text in its linguistic or ideological context: the collection of texts written or used in the same period, addressed to the same or similar issues and sharing a number of conventions."[4] But this is open to the charge of circularity: if one uses the contemporary texts to interpret *The Prince*, how does one interpret the contemporary texts? One way of doing so is by using *The Prince*. One has here therefore a chicken-and-egg problem, a relativity going round in circles that sends the mind into an intellectual spin.

Context is therefore not simply something we can take for granted. It is a conceptual and methodological problem or, rather, a set of problems. Greenblatt's essay is, among other things, an attempt to articulate, both theoretically and operationally, a notion of context that draws in one way or another on aspects of the various features of the concept of context I have just listed, with a view to at once coping with the instabilities bound up with the concept and at the same time putting these instabilities to use in the attempt to give an account of texts, both literary and nonliterary, in historical formations.[5] This is the program of what he calls the poetics of culture, to which I now turn in more detail. Broadly, the argument of "Towards a Cultural Poetics" is for a type of historical inquiry that is simultaneously dialectical (in stressing the interaction of systems of representation and practice) and nontotalizing (refusing the notion that any given historical field of representation can be made to cohere as some hierarchically stratified totality). In this double stress on the dialectical and the nontotalizable we of course immediately detect a certain relation, though a complex and ambivalent one, to the legacy of Marxism. Greenblatt says at one point that Marxism is important to him ("I'm still more uneasy with a politics and a literary perspective that is untouched by marxism"), but he also says, in the same paragraph, "It's true that I tended to like those marxist figures who were troubled in relation to marxism."[6]

What this means in substantive terms I will come to shortly. But I also want at this point to make three observations about Greenblatt's style, his whole manner of writing, because, as I shall show, this bears importantly on the more substantive questions. First, the tone is familiar (in part to do with the fact that the paper was originally a talk); second, the arguments are often embedded in anecdotes (mainly to do with Greenblatt's life on the Berkeley campus); third, and interrelatedly, his text is highly self-referential, geared as much to statements of subjective preference, feeling, and so on as to the purely objective statement of arguments (for example, the statement in respect of Marxism—"I tended to like those marxists . . ."—or the later anecdotal reference to "a student getting very angry with me," etc.). The familiar tone has got something to do with an attractive, and specifically American, attempt to loosen up the formalities of academic discourse. But there are also other aspects of this manner more directly relevant to the actual structure of Greenblatt's arguments: first, the investment in the anecdote is, from a methodological point of view, a key New Historicist move (its implications I shall return to later); second, it is noteworthy that all Greenblatt's main examples of what a cultural poetics could and should be are drawn from the twentieth-century United States (principally to do with Hollywood and Ronald Reagan), and this Amerocentric bias might also have certain consequences; third, the self-referential nature of the discourse is arguably bound up with a whole culture of self that in turn inflects in several ways how history itself is conceived (broadly, as I shall demonstrate, through models and metaphors to do with the market, the social as a space of transactions or deals among players in the marketplace).

Let me, however, come back to my point of departure: the engagement with Marxism. I start here because this, along with poststructuralism, is Greenblatt's own starting point, as an exercise in clearing the ground and setting the terms for the presentation of his own view. The first move is by way of Fredric Jameson, taking issue with some of the positions sketched in Jameson's book, *The Political Unconscious*:

> Thus the crucial identifying gestures made by the most distinguished American Marxist aesthetic theorist, Fredric Jameson, seems to me highly problematic. Let us take for example the following eloquent passage from *The Political Unconscious*:

the convenient working distinction between cultural texts that are social and political and those that are not becomes something worse than an error: namely, a symptom and a reinforcement of the reification and privatization of contemporary life. Such a distinction reconfirms that structural, experiential, and conceptual gap between the public and the private, between the social and the psychological, or the political and the poetic, between history or society and the "individual" which—the tendential law of social life under capitalism—maims our existence as individual subjects and paralyzes our thinking about time and change just as surely as it alienates us from our speech itself.

Greenblatt takes issue with the argument here attributed to Jameson, namely, the argument that any attempt to separate the aesthetic sphere from others ("cultural texts that are social and political and those that are not") is complicit with a capitalist logic of specialization that promotes a splitting of the public and private domains of experience. Greenblatt's objection to this argument takes two forms: first, the capitalist system of private property in fact generates historically a "drastic communalization of all discourse," his model for which—instructively—is the historical production of modern mass culture. This is already tendentious; no one within Marxism (however we understand that) disputes that this has indeed been one of the effects of capitalism, though the notion that commercially created mass culture can plausibly be described in terms of a process of "communalization" begs many questions. For example, does not the notion of community imply freedom from the commercial manipulation of public discourse? All our inherited models of community and the public sphere, most recently those of Habermas, suggest this; only a populist-capitalist version of the communal could argue what Greenblatt asserts, typically in the form of the familiar claim that the mass media supply what the people want. In any case, Jameson's reference to the specialization and hence privatization of the aesthetic is basically a reference to the constitution of the sphere of high culture, the aesthetic as high art, where it is indeed the case that a very powerful drive to separation has been historically operative at least since the eighteenth century.

It is, however, Greenblatt's second objection to Jameson that concern me more here, namely, the view that spheres of discourse can in fact be usefully (as distinct from ideologically) distinguished and that it is only a model of totalization that rests on a nostalgic fable of origins (according

to which public and private were once indissolubly linked, as in eigh-
teenth- and nineteenth-century fantasies about the ancient Greek world)
or an impossibly idealistic utopian scenario for a future unification of
polity and culture beyond specialization and the division of labor that
prevents us from making these distinctions. This second objection is the
more relevant one for Greenblatt's principal argument, insofar as the rest
of his essay is bound up with how to make these distinctions and at the
same time relate the distinguished entities in cultural description and his-
torical analysis. This essentially is the program of what Greenblatt calls a
poetics of culture.

To get to that program, however, there is one further step he has to
take in the preliminary clearing of the decks, this time in connection with
what he calls (a trifle misleadingly) "poststructuralism," identified with
another proper name, Jean-François Lyotard. For another road that is also
closed off here, along with Marxist ideas of modern cultural division, is
Lyotard's converse account of the postmodern condition, according to
which late capitalism generates the exact opposite effect to that specified
by Jameson, namely, a monolithic homogeneity of culture in which, via
the stratagem of grand narratives of progress and emancipation, difference
and distinction are effaced in the drive, effectively totalitarian, to a kind
of incarcerating totality. The difference between the approaches of
Jameson and Lyotard, Marxist critique of specialization and poststruc-
turalist critique of totalization, is summed up as follows:

> The difference between Jameson's capitalism, the perpetrator of
> separate discursive domains, the agent of privacy, psychology,
> and the individual, and Lyotard's capitalism, the enemy of such
> domains and the destroyer of privacy, psychology, and the indi-
> vidual, may in part be traced to a difference between the
> Marxist and the poststructuralist projects. Jameson, seeking to
> expose the fallaciousness of a separate artistic sphere and to cel-
> ebrate the materialist integration of all discourses, finds capital-
> ism at the root of the false differentiation. Lyotard, seeking to
> celebrate the differentiation of all discourses and to expose the
> fallaciousness of monological unity, finds capitalism at the root
> of the false integration. History functions in both cases as a con-
> venient anecdotal ornament upon a theoretical structure, and
> capitalism appears not as a complex social and economic devel-
> opment in the West but as a malign philosophical principle.

I won't say any more about Greenblatt's characterization of Jameson and Lyotard, Marxism and poststructuralism. They are deployed, somewhat tendentiously, as a negative point of departure for Greenblatt's own view of how culture works. How culture actually works for Greenblatt is stated in the following key passage:

> I propose that the general question addressed by Jameson and Lyotard—what is the historical relation between art and society or between one institutionally demarcated discursive practice and another?—does not lend itself to a single, theoretically satisfactory answer of the kind that Jameson and Lyotard are trying to provide. Or rather theoretical satisfaction here seems to depend upon a utopian vision that collapses the contradictions of history into a moral imperative. The problem is not simply the incompatibility of the two theories—marxist and poststructuralist—with one another, but the inability of either of the two theories to come to terms with the apparently contradictory historical effects of capitalism.

It will be clear therefore what Greenblatt wants and why the extended detour through Jameson and Lyotard is necessary to securing what he wants: a satisfactory account of contradictions, irreducible to either the model of repressive differentiation (Jameson) or the model of monological totalization (Lyotard). More specifically, what Greenblatt wants is basically a modified version of both Jameson and Lyotard, taking from each elements that can then be combined to produce a new account of the cultural workings and consequences of capitalism:

> If capitalism is invoked not as a unitary demonic principle, but as a complex historical movement in a world without paradisal origins or chiliastic expectations, then an inquiry into the relations between art and society in capitalist cultures must address both the formation of the working distinction upon which Jameson remarks and the totalizing impulse upon which Lyotard remarks. For capitalism has characteristically generated neither regimes in which all discourses are coordinated, nor regimes in which they seem radically isolated or discontinuous, but regimes in which the drive towards differentiation and the drive towards

monological organization operate simultaneously, or at least oscillate so rapidly as to create the impression of simultaneity.

We can see from this where Greenblatt is now headed: he wants to be able to distinguish discursive practices—say, the artistic and the political—but he also wants to be able to claim that they are nevertheless interconnected and moreover—this is Greenblatt's most important notion—that they are *dynamically* interconnected or, if you like, dialectically interconnected. They feed one another, are mutually constitutive in a circular process of constitution that is disoriginated, in which there is no founding moment, no overarching cause, no hierarchy of determinations. His model for this view of historical and cultural process is that of the transaction, transactions between discursive forms (i.e., a market notion, the implications of which are far-reaching and that I will come back to later).

Greenblatt gives two examples of this process, both from contemporary U.S. life: the relation between movies and politics during the Reagan presidency and the story of the convict Gary Gilmore, about whom Norman Mailer wrote a best-seller, which in turn, made into a TV miniseries, led Mailer into contact with another convict, Jack Abbott, and to another book, which led to the release of Abbott on parole, when, though through a misunderstanding, Abbott committed another murder, the story of that murder later being made into a play called *In the Belly of the Beast.*

Why Greenblatt chooses these particular examples to illustrate his view of the fluid interrelations of the artistic and the political (Reagan basing himself on the movies), or what he is now calling "social discourse" and "aesthetic discourse," is overdetermined, but preeminently because he sees them as instantiating a claim to the effect that these different spheres of discourse are, precisely, different but at the same time interconnected in a manner such that each inflects the other, as cases of art imitating life and life imitating art, a dialectical circularity of text and context, the literary and the social, where the literary or the aesthetic is itself an active force in the social construction of reality. That emphasis on the literary as an active force in the social construction of reality seems to me the strongest feature of Greenblatt's argument; it is indeed indispensable and moreover entirely consistent with the thought of a number of other cultural theoreticians unmentioned by Greenblatt (above all, perhaps, Lucien Goldmann and Raymond Williams, both of whom argued

strenuously for the notion of the active role of literature in the making of cultural formations).

There is, however, a difficulty—in fact many difficulties—that arises from the choice of examples. The fact that, for example, in the dream machine of late-twentieth-century American life movies and politics could have come to articulate one another during the Reagan presidency is not necessarily susceptible to generalization to the whole history of modern cultural formation. Second, we must attend to where these examples of the imbrication of everyday life and mass culture lead Greenblatt, that is, to the decisive formulation of what he understands by a cultural poetics toward the end of his essay. This is the crux of the matter. Here Greenblatt describes his method of inquiry in terms of a sequence of metaphors. The recursive character of cultural life, the mutually constituting circularity of representations and practices, shifts from the language of dialectics (thus rooted, in however modified a form, in the Hegelian-Marxist tradition of explanation) to an openly commercial language of deal making and exchange:

> The work of art is the product of a negotiation between a creator or class of creators, equipped with a complex, communally shared repertoire of conventions and the institutions and practices of society. In order to achieve the negotiation, artists need to create a currency that is valid for a meaningful, mutually profitable exchange. It is important to emphasise that the process involves not simply appropriation but exchange, since the existence of art always implies a return, a return normally measured in pleasure and interest. I should add that society's dominant currencies, money and prestige, are invariably involved, but I am here using the term "currency" metaphorically to designate the systematic adjustments, symbolizations and lines of credit necessary to enable an exchange to take place. The terms "currency" and "negotiation" are the signs of our manipulation and adjustment of the relative systems.

It is clear from these metaphors that, although Greenblatt talks of both production and circulation, what really interests him is circulation, a circulation of representations and practices modeled as a process of exchange. These metaphors are crucial. Not only does Greenblatt draw attention to the fact that he is using metaphor here, he also emphasizes the particular

kind of metaphor he is using: a stock of figures from the language of commerce. Given that Greenblatt himself foregrounds what he is doing, we too must pay particular attention to this moment of his essay. It is in fact the nub of the matter. What a poetics of culture as a form of historical inquiry involves and entails turns on the implications of those metaphors.

Where my own comments on Greenblatt's argument are concerned, these implications spread out on two fronts: (1) what the limitations of this implied model are; and (2) what the consequences are, both methodological and ideological. I want to arrange these comments around two interrelated questions: one has to do with the medium (or the currency, as Greenblatt might put it) in which these transactions and exchanges are conducted; the second has to do with the causes of these transactions, the whole category of causation or determination.

The medium of transaction appears to be exclusively language, discourse, text, or, more generally, representation. Culture and society, in this view, are systems of interlocking representations. We understand therefore why Greenblatt attaches so much importance to the idea of a cultural poetics: culture as primarily a matter of language and text; poetics as a set of rules and procedures for analysis. In a weak version of this, I do not see that one could have any quarrel with an emphasis on the primary importance of language; this has been one of the great contributions to social analysis of structuralism and semiotics. But the stronger version—that social life is *essentially* a matter of language, texts, discourses, and so on—is another sort of proposition altogether. We need to remind ourselves that what Richard Rorty called the "strong textualist" position is vulnerable to the charge of being somewhat myopic. Ernest Gellner claimed, in his book *Plough, Sword, and Book*, that there are three fundamental forces in the making of human history: production (economy), coercion (military and other physical force), and legitimation. Legitimation is the sphere of culture, ideology, text, discourse, and so on. The other two—production of the means of life and coercion as physical force—generally require language but are not of course reducible to it. The consequence of prioritizing language inevitably entails a form of linguistic idealism in the interpretation of history; consider, for example, Edward Said's claim (Said is cited by Greenblatt as an example of the kind of view he favors) that texts are just as important as, say, military force for understanding the history of empire.[7] If you believe that, you will believe anything; I don't think it would make much sense to the dispossessed peasants of colonial invasion and occupation.

My second question, closely related to the first, overlaps with it but at the same time can be distinguished from it. It concerns not so much the medium of the transactions of social life, as the causes, the order of determinations. I have already mentioned the view—Gellner's—that there are different forces of determination in the making of history and that, in any given situation, some will be more fundamental than others. Determinations are thus multiple but also organized as a (variable) hierarchy. Greenblatt will have nothing to do with such a notion. His conception of social life and its historical unfolding as a circularity of interacting representations and practices is a circulation without a center, dispersed, heterogeneous, and above all disoriginated. In the Greenblattian scheme things simply circulate, like money or currency, in a circulation without locatable origin. Origin is of course a problematic category, but if the problem is allowed entirely to obliterate the principle of a hierarchy of determinations, then it is unclear what is left in any precisely specifiable sense of the idea of causality. In his talk of circulation, exchange, negotiation, and so on, Greenblatt of course continually gestures at causal processes (one thing interacting with another), but he does not himself supply a model of historical explanation with any strongly marked causal properties; for this, if only for heuristic purposes, you have to have some hierarchy of determinations or, in the now discredited term, some kind of "foundation."

This lack has consequences for the project of cultural poetics and New Historicism (it will be recalled that I had two questions, one to do with limitations, and the second to do with consequences). Let me conclude with some of these consequences. The first is methodological, the second ideological.

I commented at the beginning on Greenblatt's stylistic recourse to anecdote and said that this had some bearing on the more substantive issues of his essay. The anecdote is of course famously one of the privileged objects and instruments of New Historicist inquiry: *petite histoire*, as opposed to grand narrative (what Bradshaw describes as "all those vignettes and anecdotes which typically launch New-Historicist essays"). Equally famously, or notoriously, is the procedure whereby the *petites histoires* investigated by New Historicism are put together to form a larger and more coherent (though nontotalizable) picture of historical formation. More often than not the implied relation is purely one of analogy: a typical New Historicist procedure is to describe, say, a legal case, a medical case, a work of fiction, a technological invention, and so on and then

to say that they are in some sense like each other. But, since without some further stipulation of relevance the relation of analogy is methodologically weak (you can ultimately compare anything with anything), an accompanying theoretical move is to convert the analogy into something called "homology": those artifacts, practices, and so forth, are not just like each other; they display the same structural logic. But if they display the same structural logic and moreover causally interact, are we not moving back fast toward older notions of foundation and totality, in everything but name?

Certainly Greenblatt can prove exceedingly slippery on these matters. In another programmatic essay, "Resonance and Wonder," he claims that historical connections can be made "either by analogy or causality." That simple either/or begs questions too numerous to mention. Furthermore, where the first of these principles is concerned, there is a rapid and entirely unexamined shift in the very same sentence from analogy to homology ("a particular set of circumstances could be represented in such a way as to bring out homologies"), as if analogy and homology were the same thing. But they are, emphatically, not the same thing. Where the second, more strictly explanatory category of the causal is concerned, there is an equal lack of clarity: causality is specified as "generative forces." This harks back to an earlier moment in the essay where it is alleged that "particular, contingent cases" (a category that, like the anecdote, is fundamental to New Historicist inquiry) are to be understood in terms of "generative rules." This seems to imply an equation of generative rules and causality, but the relation between rule and cause is not clarified (categorically, they are no more the same thing than are analogy and homology); nor is it clear what the consequences of such a principle for making sense of the particular and the contingent might be for the category of particularity and contingency itself. If there are large causes ("generative forces") at work in historical formations, then the contingent perforce loses much of its contingency. This looks suspiciously like an unacknowledged passage from *petite histoire* to *grand récit*.[8]

These, then, are some of the methodological consequences that we need to think quite hard about in connection with New Historicism. The second consequence I said was ideological. If you think of society as a circle, a circularity of representations, the models and metaphors for which are currency, investment, debt, return, and so on—i.e., mapped out on a network of commercial concepts—it is not surprising if you end up in a cultural paradigm within which the boundary lines between reality and

simulacrum get decisively blurred. This indeed is the whole point of the stories Greenblatt relays from the history of contemporary America: a politics in which you do not know whether you are in or out of the cinema; a culture so dominated by images that the work of criminals and the works of writers get tangled up with one another in all kinds of curiously messy ways. But if nearly all societies have images, they are not all saturated with them in the same way as, for instance, contemporary America. I thus come back here to another remark I made at the beginning about Greenblatt's approach: its overwhelmingly Amerocentric basis. (He speaks of the "circulatory rhythms of American politics," of "the poetics of everyday behavior in America," and so on, without however pausing to reflect on whether the examples of American politics and everyday life he has in mind are transferable as such to other societies. If they are not, his argument, though still interesting, becomes massively parochialized; if they are, then evidence must be produced.) Moreover, the America he has in mind here is a very particular one (there are of course other Americas): the America that conforms to Baudrillard's account of the postmodern simulacrum devoid of a referent or otherwise specifiable reality, derealized and dematerialized precisely because it is caught up in the circulation of pure exchange values.[9]

It is no accident that Greenblatt's stories involve actors and images, spectacle and violence. This too connects with a wider, though heavily specialized New Historicist interest, what I am tempted to call the "wonders" of New Historicism (it is of course a key term in the title of one of Greenblatt's most influential essays). It is a striking historical fact of New Historicism that its interests have so often been focused on certain kinds of subject matter, essentially to do with spectacle—the specular relation with the image, the forms and technologies of the visual, the whole culture of display—and then, within this general interest, certain kinds of spectacle: violent, freakish, ghoulish. High on a checklist would come bodies, often in pain and torment, or just plain dead (the victims of sensational murders), or imitations of the dead (the simulacra of waxwork museums), or freakish bodies (the freaks and monsters of the itinerant fairs of Europe and America, dwarves, hermaphrodites, werewolves, and so on). Also high on the list come gadgets, especially those bound up with technologies of vision (the telescope, the microscope, the movies); circuits (of transportation and especially of the evacuation of waste, including, again, dead bodies, what Catherine Gallagher has called "garbage-bodies"); or the great technological creations of pure spectacle (the

Panopticon, the Eiffel Tower). These are the strange objects of New Historicist desire, and, as I have suggested, the one term that we could perhaps use to sum up these various subclasses into an overarching class is "wonder."

I do not mean that one should not be interested in such things nor that being interested in them does not yield useful forms of cultural history. Greenblatt's riposte to Walter Cohen's charge that New Historicists "are likely to seize on something out of the way, obscure, bizarre" was, in its own terms, entirely reasonable: namely, that the "bizarre" (which for reasons correctly stated by Greenblatt must be put in quotation marks) has as rightful a place in historical inquiry as anything else.[10] But this rather coyly skirts the point that in privileging the "bizarre," the culture of New Historicism has effectively fetichized it in a relation of obsessive specular fascination, all the more disingenuous given the ways in which the concern with the "bizarre" as an object of voracious academic consumption has been ideologically legitimated in its equation with the repressed or marginalized term of a normative and normalizing discourse.[11] Above all, there is the complete absence, in what is alleged to be a resolutely historical endeavor, of appropriate forms of historical self-consciousness, reflecting the fact that the interest in these particular forms of the "bizarre" is a very particular kind of interest, one that will arise and flourish only in very determinate social conditions, let us say, those of late-twentieth-century California. Lest this be taken as another instance of Eurotrash anti-Americanism, that is not my position or my point at all. The culture of spectacle (what Guy Debord called *la société du spectacle*) is highly developed elsewhere, above all perhaps in France, but it is especially active on the West Coast of the United States and bound up with a whole history of the conversion of the natural and man-made worlds into commodified images put into ceaseless circulation.

"Wonder" is of course a key word in the history of the making of America. In its nineteenth-century guises, it has been investigated by Tony Tanner in a book instructively entitled *The Reign of Wonder*, where it is associated with myths of innocence. In its late-twentieth-century incarnations, however, a perverse transformation has occurred, from innocence to frisson, the garden of Eden modeled on the culture of the commodity and the gadget, on speed, the endless quest for novel sensation, the thrill of spectacle.[12] It does therefore seem to me to be more than just a coincidence that it is above all in California that New Historicist interests have prospered. But my point is that New Historicist

discourse—including Greenblatt's in "Towards a Poetics of Culture"—rarely reflects on its own conditions of birth and possibility. Its presuppositions are tangled up in the very things it takes as objects of analysis. Given moreover that New Historicism has been vehement in denouncing the ethnocentric biases of an older totalizing model of historical inquiry, it is deeply ironic that it itself should be constrained by the very ethnocentricity it sought to unmask elsewhere.

5

Representing (Forgetting) the Past

PAUL DE MAN, FASCISM, AND DECONSTRUCTION

In Paul de Man's literary and philosophical writings (which have come to be referred to as "late Paul de Man"), there appears to be a linguistic version of the doctrine of the Fall: "What stands under indictment is language itself and not somebody's philosophical error."[1] Geoffrey Hartman (in an article to which I shall return in detail below) glosses this claim as meaning that something called language is the site and source of an "essential failure" and an "original fault."[2] Language (as distinct from the specific uses to which it is put by human speakers and writers) is intrinsically and originally duplicitous, and hence the belief that error can be corrected by truth, that enlightenment can come from reflection and criticism, is a delusion. I leave on one side here the paradoxical point that, if this argument is held to be true (a clearing-away of erroneous conceptions of language), it is self-defeating from its own premises. I want rather to draw attention to the fact that this represents a curiously theological notion of language (doubly curious when we recall that deconstruction is expressly devoted to ridding philosophy of theological metaphysics, what Derrida has resumed in the category of the "onto-theological"). I want further to invite readers to consider what kind of duplicitousness, if any, they might see in the following passage. It is the opening paragraph

of de Man's article entitled "Les Juifs dans la littérature actuelle," which was published in the Belgian newspaper *Le Soir* on March 4, 1941. This is one of the articles uncovered by Ortwin de Graef, and—as its very title indicates—is at the heart of the current debate about de Man's life and work. I quote it in the original French:

> L'antisémitisme vulgaire se plaît volontiers à considérer les phénomènes culturels de l'après-guerre (d'après la guerre de 14–18) comme dégénérés et décadents, parce que enjuivés. La littérature n'a pas echappé à ce jugement lapidaire: il a suffi qu'on découvre quelques écrivains juifs sous des pseudo-nymes latinisés pour que toute la production contemporaine soit considerée comme polluée et néfaste. Cette conception entraîne des conséquences assez dangereuses. Tout d'abord, elle fait condamner a priori toute une littérature qui ne mérite nullement ce sort. En outre, du moment qu'on se plaît à accorder quelque mérite aux lettres de nos jours, ce serait un peu flatteuse appréciation pour les écrivains occidentaux que de les réduire à être de simples initiateurs d'une culture juive qui leur est étrangère.[3]

> (Vulgar anti-Semitism is wont to consider postwar cultural phenomena (the 14–18 war) as degenerate and decadent by dint of being Jewified. Literature has not escaped this lapidary judgment: one need only discover a few Jewish writers work-ing under Latinized pseudonyms to conclude that all con-temporary production is to be viewed as if polluted and harmful. This conception has fairly dangerous consequences. First, it entails an a priori condemnation of a whole literature that in no way deserves this fate. Moreover, if one is inclined to grant a certain merit to contemporary letters, it would scarcely be a flattering appreciation of Western writers to reduce them to being the mere initiators of a Jewish culture that is alien to them.)

Let us suppose we come to this paragraph as innocent readers (in the sense of being unencumbered by any foreknowledge of the de Man affair). The first sentence might well strike us as a gesture of dissociation from the ideology and cultural politics of fascist anti-Semitism, although the role of the word *vulgaire* in the sentence is ambiguous: it is either anti-

Semitism as such that is being rejected (as *vulgaire*), or it is a particular form of anti-Semitism that is being rejected (the vulgar sort, as distinct from some other, more respectable sort).[4] Similarly, the third sentence ("Cette conception entraîne des conséquences assez dangereuses") could be read as a warning about the dangers of anti-Semitism, at least in the field of culture. But the second, fourth, and fifth sentences tell us that the dangers de Man has in mind are quite other. The second sentence (particularly its second clause) is slightly odd, but the fourth and the fifth show that what de Man is objecting to here is not "discovering" (and presumably denouncing) "quelques écrivains juifs sous des pseudonymes latinisés"; he is objecting to the theme of guilt (or, rather, pollution) by association: a few Jews here and there do not make a difference; they do not entail the claim that "les phénomènes culturels de l'après-guerre" are to be seen as "dégénérés et décadents, parce que enjuivés." De Man is thus indeed concerned with refuting an error: the erroneous belief that modern literature has been contaminated by a Jewish influence. But, as the fifth sentence makes clear, the error in question is not the view that a Jewish influence or presence in modern literature contaminates; it is the view that there *is* a significant Jewish influence in modern literature.

The argument, then, is that modern literature has been mercifully spared pollution by the Jews (though Kafka is cited as one of the exemplary moderns, without, however, any reference to the fact that Kafka was a Jew). Jewishness is indeed alien and carries the threat of infection, but, as we learn later in the article, such is the healthy vitality of Western culture that its representatives have been able to resist infection ("Qu'ils ont été capables de se sauver de l'influence juive dans un domaine aussi représentatif de la culture que la littérature, prouve pour leur vitalité" [That they have shown themselves capable of escaping Jewish influence in such a representative sphere of culture as literature is proof of their vitality]). Nevertheless, de Man goes on to add, in the light of "l'ingérance sémite dans tous les aspects de la vie européenne," it might not be a bad idea if the Jews were to leave European soil (whether voluntarily or coercively is not made clear): "En plus, on voit donc qu'une solution du problème juif qui viserait à la création d'une colonie juive isolée de l'Europe, n'entraînerait pas, pour la vie littéraire de l'Occident, de conséquences déplorables" (In addition, we can see therefore that a solution of the Jewish problem that aimed at the creation of a Jewish colony isolated from Europe would not have, for the literary life of the West, deplorable consequences). It is to be noted that de Man doesn't explicitly commit

himself to this as a "solution" to the "Jewish problem"; the tense of the main verb is the conditional ("entraînerait"). Furthermore he takes care not to engage with the politics of anti-Semitism; his concerns are purely "literary." Moreover the purpose of such a solution is left peculiarly vague: it is not offered as a prophylactic measure, designed to protect Western literature from infection (how could it, since de Man has been at some pains to stress the imperviousness of literature even when the Jews are in our midst?). Rather it is simply that the disappearance of the Jews would be no great cultural loss. The status of the "donc" in that sentence is therefore unclear. Though not entirely discrepant with the major premises of de Man's argument, this recommendation (if that is what it is) seems illogical, or at least redundant: if Western ("Occidental") culture continues on its healthy way notwithstanding the presence of the Jews, what specific purpose is usefully served by getting rid of them? Perhaps the unacknowledged answer to that question, in the terms of de Man's article, is political after all. For while it is true that literature has survived intact "malgré l'ingérance sémite," the same cannot be said of Europe generally: "Les Juifs ont, en effet, joué un rôle important dans l'existence factice et désordonnée de l'Europe depuis 1920" (The Jews have indeed played an important role in the factitious and disordered existence of Europe since 1920.).

This I call duplicitous writing, though not by virtue of some original fault inscribed in language as such. I gather that some people have taken the view that it is duplicitous in the sense of being ironic, that de Man doesn't mean what he says, though I see no evidence in the article itself to substantiate such a view. Others have claimed that the article needs to be seen in context. Restricting myself to Hartman's text, at least three such contextual candidates are on offer. The first is quantitative: de Man's anti-Semitic remarks, "though ugly," are "infrequent"; scanning the corpus of wartime articles unearthed by de Graef, Hartman tells us, he "found *only* one other prejudicial reference to Jews by de Man." But suppose we remain unimpressed by the quantitative argument and address ourselves to the question of the quality of these "references"? Palliation is to hand by virtue of the other two contexts. One is stylistic. Echoing de Man's talk of "antisémitisme vulgaire," Hartman says of the article: "This is not vulgar anti-Semitism"; on the contrary, the "formulations" are "polished"; later, he observes that they are "mild," then "very general," and finally "polite." Polished, mild, very general, and polite: perhaps I am mistaken, but this surely must represent a whole new dimension in

the characterization of 1940s anti-Semitic discourse. Finally, there is the historical context, broadly the claim—to which I shall return—that very many Europeans were at the time more or less all in the same boat, victims of the anti-Semitic zeitgeist, as a distortion of what originally was a "common sort of nationalism."

Hartman also says other, far more censorious things (often within the same sentences) about de Man's anti-Semitism. And entirely legitimate considerations of context require that much of what I have already quoted be restored to those sentences, though whether syntax and logic work together in the interests of intelligibility, whether the censorious and the palliative easily coexist, remains to be seen. But I have to say that most of what I have so far taken from his text strikes me as pitifully inadequate to the issue before him, a failure not of some primally flawed thing called language but of argument, of moral imagination and historical sense. I shall explain why I hold to this view in more detail later. For the moment, however, I want to agree—the agreement will be already implicit in aspects of my own prose style—with Hartman's statement that "it is hard to be dispassionate" about all this. There are clearly many personal and contingent reasons why this has been so. Before the revelations of his record as a wartime journalist, de Man's work inspired both fierce loyalties and strong antagonisms, particularly in the literature departments of certain universities. The unfolding of the story here has inevitably got caught up in relations of friendship and enmity. And no doubt strictly professional interests involving careers and reputations have also played their part; as almost everywhere in contemporary academic life, there are territories to be defended, crowns to be grasped, ambitions to be satisfied, and all the rest of the normal yet unpleasant undergrowth of the groves of academe. The outcome, in my view, has been pretty disastrous, whether in the form of paranoid defensiveness or holier-than-thou sanctimoniousness.

The facts of the matter so far documented appear to be straightforward and shocking: under the Nazi Occupation of Belgium, de Man wrote articles for a newspaper controlled by the occupiers. This continued until the end of 1942, when, as Hartman puts it, "all but the deliberately ignorant would have known that the persecution of the Belgian Jews begun before the end of 1940 had taken a drastic turn" or, in his somewhat puzzling formulation of the same point, when "an ideological figure of speech became literal and lethal" (does this mean that as a figure of speech, anti-Semitism is relatively harmless, mere literature?). In

other words, unless we are to classify de Man among the "deliberately ignorant" (whatever that might mean), he must have known of some of the dreadful things that were going on. If these are the facts (there are of course other versions in circulation), then the notion that there is something to be done about them—that they have to be interpreted, contextualized, and all the rest—seems quite preposterous, just as it is equally preposterous to be now organizing a kind of trial. The debate about collaboration has been going on since the end of the war, the literature on the subject is extensive, and the argument over whether error or sin is the appropriate category of interpretation and judgment has been at the heart of the debate from its very beginning. There does not seem to be anything discernible in the basic facts of the case of de Man that would call for special treatment and hence justify all the nervous energy and high passion that have been expended.

And yet there is. The distinctive feature of de Man's case is that, in later years, he came to be the foremost representative in the United States of a style of critical thought called "deconstruction." In this connection, the substantive intellectual issue has been whether there is any significant relation between de Man's involvement in the terms of fascist thinking and his elaboration of the terms and strategies of deconstructive thinking. This issue has cropped up again and again in discussion but has also tended to disappear beneath the weight of the more personal and parochial passions the case has aroused. Although the issue has constantly come into view, the furor has ensured that the view remains blurred; none of the parties to the discussion, whether shell-shocked or gleeful, seems able to get a proper handle on it. Yet for those of us who did not know de Man personally or who have no vital professional stake in the fortunes of deconstruction, this is indeed *the* issue. One intellectual collaborator more or less makes little or no difference to our understanding of the phenomenon of collaboration. But does it make a difference to our understanding of deconstruction?

Hartman says that the "discovery of these early articles must make a difference to the way we read later de Man." What then is the nature of that difference, and what are its implications and consequences? Hartman never gives us a clear answer, and that lack of clarity is both instructive and, I would maintain, symptomatic of the more general intellectual disarray into which the whole discussion has tended to collapse. For this reason, I propose to confine myself here for the most part to a more detailed

analysis of the arguments and the mode of writing informing Hartman's contribution, more or less in the spirit of the activity of "close reading" that Hartman associates with the enterprise of deconstruction itself. My title moreover echoes one of his: "Paul de Man: Fascism and Deconstruction." That title represents what for me is the central intellectual issue (as distinct from speculations of a purely biographical character). I initially assumed that this title also carried the same meaning for Hartman, since it is difficult to see what other meaning it could bear.

Sustaining that assumption in the actual reading of Hartman's text does, however, turn out to be rather hard work, notably at the key moment of encountering the claim that "the discovery of these early articles must make a difference to how we read later de Man." I take it that the phrase "later de Man" is a metonymy referring to de Man's later writings and hence to the critical enterprise of which those writings were, in the United States, the outstanding example, the enterprise of deconstruction. The revelations are thus problematic for deconstruction as such (and not just Paul de Man's private relation to it). Elsewhere Hartman says that it is the "purity of deconstructive thought . . . that can now be questioned" (not just de Man's involvement with deconstructive thought but deconstructive thought *tout court*). Yet the sentence that immediately follows the one about making a difference reveals that the primary concern is in fact of a biographical order, not with the later writings as such but with their relation to a biographical drama: "The new disclosures imbed a biographical fact in our consciousness, a fact that tends to devour *all* other considerations" (my italics). In important senses, the whole of Hartman's article converges on this sentence. But "converge" is scarcely the right word. In a parody of deconstruction's love of self-unstitching and self-dispersing textual forces, Hartman's text falls apart at exactly the moment it promises to deliver. The result is a shambles, an incoherence so deep and so pervasive that it is difficult to know where to begin in the effort to sort the mess out.

But let's have a shot at this by starting with some of the features of this extraordinary and bewildering sentence. Let us even try and take some of its major terms at face value and see where they lead in relation to some of the other statements in the article. Hartman speaks of a "biographical fact" so overwhelming that it "tends to devour all other considerations." It is unclear what "tends" means here, in particular which and whose tendency is envisaged. Is it a tendency generated by the disclosures in Hartman's own thinking about later de Man? Or is it a tendency of oth-

ers, where the verb "tends" is to be understood in the sense of "in danger of being," thus designating a tendency to be resisted and avoided? Neither the sentence nor the paragraph in which "tends" appears does much to help us get at the relevant sense. If it is the former (the biographical fact tends to devour all considerations for Hartman himself), this sits impossibly with what he says elsewhere: "What is neglected by some of de Man's critics, who are in danger of reducing all to biography again, is the intellectual power in his later work." If, on the other hand, it is the tendency of others (and therefore a danger to be avoided), he clearly can't mean that either, since the biographical fact that tends to devour all other considerations has embedded itself in "*our* consciousness" (my italics)— the implied "we" necessarily contains an "I." But this cannot be where Hartman stands, because elsewhere he is at pains to dismiss those who hold exactly the view he is here describing, namely, those critics of deconstruction who "have seized on the revelations" to discredit deconstruction itself: "Their [the critics'] sense of deconstruction as morally unsound and politically evasive seems to stand confirmed." But, according to Hartman, appearances are deceptive: "Such a judgment is superficial, and divorces deconstruction from its context in the history of philosophy." Quite so. I agree entirely, certainly in the sense that the stridently polemical innuendo implying that there is some intrinsic link between deconstructive thought and fascist ideology is both blatantly false and entirely disreputable. But, in that case, what does Hartman mean when he says that all considerations regarding the status of the late de Man texts (presumably including—by definition from the force of that "all"—considerations regarding their intellectual status) tend to get devoured by the biographical fact? Where, in relation to that "tends," that "devoured," and that "all," does Hartman stand?

From the immediate context we simply cannot tell. We do, however, get some (very limited) sense of what he means when he goes on to talk of the later works in terms of what he describes as a reactive endeavor. In the light of the revelations about early de Man, we are now obliged to read later de Man as a reaction against that murky past, to see his reflection on the unbridgeable gap between intention and language, action and art, figure and letter, as "a deepening reflection on the rhetoric of totalitarianism," a "belated, but still powerful, act of conscience." So, Hartman views the late writings not as compromised (in that sense of "devoured") by the wartime episode but as a form of private atonement and confession: "It may turn out that in the later essays we glimpse the

fragments of a great confession," something in the tradition of Goethe perhaps. Well, not quite. For we also learn that "there is nothing of a confessional nature in de Man," and indeed Hartman himself is quick to condemn de Man's silence about his past ("One crucial and hurtful problem is that de Man did not address his past"). But the condemnation just as quickly evaporates when Hartman turns to the problematical status of the category of confession itself in de Man's own theoretical and critical writings.

Deconstructed in the context of an analysis of Rousseau's *Confessions*, the project of self-disclosure is presented by de Man as irredeemably caught up in the duplicitousness of language, in narratives of self-exculpation. Hartman summarizes these views for us, with apparent approval or at least with no acknowledgment that they are scarcely compatible with his own criticism of de Man for having maintained silence over his wartime activities; instead we are steered toward the idea of a suffering that is "specifically linguistic," a "linguistic pathos" that is the "painful knowledge" of having been "trapped by an effect of language." This is the language-as-original-fault hypothesis being wheeled onstage at a crucial point, along with some grotesque irrelevancies about the need to avoid "nostalgia" for a lost past and the futility of "mourn[ing] the past as lost in order to guarantee ourselves an unencumbered future." But nostalgia and mourning have nothing to do with the issue of early de Man; there is nothing there to be nostalgic about; shame and regret would be the more appropriately relevant terms. But these are exactly the terms that the deconstructive reading of Rousseau treats with a proper dose of skeptical suspicion. And out of this incredible mess of "argument," there somehow emerges an image of a tragic figure grappling with "painful knowledge": refusing to do a Rousseau on his own past, de Man avoids the narrative-linguistic traps of confession but at the same time also manages—obliquely, abstractly—to confess and so register "disenchantment" with the "errors" of the past (in the form of a "turn from the politics of culture to the language of art"). There appear therefore to be two kinds of confession here, the Rousseauist and the de Manian, the explicit and the tacit. One mentions specifics, real or imaginary ("even where there is no discernable fault or error"), and, by that act, gets caught up in narratives of self-justification; the other doesn't mention anything at all (other than the "original fault" of language) and thus escapes the dangers that beset the former enterprise. But, if this distinction between kinds of confession is to be taken seriously, why then

does Hartman reproach de Man for his silence, why is the silence about the past a "crucial and hurtful problem"?

I imagine my reader is by now as bewildered as I am in trying to hold the twists and turns of all this in my head: confession that isn't confession (which makes no mention of the specifics of the past, the "exceptional Nazi years") but still remains an "act of conscience." But the real question buried in these tortured to-ings and fro-ings is, outside the hothouse of a certain branch of the academy and its internecine rivalries and obsessions, who cares? I can well see why it matters to people who, like Hartman, were in personal relationships with de Man. But for those of us who weren't, there is no strong reason why we might be specially interested in the private motives behind the arguments developed in the later writings, as distinct from the arguments themselves. This, ultimately, seems to be all Hartman has in mind when he says that "the discovery of these early articles must make a difference in the way we read later de Man." The difference they make to our reading is indeed of a purely biographical sort, a matter of a "personal history," a "reflection by de Man on de Man"; the conjunction of early and late enables us to read the story of an individual spiritual journey from complicity to renunciation, in which the elaboration of the deconstructive project served as an intellectual instrument to help effect the journey. As for the standing of the arguments themselves, and in particular their difficult relation to questions of politics and history, Hartman has nothing to say beyond the assertion that the "epistemological hassles" we all face, and that deconstruction addresses in its accounts of philosophical and literary texts, reveal the terms in which these questions have been raised by the opponents of deconstruction as superficial ("Such a judgment is superficial").

Thus the attack elsewhere in Hartman's article on the "reduction" of the intellectual issue to biography is flatly contradicted by the ad hominem terms of his own approach. But then this has rapidly become par for the course. Although the terms vary, the basic principle of ad hominem procedure has also characterized the essential moves of the opposition in the controversy. One of these moves turns on an interpretation of a theme (a trope) that de Man took from Nietzsche and discussed in an essay in *Blindness and Insight*: the theme of forgetting. De Man's comments on Nietzsche's claim that we seek "the destruction and dissolution of the past in order to be able to live" have now been read (notably by Frank Lentricchia in remarks quoted in *The Nation*) as rationalization of the desire to bury his own wartime past: "Anyone who thinks

that he left this all behind him, that it did not motivate the life and career that followed, is crazy.... He didn't just say 'forget history'; he wanted to paralyze the move to history."[5] We thus have two conflicting interpretations of the function of deconstruction for Paul de Man. Where Hartman sees de Man using deconstruction to confront the past, Lentricchia sees it as serving the end of forgetting that past. There is nevertheless fundamental agreement between Hartman and Lentricchia on at least one point: if one sees the later writings as atonement and the other sees them as repression, they both agree on psycho-biographical explanation as the relevant frame of reference. The problem with Lentricchia's way with this form of explanation, in terms of any useful critical statement about deconstruction as such, is that it is both highly speculative and excessively generalized. There is nothing in the syndrome of forgetting that is unique to either deconstruction or fascism. There are many kinds of painful pasts other than fascist ones that people wish to repress, and there are many ways of repressing a painful past (just as there are many ways of indicting such a past) other than deconstructive ones. The thesis about repression does not therefore supply any useful insight into the intellectual structure of deconstruction as a body of thought; it merely psychoanalyses one practitioner of it.

As I have already said, I for one am not particularly interested in the question of late de Man's motives for writing but do wish to know more about the relation, if any, implied by the title of Hartman's article, between fascism and deconstruction. But perhaps on this front there is in fact nothing to learn. The absurdity of the notion that there might be some significant substantive link is indeed instantly revealed if we take out the proper name Paul de Man and substitute that of the other outstanding proponent of deconstruction, Jacques Derrida. The structure of Derrida's thinking inflected by some relation to fascism or indeed any brand of authoritarian ideology? The notion is laughable. The question of the politics of deconstruction remains of course what it has always been: extremely controversial. As Richard Rorty has pointed out, it is impossible to infer any determinate political position from deconstruction. Accordingly, its political incarnations and appropriations have been various, on a spectrum from radical feminism and Marxism to anarchic libertarianism and quietistic pluralism, tolerant of multiplicity but uninterested in concrete change, talking a lot of empowerment and the like, deconstructing fixed systems of meaning, while leaving actual arrangements more or less as they

are. The most coherent and probing formulation of this aspect of the mat-
ter that I know of is Stephen Heath's. Heath gives us, on the basis of
reviewing two books by Jonathan Culler and Terry Eagleton, respectively,
a wide-ranging review of the literature, history, and institutional settings
of deconstruction. Noting that Derrida "produces a strong deconstruction
that overturns and displaces, that undermines," he goes on to pose and
pursue the following central question:

> But in relation to what project? Other than simply the proj-
> ect of deconstruction, in which case it merely turns in the
> void, an endlessly repeated gesture, a set of themes and style
> of writing, a continual recycling of the demonstration of the
> terms of the "metaphysics of presence" and its "foundations,"
> again *not making much difference* [my italics]. Reliable guides to
> deconstruction do indeed often come out at this point with
> a kind of rational limitation of deconstruction—"don't do it
> all the time!" Thus Christopher Norris in his "New Accents"
> *Deconstruction: Theory and Practice*: "Deconstruction is . . . an
> activity of thought which cannot be consistently acted on—
> that way madness lies—but which yet possesses an inescapable
> rigour of its own." The madness of words becomes the mad-
> ness of deconstruction's knowledge of that madness; one had
> better go about one's business, texts can still be interpreted. . . .
> Culler also has an interesting comment in this connection, an
> interesting image: "One can and may continue to sit on a
> branch while sawing it." Presumably if we then say that, how-
> ever that may be, one can*not* continue to sit on the branch
> once it has been sawn, the answer will be that it never will be
> since deconstruction is a constant, an operation that will
> never be over. But this just brings us back to turning in a void,
> makes deconstruction into some universal mode, Norris's
> "activity of thought" that you acknowledge now and then for
> its own "inescapable rigour" while getting on with things as
> usual. Culler, however, develops his image: "If 'sawing off the
> branch on which one is sitting' seems foolhardy to men of
> common sense, it is not so for Nietzsche, Freud, Heidegger
> and Derrida; for they suspect that if they fall there is no
> 'ground' to hit and that the most clear-sighted act may be
> a certain reckless sawing, a calculated dismemberment or

deconstruction of the great cathedral-like trees in which Man has taken shelter for millennia." This flourishes rhetorically, but leaves everything unsuitably vague (to say the least), precisely rhetorical—calculated *for what?*[6]

Calculated for what? This is indeed a pertinent question. Seen in relation to the idea of a project, deconstruction can appear doubly pointless: doing it all the time risks turning in the void of deconstruction's endless self-reproduction (and going mad); doing it some of the time means that the rest of the time will be business as usual. Either way, nothing much happens (beyond a certain "activity of thought"), nothing gets changed. For a project implies both values and commitments, on the one hand, and, on the other hand, a set of strategies designed ("calculated") to secure the ends sponsored by those values and commitments. Although outcomes can never be guaranteed, are intrinsically uncertain, this is the only sense of the word "calculation" that is properly relevant to the business of having a project. From the way it is internally constructed, deconstruction seems unable to deal with these kinds of considerations. It shies away from values and strategies, ends and means, commitments and calculations, because it fears that this is to restore a metaphysical language of grounds and foundations. Whence the dilemma: you turn elsewhere for values and the rest, for somewhere to stand (Marxism, feminism, etc.), and try to harness the undermining force of deconstructive analysis as a strategy, practical and intellectual, in the name of those values. But this is vulnerable to the charge of self-contradiction, since it is precisely the elsewhere, the anchoring or grounding elsewhere, that deconstruction forbids, that it requires you to deconstruct in turn. Deconstruction doesn't allow you to stand anywhere, only to sit on the branch while sawing it. The alternative, then, is to abandon the idea of standing anywhere and of being able to give cogent reasons for those choices. But, as Heath says, what then is the point of deconstructive work, why bother, what difference does it make?

All this is relevant to de Man's reflection on the problematical relations among thought, language, and action. But the terms of that reflection are not the only ones for engaging with these problems, although they are the only terms that Hartman allows into the field of discussion (with what results I shall presently consider). The unavailability of an ultimate ground, an absolute foundationalist move in which to anchor ethical and political life (what Derrida calls the "ethico-political") is a familiar theme

of contemporary moral philosophy. It is, for example, central to Bernard Williams's argument in *Ethics and the Limits of Philosophy*.[7] But this does not prevent Williams from arguing for the ethical life (for the relevance of what he calls ethical "considerations") nor from claiming that rational-critical thought (what Hartman, summarizing de Man, defines as the illusions of enlightenment) has a key place in such considerations. This is not a return to foundationalist thinking; on the contrary, it emphasizes the social and historical situatedness of the projects we construct and the decisions we make. The fact that there is no philosophical calculus for our decision making does not exempt us from having to make decisions and live by them, including those of the ethico-political sort.

Decision making is in fact one of the key issues in the whole debate about the politics of deconstruction, and it turns on what has become arguably its most notorious category, the category of the undecidable. In its journeys around the intellectual marketplace, this word has come to mean so many things that it now probably has no more useful intellectual life left in it. As I understand its operation in Derrida's work, however, it has essentially two contexts. One is strictly formal, a somewhat obscure attempt to apply Gödel's undecidability theorem in mathematics to the interpretation of texts. The other concerns the question of decision making in the more ordinary senses. In this context, the undecidable is not meant as a recipe for passivity and opting out. It stresses two aspects of decisions: first, that to decide for one possibility always and necessarily entails the repression of other possibilities; second, that we cannot know fully in advance what the outcomes of our decisions will be (if we could, they wouldn't be decisions but something else, akin to what robots or computers do). In other words, the undecidable does not represent a rejection of decision but is one of the very *conditions* of making a decision.

Neither of these two emphases (on repression and on unknowability) is particularly novel (both, for example, are at the very heart of the representation of the problem of decision in tragedy). I certainly see nothing in this use of the undecidable that is incompatible with Williams's approach to the question of ethics. Everything thus depends on how the point about the absence of secure foundations is made and how its implications are handled. In that regard, Hartman's performance is nothing short of lamentable, as both an account of deconstruction and a demonstration of it in action. Hartman's way with the undecidable is for the most part to avoid decisions, to hop first on one foot and then on the

other. I said earlier that his use of such adjectives as "polished," "very general," and "polite" with reference to de Man's anti-Semitism needed to be put back in context, in particular into the sentences that condemn de Man. Here is some of that context: "But the fact remains that, however polished de Man's formulations are, they show *all* the marks, and the dangerous implications, of identifying the Jews as an alien and unhealthy presence in Western civilization" (my italics). "There is, clearly, an accommodation, *but* it remains very general, without recourse to the usual 'virile' invective" (my italics). "But I cannot ignore these expressions of anti-Jewish sentiment, *even if* they remained polite . . ." (my italics). This is all over the place. Hartman condemns, initially in no uncertain terms ("all the marks . . ."), yet retracts condemnation. He says that "the *destruction* of European Jewry" was "*abetted* by such [i.e., Paul de Man's] propaganda" (my italics). That is a very strong statement, a statement about causal and moral responsibility for decisions in history. And yet he cannot follow through, the judgment fades away into the vagueness of phrases like "perhaps culpably blind" and so forth (10). What on earth can we do with these endless backtrackings and proliferating qualifiers, phrases, and sentences that take away with one hand what they give with the other? I do not mean by this that a decision on the de Man affair is required. One might prefer the stance of irreducible ambivalence. But if that is the preferred response, it should be explicitly and scrupulously represented as such and not be confused with flailing indecision or rhetorical gestures toward decisions that are then undermined the moment they appear to arrive somewhere. Certainly, explicit and scrupulous ambivalence is not compatible with the claim that de Man's anti-Semitic formulations "show all the marks, and the dangerous implications, of identifying the Jews as an alien and unhealthy presence in Western civilization," and by the same token I see no plausible sense in which, given that claim (under which de Man's text is strictly irredeemable), the formulations can also be described as "polite."

There is, however, one area in which Hartman does make what appears to be a series of moderately clear decisions, and it calls for special comment. It is, surprisingly, in the form of an appeal to the category that has come in for quite a lot of heavy deconstructive treatment (and notably in de Man's writings): the category of history. "In the light of history, de Man's article . . . become[s] more than a theoretical expression of anti-Semitism." I am not quite sure what this means, especially the

phrase "more than a theoretical expression." The phrase that interests me here, however, is "in the light of history." History? Light? The possibility, then, of enlightenment in and through history. But enlightenment is exactly what Hartman, summarizing de Man, is skeptical about ("enlightenment as such cannot resolve error, and even *repeats* it" [my italics]). If we cannot learn from history, learn historically in the sense of being able to mount rational interpretation and criticism of past events and actions, why then the appeal to history. What sort of light comes out of history?

Nevertheless, let us persist with the metaphor of light and see where it takes us in terms of Hartman's further speculations about history, both particular and general. The sentence I have just quoted might lead us to believe that historical enlightenment in the case of the de Man affair consists in seeing just how dangerous and culpable the anti-Semitic intervention was. But this is not at all the theme of what Hartman has to say about history elsewhere in the article. Three points in particular stand out. The first is Hartman's injunction that "it remains important, however, to place oneself into that era, into its motives and attitudes." This is an odd injunction, given deconstruction's criticism of the branch of empathetic hermeneutics that believes you can recover the intentions and meanings ("motives and attitudes") of historical actors, grasp the past from the point of view of the past. This is what Hartman says, however. What kind of recovery does he have in mind? It turns out to be the frame of mind of what he calls the "common sort of nationalism" in Europe of the period (though exactly what period is left vague) and in particular the "cultural" nationalism to which de Man ("this Flemish sympathizer") was drawn. "Nothing in this common sort of nationalism," writes Hartman, "had to result in anti-Semitism." As a historical claim, this is dubious, but no matter. The real point is that the frame being set up here is deeply misleading. It may or may not be true that, prior to the Nazi occupation of Belgium, there was a form of nationalism that did not have to result in anti-Semitism. But Hartman is not talking about de Man's position on nationalism before it turned into anti-Semitism. He is talking about, trying to explain, texts written in the 1940s, that is, in Hartman's own words, "well past the time when all but the deliberately ignorant would have known that the persecution of the Belgian Jews begun before the end of 1940 had taken a drastic turn." A teleological red herring (nationalism, at least of the "common sort," didn't have to result in anti-Semitism) is thus laid across the path of the argument and yields

the following witless question (to which moreover no clear answer is given): "Was it youthful inexperience, then, or a broader acceptance of fascist ideology that made de Man write an anti-Semitic piece?" "Youthful inexperience" may be relevant, but on its own its explanatory power is zero; lots of foolish things come out of youthful inexperience, but the task at hand is to explain why this *particular* thing might have come out of it. As for "broader acceptance," I don't know what "broader" means here. But in any case, acceptance (broader or otherwise) doesn't explain much either in any relevant sense of historical explanation. What then is the point of requiring us to place ourselves "into that era, into its motives and attitudes." The effect is a discreditable one; it puts in place a smoke screen made from some notion of a relatively harmless "common nationalism" that has nothing to do with the particular historical facts of the matter in hand.

The second point is even more discreditable. This is Hartman's serving up of historical context in the form of the appalling in-the-same-boat hypothesis. In the last paragraph of his article, Hartman rehearses his feelings of moral indignation at de Man's anti-Semitism (using such words as "accuse," "abhor," and "feel betrayed"). Then comes the following (with the customary backtracking "however"): "The accusations we bring, however, are a warning to ourselves. They do not justify complacency about the relation of political ideas to moral conduct." All too true. But what has this to do with the specifics of the history of the Nazi period? What it has to do with it is specified in the following two sentences: "Many on the left also welcomed what Kenneth Burke called 'sinister unifying' and succumbed to xenophobic and anti-Jewish sentiment. De Man's 'dirty secret' was the dirty secret of a good part of civilized Europe." Yes, many on the left did succumb, and I suppose not too many questions are begged in saying that "a good part of civilized Europe" was caught up in anti-Semitism. Certainly, no one, to my knowledge, is claiming that de Man was alone in expressing anti-Semitic sentiments. But, as the deconstructionists are the first to insist, we should also attend to the rhetorical force as well as the factual claims of statements of this type. The rhetorical effect of Hartman's statement is obvious: it evokes a generalized culpability enveloping the Europe of the period, touching left and right, barbarian and civilized alike. It is code for saying we were all guilty. As history, this is both an intellectual and a moral disgrace of breathtaking proportions. It forgets or evacuates from the historical picture what crucially makes the difference: the fact of sustained, articulate, and deter-

mined opposition to the obscenities of anti-Semitism. There was not some unspeakable zeitgeist irresistibly seducing everyone into passive or active collaboration. And if Hartman were to object that of course he has not forgotten this, the important point remains: why does he not mention it? I make this point not just for the sake of something called balance but because it shows that at the time there were other options, from silence to departure to active resistance.

Resistance, however, would not seem to be a particularly meaningful category for Hartman. This brings me to the third point of his way with history. We have seen Hartman rehearsing de Man's view that enlightenment can never correct error, that it "even repeats it." Repetition is indeed the commanding figure of this theory of history. We can never accede to the dignity of rational self-understanding; we cannot correct the past. All we can do is repeat it (in which case how do we know that it is error?). Is Hartman being serious here? Is he saying that this is what de Man said? And, if so, does he agree? How can he, since he berates de Man not only for his "error" but also for not having disclosed it. Yet here he is moving toward a description of de Man's work as "a deepening reflection on the rhetoric of totalitarianism" in the following terms: "There cannot be, he [de Man] suggests, a future that will not prove to have been a past like that." Like what? Like that *wartime* past? Hartman continues: "His [de Man's] essay on Benjamin envisages a temporal repetition that subverts the hope in new beginnings, in a New Era: it subverts a hope, ultimately messianic, that always revives." Messianic hope can be plausibly represented as a dangerous animal, but was it messianic to hope, and to act on the hope, that Europe might be liberated from fascism? Were those actions simply repetition of the same sort of thing? I apologize to my reader for having to put these silly questions. But they arise inevitably from an encounter with Hartman's text.

What are the implications of this account of history, and where do they leave us with the question of the politics of deconstruction? From the terms of the account, they leave us essentially with the politics of the bystander, with the flight from decision, out of the political arena. And into what? The "literary." Hartman tells us that "the only activity that escapes the immediate ideological pressure is art itself whose deeper tradition de Man often cites as able to resist the pressures of the purely contemporary (*l'ingerence* [sic] *de l'actualité*)." This was the mode of de Man's gesture of atonement, of his "act of conscience." The relations between the key terms of this statement ("activity," "immediate ideological pres-

sure," "art," "tradition," "the purely contemporary") are indeed difficult and complex. Hartman's formulation (in particular the question-begging metaphorical "deeper") simply elides these difficulties and complexities in a reduction of "art" to the idea of an "escape." Art, or literature, thus appears as a privileged term in the construction of a generalized skeptical attitude to the category of action itself. As a strategy for questioning primitive conceptions of action (those impossibly paradoxical efforts to conceive action as emptied of the reflective, of that which is both the curse and the blessing of all active human projects), such skepticism can be immensely salutary, and in the detailed analyses and arguments of de Man's work it has often been just that.

The problem with Hartman's representation of this position is that it is made to look paralyzingly indiscriminate. Action is imperfect and incomplete; disaster is always attendant on the move from language into praxis; change is impossible; we are all in the same boat, condemned to repeat (though we can also atone). This generalized skepticism Hartman particularizes by seeing it as a critique of totalitarian programs of action originating in de Man's disillusion with the fascist version of action. But how, in the terms of this account, do we get from particular to general and back again to other particulars? Is it that the fascist compromising of action taints all action, including the action that sought to rid Europe of fascism? Does Hartman believe that? Did de Man? Is that the lesson, that ultimately nothing makes a difference? If so, it is indeed a recipe for passivity, not only saturating the field of action with skeptical agonizing but also homogenizing and equalizing all practical endeavor under the law of eternal repetition. It implies taking and leaving the world as you happen historically to find it, since the attempt to change it only succeeds in repeating the errors you seek to correct. It is not, then, that the intellectual structure of deconstruction has any intrinsic link to fascist ideology (a nonsense) but that, in Hartman's version of it (and his version of de Man's version of it), it promotes detachment from, and hence acceptance of, anything that happens to be the case, including—if that happens to be the case—fascism. If that is what deconstruction is all about (I myself, from the terms of other accounts, would prefer to believe otherwise), then, to coin a trope, forget it.

6

Representing Other Cultures

EDWARD SAID

The occasion for the following remarks on the work of Edward Said is the appearance (in French translation) of his short book *Representations of the Intellectual*.[1] It is the only one of Said's books in which the word "representation" figures in the title, although, as I shall show, the term has a very long reach into the arguments for which he is best known. The book's principal theme—the place of the so-called intellectual in the modern world—is tackled in both theoretical and personal terms, where Said relates several of his own experiences as an "exiled" Palestinian intellectual, the meaning of "exile" being of course one of the central references for understanding his work as a whole and, more particularly, for understanding what is at stake when, notably in *Orientalism*, Said activates the verb "to represent." In certain respects, however, the occasion is far from ideal, since the book cannot be said to count among Said's more impressive efforts. This is doubtless linked to the circumstances of its composition, as a minimally revised version of the BBC Reith Lectures Said gave in 1993. The text was thus originally written for, and accordingly constrained by, the conditions of a radio broadcast, and on reading it in its published form, one has moreover the impression of a job done in some haste.

At the outset, it has to be said that the strictly theoretical contribution adds little to what we already know. Its principal argument rests on a familiar contrast between Antonio Gramsci and Julien Benda and their respective accounts of the role of the intellectual in the network of relations binding the production of knowledge and the interests of power (to which Said adds a third reference, which has been of the utmost importance for many of his writings from *Orientalism* onward: the *savoir-pouvoir* nexus described by Michel Foucault). For Gramsci, working within the terms of Marxism, the category of the intellectual is defined by the notion of function, according to the opposition between the "traditional" intellectual and the "organic" intellectual. The former is absorbed in the production and reproduction of institutionally established knowledge (in the church, the teaching profession, the scientific laboratory, etc.) and enjoys a certain autonomy by virtue of what is culturally and procedurally taken for granted in all forms of established knowledge. The latter, on the other hand, is identified more with a particular organization or cause serving particular interests and thus more directly and visibly involved in the business of legitimation; for better or for worse, the "organic" intellectual is a committed intellectual (to talk the language of Sartre) for whom rhetoric and the arts of persuasion are weapons as important as reason, research, and erudition. Benda, by contrast, is radically antifunctionalist; the intellectual who delivers his knowledge and abilities to either technocratic expertise or ideological legitimation is guilty of "treason." Rooted in the values of an older humanism, Benda defends the idea of the detached, disinterested intellectual who speaks in the name of the universal against the deforming pressures of the interested *parti pris*.

In general, Said places himself on the side of Gramsci, both descriptively (in emphasizing the social and historical situatedness of the intellectual) and evaluatively (in insisting on the importance of that form of the organic intellectual Said calls the "oppositional intellectual," in open warfare with the dominant ideologies of the age). Said's word for both this situatedness and this commitment is "worldliness." It is a term that recurs in many of his works to denote a mode of being in the world (the world of the book *The World, The Text, and the Critic*). Unlike, say, the earth, the world is above all a human entity, a social and historical construction, and we are embedded in this world in ways that prohibit all flight to a position of transcendence. It is therefore not surprising that Said takes his distance from Benda, whose point of view is distinctly unworldly ("cler-

ic" is, unhappily, Benda's ecclesiastical metaphor for the disinterested intellectual). At the same time, however—this is the interesting feature of what is otherwise a somewhat inert presentation—while rejecting as illusory the idea (and the ideal) of the disinterested intellectual, Said blurs his initial contrast by redirecting Benda's quasi-religious stress on disengagement toward the more political notion of exile. The intellectual does not definitively belong anywhere or to anyone, not because he or she is out of the world but because there is no one place of settlement there. The intellectual is, or ought to be, engaged, but the existential and political form of this engagement is to be that of a permanently vigilant wandering. In that respect, one could say that the model of the intellectual valued by Said rejoins the ideal of the critical intellectual described by Isaiah Berlin (whom Said approvingly quotes) in connection with the invention of the idea of the intelligentsia in nineteenth-century Russia, that group of intellectuals denounced by Dostoyevsky as a band of deracinated cosmopolitans (above all Turgenev, whose example is also to be found in the opening chapter of Said's book).

I will return at various junctures to aspects of this little book and in particular to what might be entailed by this attempted marriage of Gramsci and Benda at the altar of nontranscendental exile. For the moment, however, let me note two important absences from its system of references, one theoretical, one historical. The historical framework of Said's overview of the fortunes of the category of the intellectual is highly restricted (essentially, the eighteenth and nineteenth centuries). But if one is going to speak, for example, of the role of the intellectual in practices of legitimation, one has to go much further back, to, say, the sixteenth century, where—as Fernand Braudel reminds us—intellectuals were conspicuously active in rationalizing the legitimacy of the modern state and its ambitions of imperialist expansion; the jurists in particular, above all in Spain and Turkey (the outstanding case was Aboul's-Su'ud under Suleiman), were what in today's terms we would call "functionary" intellectuals.[2]

The great theoretical lacuna is the absence of Max Weber and his reflection on the place of the intellectual in the modern system of the division of labor. Several of Said's themes are eminently Weberian—e.g., specialization and professionalism—but Weber himself is never mentioned. One is indeed tempted to say that Weber is omitted because what he has to say on the topic of the intellectual sits uneasily with some of Said's own theses. When Weber talks of the intellectual in relation to the

phenomenon of specialization, he does not merely have in mind the production of technical or expert knowledge; he also has in his sights the so-called disinterested or oppositional intellectual. Only the modern system of the division of labor could have created the oppositional intellectual, as, precisely, one of the forms of cultural specialization. This way of looking at things has embarrassing consequences for an argument that invests heavily in the idea of the critical intellectual; it is moreover linked to another account of the intellectual that also goes unmentioned by Said, that of Pierre Bourdieu, for whom knowledge is not just something that can be instrumentally placed in the service of power but itself constitutes a form of power, insofar as intellectual products, whether conformist or critical, function as cultural "capital" and as signs of "distinction."

If I mention the absence of Weber from Said's scheme of things, it is not with a view to belittling Said's courageous and indispensable statement of what in our times the intellectual might productively be but rather for analytical reasons: his reflection on the conditions that produce and constrain the situation of the modern intellectual lacks a requisite element of self-reflection, especially regarding the situation of the intellectual in the United States (where Said lives and works). Said in fact deals at some length with the U.S. context, notably in dialogue with the widely read book by Russell Jacoby whose principal theme is a nostalgic lament for the paradise lost inhabited by what Jacoby calls the "public intellectual," long since replaced by the "professional" intellectual largely housed in the contemporary university.[3] Jacoby himself would have done well to think more deeply along Weberian lines; had he done so, it is doubtful whether his idealized version of the preprofessional past would have survived that test. But the counterarguments of Said and others in the United States who have sought to contest this nostalgic myth by distinguishing between a good professionalism (contestatory, with its principal site in the university) and a bad one (conformist and serving the interests of the established order), although perhaps strategically necessary, overlook the history that encompasses both as two sides of the same process of modern specialization. If it is not easy to exile oneself, it is not because one is a hypocrite; it is because the very category of the "outsider" (Said's term) is an invention of the system one is out to contest. Clearly, one does not choose the circumstances imposed by history and within which one is obliged to work; we simply get on with doing what we can. There is nevertheless an obligation to reflect on that imposition

and thus to formulate the paradoxes into which even the most rebellious of oppositional intellectuals is perforce locked.

These paradoxes have some bearing on the arguments for which Said is better known in *Orientalism* and *Culture and Imperialism.* The "of" in the title *Representations of the Intellectual* presumably has a double reference: to the ways in which the category of the intellectual is represented (in, say, the writings of Gramsci and Benda) and to the ways in which intellectuals themselves represent the world. This latter reference is the point of connection with the question that haunts all of Said's work. It is the question that appears toward the end of *Orientalism*: "how does one *represent* other cultures?"[4] The precise formulation of the question tells us a great deal about Said's intellectual career (I use the word "career" in the large sense he himself gives to this word in his remarkable book *Beginnings*).[5] In the first place, it is striking that he uses the term "represent" rather than "interpret" (the term we would normally expect in discussions of this sort). I take it that the point of the substitution is to highlight a double problematic: that of the represented (the object) and that of the representing (the subject who represents). What and whom does this subject "represent"? This question is closely related to the notion of the representative intellectual (drawn from Matthew Arnold's *Culture and Anarchy*), a notion of which Said is extremely suspicious at the time of writing *Orientalism* but to which he curiously proves to be more sympathetic in *Representations of the Intellectual.* Second, Said's question is not how to represent cultures but how to represent *other* cultures. "Other" is the key word, evoking not only the extremely complex category of alterity but also the position from which this word "other" is uttered (other to what and for whom?). The exact representation of this question about representation would therefore be: how to represent a culture that is not "ours" from within a culture that is "ours," where "ours" is placed in quotation marks for the reason that, however much we belong to a culture in ways that condition how we frame questions and answers, our relation to it is in part that of the exile.

In Said's principal writings, the object of this question is "the Orient" and then, more generally, cultures that have undergone the historical experience of imperialism.[6] How to represent other cultures is of course one of the great questions of ethnology and the philosophy of the social sciences, with varying answers along a spectrum of correspondingly various degrees of self-consciousness. The classical answer is the positivist

one, appealing to the idea of an anthropological science and based on the practice of ethnographic fieldwork. One goes to another culture to do research, takes lots of notes, and then returns to write a thesis or a report that is supposed to disclose the truth of the investigated culture. This is the method initiated by the Napoleonic adventure, with the project of the *Dictionnaire de l'Egypte*. At its most naive, this is a form of intellectual tourism; at its most dangerous, it is animated by an impulse homologous to that underlying imperialism: the spirit of conquest (although one must here resist the reduction of a homology to an identity; scholars are not politicians or soldiers).

Today, the positivist reply, at least in its unqualified guises, is generally held, notably by anthropologists themselves, to be derisory. In order to represent other cultures, one has to pass through a social space of interpretation, and the problem consists in knowing whether the space in question blocks in advance interpretative passage, on the grounds that the diverse cultures of the world are autonomous and self-contained conceptual entities that can therefore be understood only from the inside. In its most radical form (often on the basis of an adaptation of Wittgenstein's notions of "forms of life" and "language games"), this is the thesis of the incommensurability and hence the untranslatability of cultures.[7] The equally radical consequence of this thesis is that anything one says about another culture from outside it is necessarily a violation of its conceptual autonomy. A third answer, which simultaneously rejects the scientist naïveté of the first and the hermeneutic pessimism of the second, affirms the possibility of an interpretation that would be less an act of violence than a complex human encounter, a meeting of categories in which there will of course be many cognitive mishits and conflicts of value but where an exchange nevertheless takes place.[8] The space of interpretation remains intact by virtue of something in common, namely, the fact that we are all human, although this something-in-common in no way entails recourse to the assumption of a universal human nature. It is rather, as Bernard Williams has aptly put it, that the existence, for any given culture, of "alien conceptions" does not mean that they are the "conceptions of aliens."[9]

In one way or another, Said's work touches on all these approaches, although sometimes the point of contact is limited or confused (there are very many important works in the epistemology of social explanation to which Said never refers). If I have understood him correctly, it is the third answer that corresponds more or less to the position he finally adopts.

The issue, then, is that of knowing—and perhaps we will never know—what the possibilities of transaction are in the space of intercultural contact, if we accept that differences are real without however hypostasizing these differences into some principle of absolute or incommensurable Difference. I will come back later to Said's way with this position. In his role as a cultural historian, however, it is above all the first answer (the positivist one) that interests Said most, specifically in connection with the historical constitution of the body of disciplines and texts whose object has been "the Orient." In this regard, above all in orientalism, the principal intellectual inspiration comes from Foucault. What Foucault supplies for Said's account is the paradigm of *savoir-pouvoir* (it remains to be seen whether the gift is in part a poisoned one). Western orientalism is a system of representations, often advanced as objective science, that, by virtue of its systematic character, constitutes a "discourse" in the Foucauldian sense, and whose objective is to circumscribe and contain the East, to name, classify, and fix an oriental Other in order to subordinate it, imaginatively and practically, to the authority of a masterful West: "Orientalism, which is the system of European or Western knowledge about the Orient, thus becomes synonymous with European domination of the Orient."

This construction is Janus-faced and at first sight paradoxical: on the one hand, the Orient is an inferior civilization ("barbaric"), and the mission of the West (for example, Napoleon's *mission civilisatrice*) is to redeem it, to bring the light of Enlightenment to the darkness of Islam (the concrete method of salvation being of course physical conquest). On the other hand, oriental culture perhaps holds the key to a wisdom unavailable to secular Western rationality; it is mysterious and poetic, with immensely seductive powers over a certain European imagination. But the paradox is superficial. The barbaric Orient and the poetic Orient are two faces of the same construction; they derive from the same logic: mysterious because other and, because other, inferior, however alluring. Either way, the Orient remains the object of the hypostasizing gaze of the West, which defines and demarcates the field of representation. Promoted in the name of science, the occidental Orient is rather a fantasy, a fiction, and moreover a fiction that is far from disinterested; in its alliance with imperialism, it is a prime example of what Benda would call intellectual "treason."

The publication of *Orientalism* (in 1978) was something of an event, especially as a disturbance to the ideological slumbers of the community

of professional orientalists (its concluding chapter has a particularly sharp political edge). For this reason alone, it perhaps qualifies, in its given field, as a classic: it was decisively new and retrospectively we can now see it as having altered the map of all subsequent discussion. On the other hand, its classic status does not mean that it should be treated as if it were a sacred monument. From a theoretical point of view, there are many problems with the argument of *Orientalism*. I will not dwell on these at great length, partly because this is already familiar territory and partly because I want to address another question that has been relatively effaced in the reception of Said's work (the question of literature). I shall simply note here some of the reservations expressed in one of the rare intelligent criticisms of Said (leaving entirely on one side the innumerable ad hominem attacks motivated for the most part by animosity and ill will), namely, the review of *Orientalism* by the anthropologist James Clifford in his book *The Predicament of Culture*.[10]

Broadly speaking, Clifford criticizes Said from the point of view of four problems of a methodological or epistemological character. First, he questions the legitimacy of the adaptation of Foucault to the project of *Orientalism*, with a particular query as to whether the passage from a corpus of ideas and texts about the Orient to the notion of a "discourse" is justified (Clifford thinks that Said confuses the very different notion of "tradition" with that of "discourse"). Second, he claims that the method of the book—as a description that seeks to circumscribe and hold an orientalist way of thinking that itself seeks to circumscribe and hold its object—reproduces exactly the totalizing gesture it contests and that as a consequence Said remains paradoxically a prisoner of the categories of a Western perspective: "A radical critic of a major component of the Western cultural tradition, Said derives most of his standards from that tradition." In fact this sentence is extremely odd: we would need to inquire further into the meaning of the word "standards," the implications of the adjective "most" (as if "standards" were a sort of collage that one could fashion on a pick-and-mix basis from a global stock), and above all what is understood by "Western." Here Clifford is guilty of an error, at once elementary and serious, for the simple reason that the "standards" in question are by no means a monopoly of the West (the trap of ethnocentrism often lies hidden in the most unlikely of places). His claim does however relate to a third objection, which does need to be taken seriously: Said gives us a version of orientalism that is deformed because it is monolithic. Flaubert's

writing has very little in common with Bulwer-Lytton's, Renan's atti-
tudes differ fundamentally from those of Louis Massignon, and so on.
In other words, Said recycles not only the totalizing but also, and relat-
edly, the essentializing move of the intellectual history he criticizes; he
gives us an alleged essence of Western orientalism and, by extension, an
essence of the West itself.

Fourth, there is the problem of truth. If orientalism is a fiction, then in
the name of what is it to be exposed and denounced as such? What would
qualify as the truth of the Orient? Certainly not a wisdom (which would
simply be to reproduce one of the aspects of the Janus-face of oriental-
ism). Sometimes it appears in Said's text to be an empirical category, what
he calls the "experience" of Orientals themselves, in particular the singu-
larity of individual experience set as a kind of reproach to the ideologi-
cal abstractions of orientalism. For example, Said devotes a chapter to
Marx, whom he alleges to have played into the discourse of orientalism
by abolishing the individual behind abstraction and generalization. But
this argument is weak: the appeal to an empiricism of experience begs the
question, because how are we to have access to this experience other than
by the mediation of interpretative categories? It moreover places Said in
flagrante delicto of self-contradiction: abstraction is not uniquely tied to
oppression; without abstraction, there is no thought at all, and of course
Said's own text swarms with abstractions (it is indeed arguably one of
Said's great strengths that he resists a certain version of the postmodernist
persuasion by holding to the cognitive and political value of intellectual
grand récit).

In sum, these various criticisms of *Orientalism* amount to the charge
that Said's own representation of a particular history of representations
lacks precisely the kinds and degrees of self-consciousness that we have
already seen to be an issue for *Representations of the Intellectual*. On various
occasions Said has responded to these criticisms, generally to repudiate
them (most notably in the "Postface" to the second edition of *Orientalism*).
The tone here can sometimes be slightly impatient, even irritated, as of
someone who feels himself to have been misunderstood. He is not always
very convincing, however. This is not of course a claim about his subjec-
tivity, his intentions; rather, Said's explanation of what he meant to do
often contradicts the logic of his argument. Take two examples. First, the
question of truth: In the "Postface" to the second edition of *Orientalism*
Said says: "I have no interest in, much less capacity for, showing what the
true Orient and Islam really are."[11] But this disclaimer merely displaces the

problem, for problem there certainly is. If the Orient of orientalism is a fiction, one can take the measure of it as fiction only by appeal to a truth, unless one is prepared to adopt the Nietzschean perspective according to which all is fiction and in the conflict of fictions it is not the true but the strong that wins. But this is not Said's point of view.[12] If there are traces of Nietzsche in Said's position, they occur in the form of a diluted or "democratized" Nietzscheanism requiring less the truth of representations than equal access to the stage of public discourse of representations in conflict with one another (for example, rights of access for what in his political journalism he has called the "Palestinian narrative," relatively ignored or even suppressed in the Western media in comparison to the prestige accorded the Israeli narrative). This, however, is simply a demand for fair play and has no bearing as such on the epistemological problematic of representation. In *Orientalism*, the criterion of truth plays an important role, not as general truth but as individual truth, the truth of experience as counterweight to the false and offensive stereotypes produced by Western generalization on the East. But one cannot coherently declare the irrelevance of truth to one's argument while at the same time incorporating an appeal to truth in the unfolding of the actual argument itself.

My second example concerns the accusation of having essentialized the orientalist tradition by virtue of a monolithic reading of it. At a deep level of argument, this charge is laden with far-reaching implication, which can be illustrated by means of a precise comparison between the orientalist thinking of Ernest Renan and Louis Massignon (they figure not only in *Orientalism* but also as the subject of a chapter in *The World, the Text, and the Critic*). In certain (more or less obvious) terms, the Renan-Massignon relation is that of a contrast: Renan, convinced of the superiority of the West, ends in a form of racism; Massignon, on the other hand, is open to the East and even identifies with it. In Said's hands, however, this contrast gets blurred and finally fades, as both are held to be complicit, albeit in different ways, in the creation of an hypostasized oriental Other; where Massignon sees an oriental wisdom he conforms to the logic of the stereotype in its romantic guise, the reverse side of the same racist coin. But this account, which finishes by obliterating difference in versions of cultural difference, fails to resolve a major question (which has nothing to do with a soft-centered liberalism setting nice-guy Massignon against bad-guy Renan). At one level, Said's judgment is unquestionably correct. While saluting both his formidable erudition and his imaginative generosity (and at the same time avoiding the sentimentalism of the

"good" orientalist), Said insists quite rightly on the insurmountable limits of Massignon's vision of the East. But that as such is not at all the question. *The* question—the relevantly deep question—concerns the status of these limits. Are they imposed by the imperialist adventure (as was so obviously the case with Renan, or with Tocqueville on Algeria), or do they stem from the fact that Massignon was not himself an "Oriental"? Do the blind spots in Massignon's vision derive from a contingent fact of history (imperialism) or from an ineluctable fact of the human condition (the fact that Massignon, like all of us, was born into one culture rather than another)? The distinction is of capital importance, unless one is prepared to assume (as Said clearly is not) that in the human condition there is not only a common human nature but one whose commonalities allow all cultures to be mutually transparent one to the other. One cannot see the universe from the point of view of the universe (in the memorable phrase of the philosopher Henry Sidgwick); or, as another philosopher (Thomas Nagel) has put it, there is no such thing, where the encounter of human societies is concerned, as the view from nowhere. If therefore there is a bad ethnocentrism (the sort founded on pure prejudice), there is also an inevitable ethnocentrism tied to the fact that we are obliged to see the world from the point of view of somewhere.

In *Orientalism* and accompanying texts, these crucial distinctions remain, to say the least, somewhat underexamined, as do several other problems generated by the epistemological circle in which the influence of Foucault holds Said captive. In some of his later writings he has tried to break this circle in the name of a more dynamic epistemology and a more fruitful cultural politics. (I will say a few words about these subsequent developments in my concluding remarks.) Breaking the circle is not easy, however; everywhere in one's path there are traps, decoys, and aporias, and, if it is true that Said's work has brought little to the epistemology of the social sciences (he is emphatically not an epistemologist), it can scarcely be claimed that epistemology itself has furnished us with real solutions to the problems of intercultural understanding. The big questions opened by Said's primordial question ("How does one *represent* other cultures?") remain open, in the perspective of an interminable debate, and it is surely not abstract reflection on the a priori conditions of interpretation that will give us the answers we most deeply and urgently need. The only thing that has the slightest chance of giving us that precious resource is concrete and practical transaction between peoples and individuals. And if, in this endeavor, we are to turn to texts as a

source of inspiration, we will probably do better to place our trust less in theoretical philosophy than in imaginative literature and its particular means for dramatizing human encounters and negotiations.

This brings me to a further, and final, question about Said's way with his own question ("How does one *represent* other cultures?"), one that has not attracted the degree of attention it merits: the question of literature. If the relations that one culture maintains with another are to be grasped in terms of representations, it follows that forms of representation as well as the effects of their social diffusion will be at the heart of Said's preoccupations. But that in turn poses special problems of analysis, above all in connection with the textual representations we call literary. Literature indeed occupies a special place in Said's writings (in *Representations of the Intellectual* he declares explicitly that literature is "my particular center of interest"). This should not surprise us, given that Said teaches comparative literature at Columbia University and has published extensively on literary topics. In the sphere of literary criticism Said is without question a formidably sophisticated reader of texts. I am thinking here in particular of his book on Conrad and the quite superb *Beginnings*; in its richly textured combination of theoretical insight—into the meaning of the inaugural moment in the act of writing—and textual analysis, the latter is very probably one of the most important works of literary criticism of our time.

Unhappily, one cannot say the same of the manner in which Said treats literature in his books on orientalism and imperialism. It is in fact, given the importance attached by Said to the principle of representation, one of the most vulnerable points of this dimension of his work. Said fully recognizes that literature constitutes a special case and in *Orientalism* makes this explicit (apropos of Nerval and Flaubert): "What mattered to them was the structure of their work as an independent, aesthetic, and personal fact, and not the ways by which . . . one could effectively dominate or set down the Orient graphically." This states categorically that the literary text or aesthetic artifact is not simply reducible to ideologies of domination, but it does so in terms that are little more than a platitude and moreover a potentially misleading one insofar as his formulation effectively recycles a discredited commonplace regarding the autonomy of the aesthetic. There is of course a literary autonomy, or, more precisely, a specificity, whose character is essential to understanding the role played by literature in the construction of one culture by another. But an

analysis of this specificity is exactly what is missing from the pages of both *Orientalism* and, even more markedly, *Culture and Imperialism*.

Said talks extensively of how Orient and empire are represented *in* literary texts, and he often does so in ways that are extremely illuminating. One thinks, for example, of the fine chapter in *Culture and Imperialism* on Jane Austen's *Mansfield Park* (the Janeites who, somewhat stunned, protested that the colonial reference is marginal to the novel's frame thereby revealed that they had understood nothing, since its importance stems directly from the fact that it is relegated to the margin). But to speak of empire in literary texts is not necessarily the same as speaking of empire as constructed *by* literary texts; the latter would require an analysis of the textuality of the text, it own modes of functioning. This we are rarely given in either *Orientalism* or *Culture and Imperialism*. There is, for example, the important issue of literary genre, initially the category of genre itself. Said never discusses it. The manner in which the formal reality of a genre seeks to grasp and represent another culture demands a reflection on the constitution, and thus the constitutive power, of the genre in question (this has been a very hot question of international cultural politics, as reflected, for instance, in the debates in Africa over the penetration of indigenous literate cultures by the novel, deemed by hostile commentators to be a cultural foreign body by virtue of being a genre of European origin).[13]

Or take the case of lyric poetry. There are many poets in Said's world, but it is only rarely that we encounter poetry, that is, in its reality as poetry (there is nothing, for instance, on what, from the point of view of French orientalism, is the key collection of verse, Hugo's virtuoso text *Les Orientales*).[14] Among other things, Hugo is famously a visual poet, and an account of the structure of artistic visualization (in vital respects quite different from the economy of the scientific gaze) demands not compliments on its status as an "independent, aesthetic, and personal fact" but precisely an analysis. It is moreover striking, given the importance accorded by Foucault to vision and hence to painting, that Said has nothing to say on the visual arts (the oriental pictures of Delacroix or Fromentin, for example) or on the genre of literary picturesque (for instance, Théophile Gautier's *Le Voyage pittoresque en Algérie*). This is not just a matter of range of reference (clearly, one cannot cover everything). Nor—the point bears repeating—is it in the name of an abstract formalism that one might reproach Said for the inadequacy of his analyses. It is exactly the opposite: if, as is the case with Said, much importance is

attached to literature and the arts as forces in the construction of the Other, one is obliged to specify how these forces manifest themselves in terms of their own formal and rhetorical operations; otherwise literature will simply disappear into an undifferentiated and homogenized mass of texts, in which case there is no point whatsoever is distinguishing the literary in the first place.

One also needs to be able to specify the effects produced by these forces, that is, the causal relation of literary culture to imperial expansion. This is an issue raised in another debate about Said's work, the somewhat acerbic review of *Culture and Imperialism* by the philosopher-anthropologist Ernest Gellner (the review triggered an abusive exchange between Gellner and Said, which, it must be said, added virtually nothing of value to the relevant discussion).[15] Gellner criticized *Culture and Imperialism* from essentially two points of view. In the first place, he accused Said of having failed to engage satisfactorily with the historical meaning of the imperial experience (broadly, as a stage in the historical transformation of traditional, agrarian societies into modern, industrial ones). This could indeed be a matter for debate, were it not that Gellner hopelessly compromised his argument by the hair-raising nonchalance he displayed before the suffering this transformation involved for the colonized countries and peoples (his phrase "a temporary imbalance of power" recalls not a little the language of Orwell's doublespeak, mentioned by Said in *Representations of the Intellectual*). Gellner's second, and more interesting, criticism, however, concerns the question of literature. As I mentioned in chapter 4, in *Plough, Sword and Book*, Gellner proposes a model of the motor of history, the three basic components of which are production, coercion, and legitimation.[16] Legitimation (the sphere of representations, texts, ideologies—in short, of culture) is important but distinctly less so than production and coercion. Whence his reservations over the theses of *Culture and Imperialism*, where, according to Gellner, Said seriously overestimates the causal power of literature as a force in imperial conquest. It is certainly true that on this question of literature and historical causality, Said's text leaves much hanging in the air. Take the following, curious sentence from the introduction: "The main battle in imperialism is over land, of course; but when it came to who owned the land, who had the right to settle and work on it, who kept it going, who won it back, and who now plans its future—these issues were reflected, contested, and even for a time decided, in narrative." There is nothing to which one could object in this sentence, apart from its end:

"decided" is strong and, if taken in a causal sense, decidedly false. But in any case, if Said here follows Lucien Goldmann, Raymond Williams, and others in foregrounding a conception of literature as an active force in the social construction of reality, the only way such a hypothesis can be tested is by means of a sociology of reception that would examine the formation of imperialist attitudes by the circulation of literary texts and their influence on the reading public, a project that is entirely absent from Said's work.

In fact, by the time of *Culture and Imperialism*, one senses a certain fatigue with literature, in contradiction with the high value Said's general theses oblige him to assign to it. Too often analysis is replaced by somewhat breathless lists of writers; the canonically complicated cases (such as Montaigne and Joyce)[17] are simply not there; the literary readings are rapidly dispatched and sometimes actively deforming of the texts they address. Consider his account of E. M. Forster's *Passage to India*. Said characterizes *Passage to India* as a novel dominated by an Englishman (Fielding) "who can understand only that India is too vast and baffling, and that a Muslim like Aziz can be befriended only up to a point, since his antagonism to colonialism is so unacceptably silly."[18] But this is a caricatural description of the novel, which not only wipes out the irreducible ambiguity that stems from the contrasting points of view of Fielding and Aziz but also—and more seriously—suppresses the novel's ending, where it is Aziz, not Fielding, who refuses or defers friendship, precisely because of the British colonial presence.

These failures of reading both surprise and depress given what, from previous work, we know of Said's literary capabilities and suggest that, at least where the question of literature is concerned, how "culture" stands with relation to imperialism requires a great deal more thought. But if there are disappointments for us here, there are also invigorating new challenges. If there is a certain lassitude with regard to literature, on the more general question of intercultural contact and understanding in the conditions of the late twentieth century, there is also a new, post-Foucauldian energy. I spoke earlier of the epistemological circle into which Said locked himself with some of the arguments of *Orientalism*. *Culture and Imperialism* is in part the attempt to break this circle, with a powerful case for the possibility of dynamic cultural encounters in the late twentieth century as a way of negotiating the problematic of self and other, however gropingly and of course only on condition that dialogue take place on equal terms (otherwise it is condemned to be a dialogue of

the deaf).Two of the key terms of Said's writing, "worldliness" and "exile," here come together in the context of globalization.

This opening to the possibilities of intercultural dialogue demands a new map of the world, a map that is difficult to imagine and even more so to draw.[19] It would be a map without a master mapmaker and based on a sensibility quite different from the "passion for maps" of which Said speaks in connection with Marlow of Conrad's *Heart of Darkness*. Nor should it be confused with that postmodern version of the tourist brochure inviting us to partake at our leisure of the excitements of the Hybrid (in its consumerist guise, this is ironically part of the legacy of orientalism itself).The forms that might be taken by the dialectic or dialogue of self and other, sameness and difference, are entirely unpredictable and certainly saturated with difficulty and paradox, of which perhaps the most intractable is the famous paradox of ethnocentrism.This is the paradox that uncomfortably unsettles the pluralist rejection of the idea of cultural superiority: if, in the name of respect for other cultures, we celebrate tolerance, does this not inevitably reinstate a hierarchy: tolerant cultures are superior to intolerant ones? Indeed it is doubtless in function of this paradox that Said, while denouncing the ethnocentrism of Western orientalism, has also refused any complicity with nativist nationalisms and fundamentalisms.

This is the sort of paradox that would have delighted Voltaire (whose example, specifically the Voltaire of the Calas affair, Said approvingly cites in *Representations of the Intellectual* as one of the models of the enlightened intellectual). Since Voltaire was one of the great figures of the Enlightenment that furnished in part the ideological justification of Napoleon's *mission civilisatrice* in Egypt, this inclusion in Said's pantheon may cause some surprise. It is entirely comprehensible, however, and suggests moreover a further analogy. I am tempted to say that it is to the age of Enlightenment that mutatis mutandis Said in fact finally belongs. Perhaps not exactly alongside Voltaire (since, as Roland Barthes pointed out, in Voltaire's works one travels a lot without ever leaving home). Rather the comparison that comes to mind is with Diderot.[20] Naturally, to conclude by electing this Palestinian-American an honorary Frenchman is prima facie bizarre. Not of course any Frenchman (for example, those fine republicans who, in the name of the *loi républicaine*, recently sought to expel the *sans-papiers*). And I doubt if Said himself would find the thought anything other than laughable, above all when I recall how he compliments Massignon for having transcended "the local anecdotal circumstances of a Frenchman and French society."

In any case, with this suggested comparison I do not mean to say, with Clifford, that Said's thinking is rooted in a Western or European discourse (since I am really not sure what these terms mean). I am referring here less to a geography or a culture than to a style. Diderot is the oppositional intellectual par excellence, a voluntary exile within the structures and institutions of his society. More important, Diderot is an exile not only in relation to the great institutions of eighteenth-century orthodoxy but in his very mode of thought, in perpetual movement, fluid, mobile, nomadic, a thought that goes in all directions, that is based on dialogue, and that is above all exiled, or rather self-exiling, in its love of paradox (for example, the effervescent and destabilizing paradoxes of the *Supplément au voyage de Bougainville*). Said's thought is also constitutively mobile, traveling not just between cultures but also between interests and disciplines. Said is not a philosopher in the sense of systematic philosophy or even a theoretician. He is an essayist, in the strong, Montaignian sense and, like Diderot, committed to intellectual experiment and adventure. It is accordingly that he writes, in the introduction to the collection of essays *The World, the Text and the Critic*: "For if I am to be taken seriously as saying that secular criticism deals with local and worldly situations, and that it is constitutively opposed to the production of massive, hermetic systems, then it must follow that the essay—a comparatively short, investigative, radically skeptical form—is the principal way in which to write criticism."[21] *Orientalism* and *Culture and Imperialism* are important interventions in spheres where the West has sought to blind itself to its own history, and they are therefore the books that have had the greatest impact. But arguably they are not in fact Said's best. The best, in my opinion, is the teeming collection *The World, the Text and the Critic*, a text that, in the vitality of its border crossing and its restless contempt for all settled orthodoxies, produces the hybrid as distinct from merely talking about it.

The essay is, then, a "radically skeptical" form, bent on disrupting and dislodging intellectual sedentarities wherever they are to be found. Diderot writes in the *Pensées philosophiques*: "*Tous* les peuples ont de ces faits, à qui, pour être merveilleux, il ne manque que d'être vrais; avec lesquels on démontre tout, mais qu'on ne prouve point; qu'on n'ose nier sans être impie, et qu'on ne peut croire sans être imbécile" (*All* peoples hold to things that are marvelous only on condition that they are not true, with which one demonstrates everything but proves nothing, that one cannot deny without being impious, and that are impossible to believe without being stupid) (my italics).[22] I emphasize *tous* for a some-

what dispiriting reason that prompts a final analogy between Diderot and Said: The French parliament condemned the *Pensées philosophiques* to be burnt in 1746. Said, who, in the name of dialogue, has assumed for so long the difficult paradox of pleading as an exile for the cause of the Palestinian homeland, recently suffered the bitterly ironic fate of seeing, as a result of his public disagreements with Arafat, his books withdrawn from sale by the Palestinian authority in Gaza and the West Bank.[23] This act of censorship, hardly encouraging for the situation of the oppositional intellectual, may however encourage us to carry forward another of Diderot's maxims: "Le scepticisme est le premier pas vers la vérité" (Skepticism is the first step toward truth).[24]

7

Representation or Embodiment?

WALTER BENJAMIN AND THE POLITICS
OF *CORRESPONDANCES*

"It is characteristic of philosophical writing that it must continually confront the question of *Darstellung*." This—the opening sentence of the "Epistemo-Critical Prologue" to *The Origin of German Tragic Drama*—is arguably the most important and philosophically freighted sentence in the entire Benjaminian oeuvre. In quoting it in English translation I have left the original *Darstellung*, because the way this particular word—with a long history in German philosophy and aesthetics—is translated at once raises and potentially begs many questions: is it better translated as "representation" or as "presentation"? The published translation has "representation," which does indeed correspond to one of the senses of the German (for example, a theatrical representation), and, on the back of this rendering, strong claims have been entered regarding the character of Benjamin's thought in general. Susan Handelman, for instance, unambiguously opts for "representation": "The term *representation* is critical here. . . . This emphasis on representation distinguishes Benjamin from Heidegger and from many mystical theories of language."[1]

In many ways, Handelman is ultimately right, but, if she is right, it is for the wrong reasons. For in her eagerness to place Benjamin on the side of representation, she fails to address what is or might be implied by

Benjamin's original German: the use of the term "*Darstellung*" rather than the more standard *Vorstellung*. For those like Handelman who would effectively collapse this distinction, *Darstellung* is at best an uneasy semantic brother to *Vorstellung*. More commonly, in the relevant tradition of German thought to which Benjamin in so many ways belongs,[2] the relation is one of opposition. Both Paul Ricoeur and Louis Althusser variously emphasize the importance in the work of Hegel and Marx of this opposition. Ricoeur insists that "representation" is a mistranslation of *Darstellung*, while Althusser too argues that *Darstellung* is more appropriately associated with notions of presentation and presence, an immediacy of comprehension as against the mediated and distorting realm of *Vorstellung*, the sphere of ideology.[3] This in turn suggests a grounding of the relevant tradition in what Michael Sprinker calls "the domain of the aesthetic as a general epistemological category" and would therefore take us back to the origins of the tradition in German aesthetic theory, notably to Schiller's notion of *darstellend denken* as the modality of art (a phrase that Wilkinson and Willoughby translate as "presentational thinking").[4]

From there we might find ourselves looping back to Heidegger (and Benjamin). *Darstellung* makes fairly few appearances in Heidegger alongside the repeated, and repeatedly negative, appearances of the term "*Vorstellung*" (the index to the McQuarrie edition of *Being and Time* has no entry for *Darstellung*). *Vorstellung* is the term for what Heidegger calls "enframing," the stance of the age of the world picture and the modern obsession with enclosing, taming, and dominating nature examined in *The Question Concerning Technology*. Against the split and divided regime of *Vorstellung*, however, there is "another *Stellen* . . . namely that producing and presenting (*Her-und-Dar-stellen*), which, in the sense of poiesis, lets what presences come forth into unconcealment." Poiesis is that which "lets what presences come forth into appearance."[5]

Benjamin's use of the term "*Darstellung*" would seem to be in many ways close to Heidegger's poiesis. Indeed even Handelman, anxious to oppose the two, argues that what distinguishes Benjamin from Heidegger (representation as construction, specifically as configuration or "constellation") is best understood by way of an analogy with Mallarmé's poetics, where constellation becomes "illumination" ("the idea of an illumination which appears from the interrelations of words themselves"). Making sense of that analogy, however, with its foregrounding of the aesthetic over the cognitive/conceptual, seriously damages the very opposition the argument seeks to sustain. We would then perhaps do better to

follow here the example of the translator of Hans-Jost Frey's remarkable essay on the "Epistemo-Critical Prologue" and render *Darstellung* not as representation but as presentation. *Darstellung*, in Frey's (translated) words, is that which "is without mediation."[6] In the terms of Frey's brilliant account, Benjamin's thought thus emerges as in fact radically antirepresentational, geared rather to notions of showing, making visible, shining forth ("I have nothing to say, only to show," as Benjamin put it in connection with the Arcades Project) and hence to notions of immanence, immediacy, and embodiment.

Against the background of these preliminary remarks on terminology, the Arcades Project is what I am principally concerned with in this chapter, although in terms of a set of references that might be cause for some surprise. As is well known, Benjamin had a highly developed taste, even a genius, for the aleatory. Sniffing out the more obscure corners and recesses of modernity, he would stumble by chance, or at least as if by chance, on the thing that could be guaranteed to take you by surprise, that jolts you into a question, or a questioning frame of mind, and a new awareness of the phenomenon under investigation. This aspect is integral to the Benjaminian method, a key component of his micrology, and doubtless owes much to his contact with the surrealist interest in the "objet trouvé" and what André Breton called (somewhat opaquely) "objective chance." The alliance of the aleatory with the fragmentary (the fragmentary style of his writing) is also one of the reasons why Benjamin is so difficult to read. The surprise is often delivered in the form of a logical or syntactic ellipsis or, even more radically, without any accompanying contextualization at all, presented without commentary, surrounded, so to speak, with silence.

It is not my purpose to try to emulate Benjamin's method here. I mention it, however, because it is relevant to my topic in a way that we shall shortly see. The topic itself is a familiar one: the topic of *correspondances*, a doctrine and practice associated in particular with Baudelaire and that I want in part to consider in relation to Benjamin (or, rather, Benjamin's relation to it) by way of an equally familiar, though notoriously difficult constellation of concepts binding together notions of language and signification, symbol and allegory, the city and the commodity, and melancholy and exile, as some of the founding terms of Benjamin's engagement with modernity. But I want to begin with, and (after various detours) finally return to, a point or moment in this constellation that is not par-

ticularly familiar, that indeed to my knowledge has not been addressed in the commentaries on Benjamin (although there is much, especially in German, that I have not read). This moment is the moment of surprise. Encountering it is likely to stop one dead in one's tracks, making one wonder what Benjamin thought he was up to in the relevant notation and generating a range of questions, the answers to which are far from obvious (they certainly cannot be short-circuited in the way Handelman proposes).

I refer to the curious moment in the Baudelaire section of the Arcades Project when Benjamin, in a discussion of *correspondances*, dredges up from his tireless excavations of the resources of the Bibliothèque Nationale a quotation from the work of the late-eighteenth-century/ early-nineteenth-century ultra–right-wing thinker Joseph de Maistre. De Maistre was a reactionary theocrat, best known for his hostility to the French Revolution and modernity generally. His extraordinary book *Considérations sur la France actuelle* argues a Catholic-providentialist view of the Revolution as divinely inspired catastrophe. According to de Maistre, the Revolution ended logically in the Terror or, rather, teleologically: the excesses of the Terror accomplish a telos whereby God simultaneously punishes France for having embraced the secular values of the Enlightenment and saves France from revolution by ensuring that it falls apart in murderous excess. In this sense the revolutionaries are the unwitting instruments of divine will, in a kind of bizarre reverse Panglossianism. De Maistre's recipe for a return to order is a massively repressive ideological and judicial state apparatus run by a theocratic priesthood and a vigorously active public executioner.

Benjamin probably found himself reading and thinking about de Maistre as a result of his immersion in Baudelaire (the quirkily reactionary Baudelaire of the Second Empire was increasingly drawn to the radically antiliberal views of de Maistre). But this sort of more or less predictable contextualization is not at all my concern here (that would be more the routine business of scholarly editorship of Benjamin's work), and moreover it still leaves a large surplus for interpretation. For Benjamin here is not quoting de Maistre's views on revolution, modernity, the state, capital punishment, and so forth; he is quoting de Maistre on the doctrine of *correspondances* and moreover contextualizing the quotation in terms of what we know to have been one of his own major concerns, notably, the difference between symbol and allegory. Here is the relevant passage:

In einer bedeutenden Stelle bei De Maistre tritt nicht nur die Allegorie ihrer satanischen Provenienz nach und ganz mit den Augen, mit denen später Baudelaire sie sah, auf, sondern es erscheinen auch—in Anlehnung an die martinistische oder svedenborgsche Mystik—die *correspondances*. Und zwar bilden sie aufschlussreicher Weise den Widerpart der Allegorie. Die Stelle befindet sich im achten Gespräch der Soirées und heisst:

> On peut se former une idée parfaitement juste de l'univers en le voyant sous l'aspect d'un vaste cabinet d'histoire naturelle ébranlé par un tremblement de terre. La porte est ouverte et brisée; il n'y a plus de fenêtres; des armoires entières sont tombées; d'autres pendent encore à des fiches prêtes à se détacher. Des coquillages ont roulé dans la salle des minéraux, et le nid d'un colibri repose sur la tête d'un crocodile. Cependant quel insensé pourrait douter de l'intention primitive, ou croire que l'édifice fut construit dans cet état? . . . L'ordre est aussi visible que le désordre; et l'oeil, en se promenant dans ce vaste temple de la nature, rétablit sans peine tout ce qu'un agent funeste a brisé, ou faussé, ou souillé, ou déplacé. Il y a plus: regardez de près, et déjà vous reconnaîtrez une main réparatrice. Quelques poutres sont étayées; on a pratiqué des routes au milieu des décombres; et dans la confusion générale, une foule d'*analogues* ont déjà repris leur place et se touchent.[7]

(In an important text by Joseph de Maistre we see appearing not only the figure of allegory, displaying its satanic provenance in the same perspective that will later be Baudelaire's, but also the doctrine of *correspondances* inspired by the mysticism of Saint-Martin and Swedenborg. The latter constitutes, in a revealing fashion, the counterpart to allegory. This text is to be found in the eighth of the *Soirées de Saint-Petersbourg* and reads as follows:

> One can form a perfectly exact idea of the universe by seeing it in the light of a vast exhibition room of natural history shattered by an earthquake. The door is open and broken; there are no more windows; entire cupboards have collapsed; others hang from pegs about to come loose. Sea shells have rolled into the room devoted to minerals, and the nest of a hummingbird rests on a crocodile's head. Nevertheless, what madman could entertain doubts as to the original intention or believe that the edifice was constructed in

this state? . . . Order is as visible as disorder; and the eye, in survey-ing this vast temple of nature, reestablishes without difficulty everything that a baneful agent has broken or falsified or soiled or displaced. There is more: look closely, and already you will recog-nize a reparative hand. Some of the beams are propped up; path-ways have been made in the middle of the rubble; and, in the gen-eral confusion, a host of *analogies* have already taken up their place again and enter into contact with one another.)

My question, then, is what do we do with this moment? What I want to do with it is to orient Benjamin's thinking about *correspondances* toward an intersection of aesthetics and politics. Given the characteristic ellipses of Benjamin's thought, this is not easy to do. One must often proceed by way of inference and even sheer guesswork. What follows is by and large just that.

Let us first recall the doctrine of *correspondances* as it works in Benjamin's principal source, Baudelaire. Crudely sketched, *correspon-dances* in Baudelaire's aesthetic and critical writings occupy three dimensions: psychological, aesthetic, and metaphysical. The psycholog-ical dimension has to do with the theory of perception known techni-cally as synesthesia, that is, the process whereby one order of sense per-ception can evoke or be translated into another (the olfactory evoking the visual, the visual evoking the auditory, and so on). The aesthetic dimension concerns the mutual suggestibility and convertibility of the arts, whereby, for example, the colors of painting can evoke the tonali-ties of music and vice versa, a notion that will be formalized in the Wagnerian and symbolist idea of the total work of art (the model of the *Gesamtkunstwerk* described in Wagner's theoretical writings already sug-gests a link with a certain politics of a rather alarming sort, the totali-tarian sort, the link proposed by Adorno in his book on Wagner). Finally, there is the metaphysical dimension, which derives from a tra-dition of counter-Enlightenment mystical thought running from Jacob Boehme through Swedenborg into the nineteenth century. The key notion here is that of a system of correspondences uniting the earthly and the transcendental, the material and the spiritual, a symbolic or ana-logical language given by God to man before the Fall and ensuring an unbroken passage from the natural to the divine. The system occupies a vertical axis, so to speak, in which it functions simultaneously as both *archē* and *telos*, origin and terminus of the meaning of the cosmos. This is the metaphysical doctrine that Baudelaire refers to in his essay on

Victor Hugo as the God-given "universelle analogie" and in part enacts in the famous sonnet "Correspondances" through the image of nature as a "forest of symbols."

These various axes of the theory of *correspondances* converge on a term central to Baudelaire's aesthetics and to several branches of nineteenth-century thought generally, including social and political thought. This term is "harmony," a musical analogy appropriated by Baudelaire as early as the 1845 Salon as the foundation of a whole aesthetic. As the analogy implies, the purpose of art is to unify and synthesize, to overcome division and fragmentation and replace discord with concord. I shall return to this word, "harmony," toward the end of this chapter.

These then are, at least in part, the terms on which Benjamin discusses the principle of *correspondances* in the work of Baudelaire. For Benjamin, *correspondances* in Baudelaire are geared to a project of repairing broken experience ("the *correspondances* record a concept of experience," in the richly integrating sense given to "experience" by the German term *Erfahrung*).[8] The psychological mechanism that generates the process is that of memory; "*correspondances*," writes Benjamin, "are the data of remembrance" (141). Thus *correspondances*, allied to the work of memory, effect and embody a return to a point of origin, a first moment of happily undivided being. In Baudelaire this is characteristically thematized as a recovery of childhood ("l'enfance retrouvée à volonté," as he put it in the essay on Delacroix) or more generally a prelapsarian condition, whose mythical form in our culture is the Garden of Eden, the paradise lost of, say, the poem in *Les Fleurs du Mal* with its evocation of "les paradis parfumés . . . le vert paradis des amours enfantines." Lyric poetry based on *correspondances* is the royal road of retrospective access to a lost harmony of being, staged, for instance, in a poem such as "Parfum exotique," a poetic text constructed as a synesthetic network of analogies converting one order of sensation into another, whose point of origin is contact with a woman's breast ("Quand, les deux yeux fermés, en un soir chaud d'automne, je respire l'odeur de ton sein chaleureux"), generally identified as the breast of a lover but just as plausibly associated with a fantasy of return to the maternal body.

This use of the principle of *correspondances* to evoke or even re-create a lost unity is visibly regressive. In the conditions of modernity the structure of *Erfahrung* is a fictive one, shadowed by nostalgia for "something irretrievably lost" (139). Benjamin thus sees it in relation to Baudelaire as a form of wish fulfillment and self-protection, reflecting an effort to

repackage a fractured self in what he calls a "crisis-proof form" (140), that is, one that will protect the psyche from the shocks inflicted by the conditions of modern life, especially in the great city. Under this description, the principle of *correspondances* attracts therefore an essentially negative valuation: it is neither adult nor honest. But if it does so, this is to some extent against the grain of some of Benjamin's other tendencies and commitments, above all those associated with the so-called mystic side of Benjamin revealed crucially in the relation between his theory of language and a theory of the symbol.

For Benjamin, the mystic plays with a view of language in terms reminiscent of the doctrine of *correspondances*. Michael Jennings, for example, quotes Benjamin as committed to a belief in a network of "secret affinities" underlying "a spiritual and psychological connection of man to his world,," the phrase "secret affinities" being a direct echo of Théophile Gautier's "affinités secrètes," Gautier in turn being one of Baudelaire's main precursors.[9] The secret affinities between things are also part of the ground of Benjamin's version of the symbol. In Benjamin's writings (notably in the three essays "On the Mimetic Faculty," "On Language in General and the Language of Man," and "Doctrine of the Similar"), the notion of the symbol is articulated by way of nomination, a primary act of nomination that finds or forges a unity of matter and spirit: "Only through the linguistic essence of things can man reach outside himself to knowledge of them—in the Name."[10] This is Benjamin's version of linguistic Cratylism, or, since it is less Plato than Hamann who serves as a source here, a version of the Adamic origin of language as a form of primordial naming.

Another name for *the* Name is the symbol, and it is on the side of the symbol that *correspondances* belongs.[11] If the impulse behind *correspondances* is to repair broken experience, to make whole what has been splintered by time and history, *correspondances* partakes of the unified, atemporal status of the symbol, in which psyche and body are not divided, signifier and signified are not split; where representation is also presentation or, better, embodiment, in the sense of the presence in the sign of what the sign denotes.[12] Thus, just as the metaphysical dimension of *correspondances* belongs to romantic pantheism, whereby the divine is everywhere present in the natural, so its literary correlate derives from a romantic aesthetic ideology that dreams of an original moment of unmediated expression in which word and thing, meaning and form, appearance and essence are one.

The problems with this imagining of an original linguistic or signify-

ing condition of man are of course notorious: at best it is a speculative fable; at worst an empty fantasy. In any case, if paradise is where we once were, it is not where we are now or are likely to be. The messianic side of Benjamin holds out the possibility that history might lead to a reopening of the gates of Eden, a belief linked to the well-known notion of criticism as *Rettung* and the redemptive theory of language and culture. On the other hand, the catastrophistic vision of history sketched in *Theses on the Philosophy of History* suggests that the possibility is remote. Certainly the gates are emphatically shut to what Benjamin calls modernity, a world the gods have long since abandoned (and here Benjamin is close to Hölderlin) to the realities of division: division of labor, division of the psyche, division of the sign. In these conditions, the language(s) of man is not the language of symbiotic nomination, the consubstantiation of word and thing. It is an instrument of exchange, where signs are abstract and arbitrary (in the Saussurian sense), tokens subject to the law of substitutability, the language not of Eden but of the Tower of Babel.

For Benjamin, modernity means many things but supremely the historically proximate modernity of capitalism and the culture of the commodity form. Benjamin's reflection on the phantasmagoria of the commodity and its relation to the respective regimes of symbol and allegory is of course a much-discussed subject, and I myself have nothing new to add. Indeed the path I want to go down is somewhat different. But in order to gain access to this path, it is necessary to cross that (deceptively) familiar terrain by way of a few preliminary remarks. The first is quite simply that some people appear to believe that mapping this terrain is itself quite simple. It is not, or if it is, a lot of interpretative clearing-away has to be done in the face of what look like some rather formidable confusions. Some of the statements of the Arcades Project look strictly contradictory, such that the distinction between symbol and allegory and thus the pertinent relation with the phantasmagoria of commodity form get somewhat blurred. For example, at one point Benjamin makes the following claim: "Baudelaire idealises the experience of the commodity by assigning to it as a paradigm the experience of allegory" (J 66,1). And later in the same section of the Arcades Project: "The model of [Baudelairian reverie], allegory, corresponded perfectly to the fetishism of the commodity" (J 79a, 4).

On the face of it, these claims look bizarre. For, as Benjamin argues elsewhere, allegory does not idealize the commodity; on the contrary, it demystifies it. Relatedly, allegory does not provide a model of commod-

ity fetishism; rather, it exposes the fetishistic character of the commodity that the commodity form itself seeks to disguise. There are therefore prima facie contradictions here, which the experts will doubtless continue to argue over. For my purposes, I take it that the general thrust of Benjamin's argument is that the mode of expression most closely aligned with commodity is in fact the symbol. This of course seems initially a perverse alignment. The symbol and the commodity would appear to be exact opposites, reverse mirror images of one another: the symbol is pure transparency, the site of "real presences" (to use George Steiner's phrase); the commodity is a lie, a pretense, a simulacrum of the symbol inducing a kind of hypnosis in which we confuse appearance for essence (what Susan Buck-Morss in her commentary on Benjamin has called "the magic-lantern show of optical illusions").[13] But what if the symbol were also a lie, itself a form of phantasmagoria, a kind of seductive magic-lantern show?[14] Indeed the word "magic," which is so important in Marx's analysis of the commodity, is also an important term in Baudelaire's aesthetics, most notably in connection with the place of *correspondances* in his conception of lyric poetry. Poetry is famously for Baudelaire "une magie suggestive" and "une sorcellerie évocatoire" and underpins a view of the function of poetry as the attempted reenchantment (in the full, quasi-magical sense of "reenchant") of the disenchanted world of modernity. As such, its seductiveness is also shadowed by an anxiety, the fear that poetry is but a box of tricks, a source of illusions, precisely, like the commodity, a magic-lantern show and thus object of irony.

Irony lies on the side of allegory, and the function of allegory is to tell the truth of commodity; its role is to "clear the entire ground and rid it of the underbrush of delusion and myth" (N 1,4). Allegory does not idealize the commodity form; rather, it discloses the arbitrariness and artifice masked by the phantasmagoria of the fetish and shows that the meaning of the commodity is not something inherent to it but constituted by a logic of equivalence and exchange whereby meanings can fluctuate in the same way as prices: "Modes of signification change almost as fast as the price of commodities. In fact, the meaning of the commodity is its price; as commodity, it has no other. It is for this reason that the allegorist is in his element with the commodity" (J 80, 2). Allegory, then, is a form of antimagical thought, geared to disenchantment, to loss, exile, melancholy, and mourning for our expulsion from the paradise celebrated by the strategy of poetic *correspondances*. It restores

human creations to time, decay, and lack, the lack of fit between the material and the transcendental.

In Baudelaire this translates, at the level of poetic practice, into a double negative move away from the euphoria otherwise invested in *correspondances*. The first, which is not noted by Benjamin himself, is the partial collapse of the rhetorical economy of *correspondances* in, for example, the famous sonnet called "Correspondances." I mean here the movement in the poem, analyzed by Paul de Man, whereby the rhetorical-syntactic pivot of the poem, the word "comme" that holds together the poem's analogical structure, finally collapses in the last tercet where the last instance of the word is no longer a term of analogy but the grammatically quite different, and semantically far more inert, term of a pure enumeration, of a list rather than a comparison.[15] The second move is the one noted by Benjamin, namely, the shifting of the construction of *correspondances* from symbol to allegory, from the natural world to the man-made world of artifice, exposing the manufactured character of the poetic text in the age of manufacturing itself. *Correspondances* are thus transformed and demystified by virtue of their insertion into the contingent origins of human fabrication. As such they are severed from any putative connection with a divine and timeless origin. They now belong irredeemably to time and history and thus, in the Benjaminian scheme of things, to the syndrome of ruins and the destruction of harmony. As he puts it in the *Central Park* text, "Baudelaire's allegory bears . . . traces of a wrath that was at such a pitch as to break into this world and leave its harmonious structures in ruins."[16] Under the allegorical dispensation, Baudelaire's world is shadowed by the specter of ruination, the exhaustion that, as Benjamin also phrases it, puts "centuries" between the present and the preceding moment, a jaded form of *différance*, enabling the distinctive move whereby Baudelaire will place what Benjamin calls "antiquity" into the very heart of modernity.

In summary, it is possible therefore to postulate a relation between *correspondances*, the symbol and the commodity, whereby *correspondances* become an object or a category that falls under suspicion as a form of mystification and is finally wrecked by the countervailing power of allegory. This, however, is only one chapter of the relevant story. And the plot, so to speak, thickens somewhat in the other chapter, the one that particularly concerns me here, and will lead us back to my point of departure in the writings of Joseph de Maistre. For if the economy of the symbol and of

correspondances is complicit in the ideology of the commodity, how is it that the doctrine of *correspondances* proved so attractive to bodies of thought resolutely hostile to the forms of social modernity that produced the culture of the commodity, the tradition of anti-Enlightenment and anticapitalist critique that, in its English versions, was described by Raymond Williams in his book *Culture and Society*?

This question brings us to the intersection of aesthetics and politics I mentioned at the beginning. Where Benjamin is concerned, it takes us potentially down (at least) two paths. One is by way of early-nineteenth-century utopian social thought, especially the writings of Fourier. Fourier adapted to a form of social theory and historical prophecy the very term that Baudelaire used in constructing his early conception of lyric poetry: namely, the term "harmony." Harmony, the Harmonien Order in Fourier's phrase—the physical expression of which is the communitarian model of the phalanstery—is what will replace the disorders of what Fourier calls *Civilisation*. Civilization is what we in turn, with Benjamin, would call capitalism, the rationalized system of the modern division of labor and specialization of function, the society of rights, contracts, and competitive individualism that generates the systems of circulation and exchange that confer such prestige on the commodity; in short, the replacement of *Gemeinschaft* by *Gesellschaft*, a replacement that Fourier's scheme seeks to invert in a projection toward a utopian future that will recover a paradise lost.

For my purposes, the important point here is that the principle of *correspondances* plays a founding role in the construction of this scenario. The theoretical foundations of Fourier's model of society are openly metaphysical, even cosmological, and rest on the idea of a primordial unity given to man by God, the form of which is that of universal analogy or what he relatedly terms "attraction." Analogies, similarities, resemblances are what bind the cosmos, as well as humans to the cosmos and to each other, in a spirit of cooperation perverted and destroyed by the advent of *Civilisation*. There is also, although it is merely incidental to Fourier's main concerns, an aesthetics of *correspondances* (somewhere he sketches a literary version of *correspondances* around the idea of a kind of prose poetry that, as a network of analogically interactive terms, would be an artistic analogy for the utopian community).

We know of course that Baudelaire, pre-1848, was greatly interested in Fourier, and we also know that so too was Benjamin. Fourier's writings figure substantially in the Arcades Project, and, in connection with

Benjamin's contacts with French surrealism, notably the splinter group around Georges Bataille, Klossowski has informed us that in the group's meetings with Benjamin what they most wanted to discuss with him was his interest in Fourier.[17] But Baudelaire was soon to abandon his interest in Fourier (his references to Fourier after 1848 are almost without exception unambiguously contemptuous), moving toward a quite different politics, and it is unlikely that Benjamin could have been in thrall for long to Fourier's vision of the reopening of the gates of paradise. For if Fourier looks to the future, he does so, as it were, with a backward glance to an ontology of origins. The Fourierist utopia is not just a creation but also a recovery of a unity written into the world by God and subsequently lost by man.

Organicist imaginings of a prelapsarian human society are very much part of the tradition of anti-Enlightenment critique from the late eighteenth century onward, and they are often quite deeply reactionary in their political drift. This is the second of the two paths down which the doctrine of *correspondances* can lead us. Joseph de Maistre belongs, in his peculiarly hysterical way, to this tradition, and if Baudelaire becomes increasingly interested in de Maistre, it is because he too in his later years reacts against the secularized, commodified order of capitalist modernity in terms that could themselves be described as hysterically reactionary, were it not that the hysteria is generally contained by a quirky and often unreadably opaque mode of irony.

This is how or where we might begin to make sense of the politics of *correspondances*, of the appearance of de Maistre in Benjamin's researches, and finally of Benjamin's own growing skepticism vis-à-vis a doctrine that elsewhere, and especially in his theories of language, had so tempted him. For there is also a theory of language in the work of de Maistre—or, rather, a theory of the origins of language—that closely resembles the Cratylist/Adamic fantasy to which, via Hamann, Benjamin himself had been drawn. In his historico-political-metaphysical treatise *Essai sur le principe générateur des constitutions politiques* (which picks up some of the arguments of the earlier *Considérations sur la France actuelle*), de Maistre devotes several chapters to questions of language and signification. In the beginning, there is the name, and the name is proffered by God ("Dieu seul a droit de donner un *nom*" [God alone has the right to confer a name]).[18] Names are not arbitrary signs ("les noms ne sont nullement arbitraires" [names are in no way arbitrary] [86]); they are iconically or onomatopoetically motivated, that is, they resemble or, better, embody in

their very materiality what they designate. This theory of the name also involves a prioritizing of speech over writing. Speech is the living language, divinely originated messages encoded on human breath; writing, on the other hand, is a dead letter, and the death of living human institutions ("le néant de l'écriture dans les grandes institutions" [the nothingness of writing in great institutions] [40]).

Here, then, we have a version of human society based on a divinely authored and authorized logos.[19] It is of course an anti-Enlightenment theory, an attack on conventionalist accounts of language geared to instrumentality and exchange and cognate with the rationalized, secular modern economy of exchange. Modernity, in the de Maistrian view, is a version of the Fall, a fall from grace or, in an interesting reappearance of the key term from Baudelaire's aesthetic of *correspondances*, a loss or diminution of "harmony": "La note tonique du système de notre création ayant baissé, toutes les autres ont baissé proportionellement, suivant les règles de l'harmonie" (The tonic note of our system of creation having dropped, all the others have followed proportionately, according to the rules of harmony).[20]

If this is to be read as a critique of the destruction of *Gemeinschaft* by an alienating and reifying *Gesellschaft*, it is very difficult to read it with any degree of sympathy.[21] In de Maistre's scheme of things, the prestige of the divinely authored Name is characteristically conferred on the warrior class, the victors and the conquerors, as a reward for their exploits, and it is further associated politically with the construction of the nation-state: "Et, moi, je crois, et même je sais que nulle institution humaine n'est durable si elle n'a une base religieuse; et de plus (je prie qu'on fasse bien attention à ceci), *si elle ne porte un nom pris dans une langue nationale, et né de lui-même, sans aucune délibération antérieure et connue*" (And, for myself, I believe and even know that no human institution can last if it does not have a religious basis, and moreover (I beg my reader to pay special attention to this), *if it does not bear a name taken from a national language and born of itself, without any anterior and known deliberation*) (85–86). Here is the dream of a language linked to a purified body politic, purified by violence and maintained by repression. De Maistre's view of the God-sanctioned and well-regulated society is a thoroughly punitive one, an ur-version of what today we would call a politics of totalitarianism.[22]

This may well return us, under a very particular light, to the moment in the Arcades Project where Benjamin cites de Maistre on *correspondances* and suggests a relation with the question of symbol and allegory. The pol-

itics of the symbol would appear as a politics of embodiment (the signi-
fied in the signifier), the archform of embodiment being the state. This
was also a theme of German romantic thought in the production of what
de Man termed aesthetic ideology and that he held to stand in an inti-
mate relation to twentieth-century fascism. This is a deeply controversial
proposition, and I must immediately say that the line of reasoning that
matches Schiller to Goebbels and sees romantic aesthetic ideology as
leading straight to the extermination camps is not only silly but frankly
disreputable, especially insofar as it displays the very properties of
anachronistic and teleological thinking that de Man in a deconstructive
mood was so anxious to reject. Nevertheless a link of some sort in
Benjamin's mind between the symbol and totalitarian politics seems to
have been active around the time of the Arcades Project, in particular
bound to what Benjamin was to call the aestheticization of politics under
fascism. There is of course a theoretical alternative to making sense of
Benjamin's reference to de Maistre. It scarcely bears imagining though
perhaps has to be imagined: namely, reading Benjamin's brief encounter
with de Maistre as sympathetic. That in turn would mean having to
accept that there is in fact an authoritarian politics in Benjamin, given a
left spin and explicitly opposed to fascism but in its logical structure akin
to the "political theology" of Carl Schmitt (who was himself a great
admirer of de Maistre).[23]

I have argued here for a more skeptical and secular Benjamin, though
perhaps at the cost of making him, implausibly, a child of the
Enlightenment. Certainly, to get from the doctrine of *correspondances* to
this is a very large step, and I am acutely conscious of having taken short-
cuts or having leapt over the ground with gaping holes beneath my feet.
What I have proposed is an antitheological reading of Benjamin, but this
is predicated on a controversial set of claims regarding the status of the
theological in Benjamin; in the relevant set of terms (the paradisiac, the
fallen, and the messianic), it is unclear whether Paradise, the Fall, and the
Messiah designate historical categories (to do with what comes before
and after) or psychological and experiential ones, as metaphors in a phe-
nomenology of the structure of desire and memory. But the case I have
outlined does seem to me to be at least a possible point of departure, a
working hypothesis, for making sense of this otherwise odd, slightly baf-
fling moment in the Arcades Project.

8

God's Secret

REFLECTIONS ON REALISM

I have to begin on what might seem a potentially discouraging note by remarking that, in a project devoted to discussing the idea of mimesis and commemorating the magisterial work of Erich Auerbach, I shall not really be talking about either, although I hope it can be taken more or less for granted that the shadow of Auerbach looms over virtually everything I will be saying.[1] My concern is broadly speaking with certain intellectual developments post-Auerbach, in connection with the concept of realism, historically and theoretically a subspecies of the concept of mimesis. The two—mimesis and realism—are often used as if they were interchangeable. They are not of course interchangeable, but they are very closely related, such that when, for example, Lukács talks of realism as a dynamic projection of the underlying historical forms of the social world he is talking in a way that in its deep conceptual structure is very like Aristotle's way with mimesis as a dynamic cognitive system (or at least the version of Aristotle on mimesis emphasized by Paul Ricoeur in *Time and Narrative*).

In this connection, I am also struck by the move Auerbach makes in the closing pages of *Mimesis*, where the term that dominates in this summing-up moment is not mimesis but indeed realism. Describing and jus-

tifying his method—the use of short passages from which is exfoliated a vast panorama of the history of the representation of reality in Western literature or, in a term I shall revert to again, a method based on the use of the figure of synecdoche, the token standing for a more general type— he distinguishes his method from the project of doing what he calls "a history of European realism" and, in the epilogue, "a systematic and complete history of realism."[2] Here, in this discussion of methodology, the commanding term of the title of his book—mimesis—has been displaced by realism, referring not to a local history from, say, the eighteenth-century onward but to the *whole* history, from Homer to Virginia Woolf, that has constituted the purview of the book. Auerbach himself thus basically conflates the two concepts.

In any case, realism is my topic, and in essentially two contexts: first, as a kind of stock taking of the recent fortunes of the concept; second, and relatedly, as a revisiting of some of the basic intellectual moves that found the concept, in particular the way in which the idea of literary realism has been consistently motivated theoretically by means of an appeal to a set of *visual* analogies (I mean in ways much deeper and more far-reaching than the restricted, though interesting notion of *ekphrasis*).[3] Auerbach's own relation to the visual analogy, to the idea of writing as a form of picturing, is ambiguous. But we might provisionally put down as an initial marker the fact that the point of departure of Auerbach's whole investigation crucially turns on a moment of visual experience and moreover a visual experience relating to a scene of recognition (the recognition of Odysseus by his scar), recognitive experience being fundamental to several of the arguments to which I shall allude (perhaps most notably Raymond Williams's observations on the social function of representational art in *The Long Revolution*). We might also recall here the absolutely strategic value attached to vision in the brilliant chapter on the memoirs of Saint-Simon in Auerbach's book, the way the whole analysis of Saint-Simon's manner of moving from notation of the particular to evocation of the general, precisely from token to type, individual to history, revolves around a stress on the language of sight and insight, as if seeing were the very ground of understanding and representation. We might also recall here Auerbach's remarks on Balzac: Balzac's address to what Auerbach calls "the mimetic imagination of the reader" is defined as an appeal to "memory-pictures," which could of course be one way, a mentalist-pictorialist way, of describing literary art as based on the production and reproduction of recognition scenes.[4]

These, then, are my two principal purposes: a review of a recent intellectual history and a return to some founding conceptual and analogical moves. Realism, as a literary-cultural concept, has had a strange history. Not the least interesting feature of that history is that it is not yet over; despite many modernist and postmodernist declarations of its death, the concept has an uncanny capacity for springing Lazarus-like back to life, returning again and again to the agenda of discussion. For if it appeared to have been escorted definitively offstage by the high modernism of the early twentieth century, how then is it that the question of realism remains so actively central, though subject to varying evaluations, in the late twentieth century, in, say, the critical work of Roland Barthes or Raymond Williams? What exactly is at stake in these constantly renewed returns? One line of interest has been strictly scholarly, as part of the continuing endeavor to explore a historical field (generally as cases, in the New Historicist style, from the relevant archive of representations, on a spectrum from texts to museums). It is of course no accident if "relevant" here has meant essentially the nineteenth century and in particular nineteenth-century France: the exemplary place and moment of what we conventionally understand as the great tradition of realism (what Engels, in the well-known letter to Miss Harkness, called "the triumph of realism").

Yet the history in question is not simply archival. Viewed as a cultural history in the broadest sense, it displays the following, somewhat paradoxical property: if the nineteenth century is the age of the flowering of realism as a set of literary and pictorial practices, it is not the age of its sophisticated theoretical articulation (famously, the nineteenth century, whether in terms of defense or attack, theorized the idea of realism in exceptionally naive terms). As developed concept, realism belongs rather to the twentieth century, in the form of the abiding, even obsessive returns to which I have referred. Here we can distinguish at least three key moments of inquiry and evaluation. First, there is the moment of Marxism, notably the elaboration and defense of the idea of realism in the later work of Georg Lukács, where it is promoted as epistemologically and aesthetically superior to an allegedly antirealist modernism. This is a line of argument continued in the work of Raymond Williams, with the added twist, however, that much of the modernism rejected by Lukács (for example, Proust and Joyce) is incorporated by Williams as an experimental, if problematic, extension of the realist canon itself.

The broad shape of Lukács's argument rests on the category of the

type or the typical. The type is a kind of microcosm, a representative example formed as a combination across different levels of narrative articulation (plot, character, background, etc.), of moments that, in their combination, give a powerfully coherent account of the basic forms and patterns of life at a particular historical juncture and thus reveal the world, or a part of the world, in its inner principle of intelligibility. In this view, representation in literary realism is a mode of understanding; it is accorded very strong interpretive-cognitive values. It is a view whose intellectual pedigree derives from the totalizing ambitions of Hegel and Marx, and it is also in this tradition that one would, I think, locate Auerbach, not only by virtue of his own interest in the use of the typical moment in literature to express a wider configuration of historical and social experience but by virtue of his very method, his own use of the representative example (the extract) as a kind of synecdoche for the much larger story he tells.

There was (and still is), however, a problem in all this, namely, what is the exact status of the allegedly representative or synecdochic example? What is the meaning of the example? What are the grounds of its representative value? What and where is the principle that allows for the unproblematic passage from microcosm to macrocosm? Does not the argument imply both the possibility of a transcendent order of knowledge and the primacy of a transcendent knowing subject, a privileged form of the Hegelian *Geist* ensuring and authorizing the relation of microcosm to macrocosm?

The potentially idealist (and ideological) implications of this view are part of the concerns of the second influential moment in the twentieth-century way with realism, the moment of structuralism and poststructuralism, developed largely as critique of the idea of realism, most influentially in Barthes's seminal *S/Z*, arguably *the* critical-theoretical text of and for the post-1968 generation. Barthes's key move was to look at realism less in terms of substantive representational claims than as forms of representation, constructed and constructing practices, that characteristically (like the accompanying panoply of legitimating theoretical ideas) presented the forms as if they were substances or, in the well-known semiological formulation, "convert culture into nature." Literary realism in short was the cultural brother of ideology or more accurately was itself an ideological operator performing the primary task of ideology: naturalizing socially and historically produced systems of meaning. The distance of Barthes's approach from that of Lukács is conveniently measured by

contrasting the latter's attachment to the category of the type, as the very ground of representation, with the former's insistence on the stereotype, as the mark of realism's incorrigible complicity in the conservatism and bad faith of ideology. Realism, in Barthes's view, traffics in the stereotype, in culturally solidified and ideologically congealed systems of knowledge, what Barthes, following Aristotle, calls "doxa," forms of common belief and reference that naturalize a particular construction of reality.

Third, there was—and continues to be—the moment of feminism, often in harness with critical themes from poststructuralism and notably in a particularly active deployment of issues and categories from psycho-analysis, the basic drift of which has been to align the representational strategies of realism with the production and reproduction of the ideo-logical terms of patriarchy. This last moment is one that will especially preoccupy me here, above all by virtue of its strong focus on the body, on the tracing of representation from and across the body.

In distinguishing these three exemplary moments, one should be wary of drawing too neatly differentiated a map or too simple a set of endorse-ments. The picture is more complex. It does not, for instance, form a sim-ple chronology; there are many relations of overlap between all three. There are also intellectual convergences, as well as some knots and tan-gles. For example, if Barthes's literary semiology is to be read, at one level, *against* Lukács, it does so to some considerable extent from within the space of Marxism, especially—as a form of critical analysis (what in *Mythologies* Barthes called a "semioclasm") concerned with ideology—in its use of notions from Marx's *The German Ideology*. Or again, if we think of psychoanalytical theory as a major modernist source for disrupting the field of representation (through the agency of unconscious desire), what do we make of Raymond Williams's curious suggestion that the best way to read the Freudian text is as a realist novel? Is this merely a perverse antimodernism, anxious to hold on to the realist canon at all costs? Or does it direct attention toward a subtler and more tenacious life within the concept of realism to which we must attend?

One shortcut for gaining some initial purchase on these different questions and problems is by way of a form of shorthand within many of the arguments and positions themselves. It is probably no accident that one proper name recurs throughout the history and variety of debate: the name of Balzac. For Lukács, Balzac is the quintessential representative of the great realist tradition. For Barthes—analyzing the story *Sarrasine* in *S/Z*—Balzac stands for the intimate relation between literary realism and

the workings of ideology (the "cultural codes"). In certain feminist argu-
ments, Balzac is the pure demonstration of the relation between the order
of realism and the order of patriarchy (Balzac characteristically fantasizes
the artist on analogies with the father, the king, the emperor, and God);
indeed in one version of the feminist case, even to *speak* of Balzac today
(rather than of, say, George Sand), whatever the actual terms of the criti-
cal discourse in question, is to perpetuate a system of thought and values
from which we need urgently to free ourselves (by speaking instead of,
say, George Sand). This seems, however, a somewhat rigid polarization of
the matter. Much is lost in simplifying Balzac as "Balzac," as a metonym
displaying exactly the same fetishizing and immobilizing force associated
with the method of metonymic nomination that Jakobson advanced as
the basic technique of realism itself.

 In returning to the example of Balzac, I want to speak briefly of one
particular text, a narrative about painting and painters: that relatively
unknown masterpiece situated at the edge of the *Comédie humaine* called
The Unknown Masterpiece. Let me begin, however, with a scene of read-
ing, the scene of another painter reading Balzac's story. In his *Souvenirs sur
Paul Cézanne*, Emile Bernard records a conversation in which he raised
with the painter the topic of Balzac's story. Cézanne, who had a copy of
the book "tout fripé, sali et décousu" (crumpled, soiled, and unstitched)
almost permanently at his bedside, said not a word but rose to his feet,
pointing agitatedly and tearfully at himself: "Il se leva de table, se dressa
devant moi, et frappant sa poitrine avec son index, il s'accusa, sans un mot,
mais par son geste multiplié, le personnage du roman. Il en était si ému
que des larmes emplissaient ses yeux" (he rose from the table, drew him-
self up in front of me, and, striking his chest with his index finger, he
declared himself, without a word but by his repeated gesture, to be the
character in the novel. He was so moved by this that tears filled his eyes).
I shall discuss later how this was not the only thing that happened to
Cézanne's eyes on contact with Balzac's book, but this episode alone
already speaks of a deeply powerful identification with Balzac's story of
the seventeenth-century fictional painter Frenhofer, who spends ten
years trying to create the perfect picture of a woman but ends up paint-
ing what in the story itself (which mixes fiction with seventeenth-centu-
ry fact) the young Nicholas Poussin describes as "nothing but confused
masses of colour contained by a multitude of strange lines forming a high
wall of paint."

 Cézanne's identification with Frenhofer thus suggests that Balzac's

narrative is appropriately seen not in relation to doctrines of realism but as an anticipation of the adventure of modern painting. It is, however, unlikely—to use the absurd conditional perfect—that Balzac himself would have approved of this alignment with modernism. In the preface to another work he described *Le Chef d'oeuvre inconnu* as a cautionary tale designed to illustrate "the laws that produce the suicide of art." This is emphatically not a case of "Frenhofer, c'est moi" but rather the robustly commonsensical approach of a writer who, despite the famously exotic accoutrements of his work (monk's habit, nocturnal regime, and endless cups of black coffee), nevertheless construed work itself on the model of the industrious bourgeois; who perceived himself as less the Frenhofer (or the Napoleon) than the César Birotteau of art, for whom getting the job done was the task at hand and for whom the main danger was not derailment by demonic possession but exhaustion from overwork. But if that interpretation has encouraged an interpretation of the story as the embodiment of what Frank Kermode (in *Romantic Image*) calls an "error" and a "failure," this edits out all manner of ambiguity and complexity. For instance, whatever we think has happened on the canvas that the other two painters in the story find unintelligible (a reaction that precipitates Frenhofer's death and the destruction of his whole oeuvre), there is nevertheless a substantial oeuvre: Frenhofer's studio seems as packed with pictures as the *Comédie humaine* with novels, and according to the two other painters, they all—apart from the final picture—seem to be masterpieces. Whatever Frenhofer's "problem," it doesn't appear to be his work rate or the quality of his output.

This suggests that we should vote against the cautious standpoint and add our voice to the growing body of opinion (since 1980 there have been no fewer than four major books devoted to reinterpreting this relatively short narrative) that there is more to it than meets the skeptical eye and that the drama of Frenhofer's wilder brush strokes can be anachronistically aligned with later art and notions of art. For example, in this story where sexual feeling and fantasy everywhere inform the activity of painting, we may find ourselves thinking of Picasso (Picasso was also obsessed with Frenhofer and did the illustrations for the Vollard edition of the story). More generally, anachronistic reading is legitimized by the text itself. Although the topics it rehearses were not alien to seventeenth-century discourse on painting (Balzac was almost certainly acquainted with Félibien's *Entretiens*), the seventeenth-century setting

serves primarily as a narrative distancing device for a reference that is clearly contemporary, namely, that version of the nineteenth-century quarrel of the ancients and the moderns that we know as the neoclassical versus romantic controversy over the respective merits of line and color. Frenhofer is unambiguously of the color party and, in this respect, a reflection of what Balzac would have learnt from Delacroix, Gautier, and the Hugo cenacle (it was Hugo who was to call for an artist willing to put "chaos in his brushes"). On the other hand, an aftereffect of Balzac's own use of backward anachronism (projecting the nineteenth century into the seventeenth) is that later readers have felt entirely at ease with running the anachronism forward and seeing the text as a prophetic anticipation of the terms of twentieth-century painting, what Rilke called Balzac's "unbelievable visions of future evolutions," a future that will include not only Cézanne and Picasso but also abstract expressionism (de Kooning was also greatly taken with the story and claimed that it was a preimagining of cubism).

Balzac's text, however, is not only a document for intellectual and art history but also a story, a narrative performance that needs to be described and evaluated in appropriately literary critical terms. Harold Rosenberg tells us (in *The Anxious Object*) that de Kooning's interest in the tale arose against a background of anxiety over the painting of the series known as "The Woman." "The Woman" or, in Jacques Lacan's self-erasing phrase, "T̶h̶e̶ Woman," is what *Le Chef d'oeuvre inconnu*, as both narrative and art theory, is all about. As narrative, the text turns on a withholding of secrets and their partial disclosure in an act of exchange (in this respect it resembles the structure of *Sarrasine* as analyzed by Roland Barthes and especially the operation of what Barthes calls the hermeneutic code). The secrets are in part trade secrets and thus elements of an initiation story emphasizing the theme of the new autonomy of the artist (Frenhofer is described as representing "art with its secrets, its passions, its reveries"). But the secrets in question evolve around a very particular artistic question (how to paint the female nude), and the reveries are visibly erotic. Frenhofer treats the woman in his picture as if she were a clandestine mistress (as indeed the model herself was while alive), and his reluctance to show the picture to Poussin and Porbus is overcome only in return for the loan of Gillette—herself both model and mistress to Poussin—in the effort to finish his picture. Poussin agrees to the exchange but against both the wishes of Gillette and his own judgment

or, rather, his fears (Poussin's fear is that Gillette's naked body will be defiled by exposure to the gaze of another artist).

Gillette (*Gillette* was initially one of the titles given to the story by Balzac) thus functions as the object of a troubled transaction in which art and sex become inextricably entangled: Poussin looks at Frenhofer looking at Gillette and "a thousand scruples tortured his heart when he saw the old man's rejuvenated eye undress, so to speak—as painters do—the young girl and guess the secrets of her curves and shapes." The secrets, then, are secrets of sexuality, and in that magnificently equivocal sentence the narrator's own manner of speaking ("so to speak") molds itself to the hesitancies and ambiguities that surround the painting in the story. For representing female form in paint is not just a matter of creating an image based on what Frenhofer calls "the laws of anatomy." It is also the enterprise that Frenhofer grandly calls the painter's attempt to "steal" nothing less than "God's secret," to master a sexuality posed as radically other, as a mysterious essence and ground of being; or, to return to the terms of Lacan's paper ("God and the *jouissance* of the Woman"), Balzac's painter is in thrall to the alleged mystery of sexual difference. God's secret is, as Lacan puts it, that "face of the Other," the "Godface as supported by feminine *jouissance*," around which male fantasy hopelessly turns in pursuit of an ever-elusive knowledge (and it may be interestingly recalled here that one of Lacan's illustrative examples in his essay is a work of art, Bernini's sculpture of St. Theresa in a mystico-erotic trance).

Le Chef d'oeuvre inconnu is thus a story in which artistic and erotic interests converge in a scopic regime of desire, knowledge, and representation. The relation of the male artist to the female nude is not just one of sexually interested looking (wanting what he paints) but also of *looking at sexuality itself* (wanting a knowledge he can get into paint). The desired secret is not the desire of the female body as such but the action of the male gaze on the desire of the female body, wanting to know the flesh of woman as it reacts to being looked at by the male. It is no wonder therefore that the narrative is also a story of possessiveness, jealousy, and rivalry and that it ends in all-around disaster: the death of one of the artists and (as Barthes would have put it) the "castration" of the other (Poussin, whose desire for Gillette is fatally wounded by his deal with Frenhofer). It also, as narrative, has an appropriately emasculating effect on its (male?) readers. Its high point is—as so often in Balzac—a moment of low melodrama: the absurd "keyhole" situation where

Poussin and Porbus wait outside Frenhofer's studio, both listening intently, Poussin dagger in hand, while Frenhofer paints Gillette: "The two men, as they stood in the shadow, resembled two conspirators awaiting the hour to strike a tyrant down." But what they wait to see they never see, and nor do we, the readers of the tale. Instead we have a superb narrative ellipsis. The next sentence is " 'Come in, come in,' said the old man to them, glowing with delight." The story thus simultaneously hints at and withholds what we want to know or alternatively implies—in a perspective of parodic demystification—that perhaps in fact there is *nothing* to know.

"Nothing" however is itself an ambiguous term. Of the "missing element" in Porbus's painting of *Marie L'Egyptienne*, Frenhofer says that "nothing is everything." No-thing is of course another figure in the representation of female sexuality, torment to the male artist by virtue of being a visual zero. Here then is a book about a crisis of representation, but where the essential attempted move by the artist is not in fact beyond the figure toward abstraction but rather deep into the figure and its secret life, from the surface forms of anatomy to the inside of flesh, to the pulse and rhythms of blood. "You give your woman beautiful robes of flesh," says Frenhofer, again of Porbus's picture, "but where is the blood?" Red is indeed the color that dominates the text, as both artist's pigment and bodily symptom (the characters blush a lot in the story). It is also the color of seeing exhausted or agitated by its efforts to seize the object, that is, the color of bloodshot eyes (a fact Georges Didi-Huberman makes much of in his extraordinarily brilliant account of *Le Chef d'oeuvre inconnu* in *La Peinture incarnée*). This moreover takes me back to where I began, to the example of Cézanne, not, however, to the pathos of his mute identification with Frenhofer but to the report of a more disturbing experience, starting with bloodshot eyes and veering toward delirium and madness: "Et les yeux, n'est-ce pas? ma femme me le dit, me sortent de la tête, sont injectés de sang. . . . Ils sont tellement collés au point que je regarde qu'il semble qu'ils vont saigner. Une espèce d'ivresse, d'extase me fait chanceler comme dans un brouillard, lorsque je me lève de ma toile. . . . Dites, est-ce que je ne suis pas un peu fou? . . . L'idée fixe de la peinture . . . Frenhofer" (And the eyes, no? my wife informs me, start out from my head, are bloodshot. . . . They are so glued to the point at which I am looking that it seems that they are about to bleed. A form of intoxication, of ecstasy, makes me totter as if in a fog, when I rise from my canvas. . . . Tell me, am I not a little mad? . . . The obsession of painting . . . Frenhofer).

What then might be the moral of all this, the implications for a more general view of the conceptual underpinnings of Balzac's art and more specifically for what we understand by literary realism? Balzac's magnificent tale of passion, madness, and death turns on an issue of representation, specifically the representation of a female body by a male painter, and I want to claim that this gives us a set of terms for thinking about the problematics of realism. There are several reasons why the story of Balzac's crazy painter may serve as a parable or allegory of realism. One concerns its use of the visual arts not simply as a contingent literary representation of the act of painting but because the visual arts work importantly as an analogy for literary representation itself, as based on a tacit but founding invitation to visualization (realism invites us above all to look at the world and as such is part of the more general culture of modernity that Heidegger defined as the Age of the World Picture). A second reason has to with the object of representation: the body, specifically the female body. At his most euphoric, Frenhofer describes his project, in one of many feverish speeches to his two colleagues, as nothing other than the attempt to "steal God's secret," thus at a stroke (a brush stroke, one is tempted to say) aligning representation, metaphysics, and sexuality. For, as we have already seen, "God's secret" here is an alleged "essence" of "Woman," and the project of pictorial representation is the effort to master a sexuality posed as radically other, as a mysterious essence and metaphysical ground of being. This again is a far from contingently chosen object but reaches deep into the logic and structure of representation. It is also, for example, part of the lesson of Barthes's *S/Z*, where the bar between the two letters signifies the slash of gender and the barrier of sexual difference: Sarrasine and Zambinella, the former another male artist (a sculptor) obsessed with the body of Zambinella but in the form of a category mistake (Zambinella is a castrato taken for a woman). The question of sexual difference is thus at the very heart of the text, not only thematically but also formally, in its constitution as text, notably at that level of organization commanded by the "symbolic code." The "symbolic" in Barthes's scheme of five basic codes governing the realist text is understood in a roughly Lévi-Straussian and Lacanian sense, the symbolic order based on very general binary oppositions, crucially the binary system of sexual difference (which, however, as a "limit-text," *Sarrasine* does as much to disrupt as to confirm).

In this view, questions of the body, gender, and sexuality are not just themes of the realist corpus; they connect with basic presuppositions and

furnish constitutive categories. They give flesh, so to speak, to what else-
where (in the essay "Diderot, Brecht, Eisenstein") Barthes describes more
abstractly as the "triangular" model of realist representation: a subject posi-
tioned as a viewer carves out a field shaped as a triangle with the viewer's
eyes as the apex.[5] This of course recalls the classical model of perspective
and shows why analogies with vision and the visual are so important (in
Barthes's scheme the visual reference covers the nonvisual arts as well). In
this account, realism is best understood as an economy of positions and
drives based on the relation of actual or imaginary looking, an economy
where there is typically, or stereotypically, a male looker (painter, narrator,
etc.) and where one of the privileged objects of vision is the body of a
woman. The latter attracts the gaze of the former as the figure of the mys-
tery of sexual difference, as the figure of the origin, the ground of the sym-
bolic order. In the case of painting, the two most notorious nineteenth-
century images of the female body are Manet's *Olympia* and Courbet's
aptly named *L'Origine du monde*; in the former, the woman's left hand lies
flexed over the genitalia as a provocative game of hide-and-seek with the
imperative to look, a secret withheld (or perhaps as a tongue-in-cheek
statement to the effect that there is no secret other than in the head of the
viewer); in the latter (the original of which disappeared immediately into
the private collection of its—male—commissioner), the focus of the gaze
is fully on the female genitalia, though as dark continent, thus leaving end-
lessly open the question as to whether the term of its title, "origin," is
intended ironically or is merely the symptom of a scopic, voyeuristic inter-
est in the object that steers close to the idiom of pornography.

It is therefore of considerable significance that in so many of the rele-
vant nineteenth-century images and representations the naked female
body should figure so frequently as object of display or spectacle. The
archive continuously discloses its own secret or rather its abiding preoc-
cupation with a secret. It is a preoccupation also shadowed by an anxiety,
the anxiety that God's secret might turn out to be unmanageably dan-
gerous (in Balzac's story it generates rivalry, hatred, violence, madness, and
death). This is one reason why the grounding analogy between the writ-
ten and the visual in the theoretical articulation of realism is not simply
a theoretical point but also connects with a precise cultural and institu-
tional politics; for example, the various nineteenth-century literary trials
turned to a large extent on the prosecution's claim that the texts in ques-
tion contained dangerous solicitations to visualization, notably focused
on questions of the body and sexuality.

The body and sexuality thus hold out the promise of contact with an origin, anchoring the representation of reality in the ultimate unveiling of a truth (in terms of ancient thought, the moment of *aletheia* or *anagnorisis* or, in Barthes's system, the moment of the fulfillment of the hermeneutic code). But that truth (if such it is) threatens mayhem and panic. Plato famously fears mimesis because it menaces the body politic with noxious fakes. It is less commonly remarked that mimesis is also feared because of an association with the uterus (Plato's example in censuring mimesis is the practice of the womenfolk telling "emotional" stories to children) or more accurately with the uterus convulsed (Maxime du Camp described the body in Courbet's picture as "convulsé"), with, that is, the condition of hysteria.[6] For all the confidence of its presuppositions, models, and strategies, realism's engagement with the female body is permanently accompanied by the worry of something running out of control, at once fueling and exceeding the will to truth and knowledge. "Woman" is always a point of trouble for the classic tradition of realist writing and is one reason why so many of the relevant narratives are stories of female adultery and families falling apart, with a corresponding stress on the containing authority of the male sexual body (the phallus), the emphasis in and on narrative—crucially the tradition of the European *Bildungsroman*—as the story of socialization into the order of property, filiation, and descent commanded by the Name of the Father (literally the transmission of the name through the line of inheritance that so often forms the backbone of the plots of European narrative). The *Bildungsroman* is, as it were, the other side of the coin to the anxiety represented by what Freud called the *Familenroman*, the former being part of the symbolic apparatus for covering over what is revealed in the fantasy structure of the latter, namely, the knowledge that there is no knowledge, that, in Freud's curious slippage into Latin, *pater semper incertus est*.

Here then is the deep ambiguity of the project of realism, predicated on a desire for stable knowledge while encountering the conditions of its impossibility. The ambiguity is not, however, a contradiction, or, if so, it is a dialectical contradiction in the sense that the conflicting terms are the mutually constitutive terms of a general logic. Whether as drive to mastery or encounter with the unmasterable, realism is involved in the production of knowledge regimes across the body as an economy of the knowable and the unknowable, each reinforcing the other. This is Foucault's principal point regarding the historical culture that produced simultaneously the modern discourses of both realism and sexuality. The

common assumption is that the body, in particular the female body, houses a mystery, an enigma wrapped around an essence, that may or may not be known but supplies the key to being.

Freeing ourselves from these metaphysical and ideological notions of hidden essence and suchlike has been at the forefront of contemporary critical theory and literary practice. But the offered terms of opposition and rejection are themselves problematical and raise questions that bear directly on how we might continue to understand the idea of realism today. For example, the notion of essence attaches controversially to one of the principal spokeswomen for the antirealist critique in the name of, precisely, the body, Hélène Cixous. As is well known (notably from the essay "Le Rire de la Méduse"), one of Cixous's concerns is to bring writing back to the reality of the body in ways that liberate both, the body and the text freed from the systems of control and syndromes of paranoia into which they have been allegedly locked by the traditional practices of literary realism. But this immediately raises a question as to whether in this version the body reappears, in what is otherwise proposed as an antifoundationalist aesthetic of dispersal, as yet again a kind of foundation, a guarantee of contact with the real, and more precisely as a kind of origin. Does the place of the body in Cixous's argument in effect involve not so much a rejection of realism as its redefinition in late-twentieth-century conditions? Might we not be tempted to say that the argument that demands a return of writing to the pulses and rhythms of the body, and in particular the female body, is an argument in defense of a feminist realism (were it not that this might start to sound like a parody of Polonius's proliferating distinctions)?

In several of its aspects, Cixous's argument certainly looks like this. Indeed in one vital respect it even comes across as *plus royaliste que le roi*, and that is in its very deployment of the category of the body itself. For the text Cixous envisages is not merely about the body, it is itself a body ("texte, mon corps"), the body of the text as material incarnation and end to the regime of the arbitrariness of the sign. This desired relation between body and text is one way of stating one of the wildest dreams of realism, the dream according to which representation becomes embodiment, in which the text no longer stands for something but is itself a presentation of that of which it speaks. As she puts it in one of her essays, significantly titled "Le dernier tableau ou le portrait de Dieu," it is the dream of a writing that would be a "présent absolu," where the "présent" and the presentation in question would be the movements of bodily sensation

and perception (the aesthetic act thus restoring something of the old sense of *aesthesis*). In the conception of such a project it is therefore perhaps no surprise that the terms of both God and painting should reappear, commanding not only the title of the essay but also its whole argument. The notion of God's portrait, in which we might *see* God ("voir Dieu," she writes, again evoking the relation of looking and seeing), is a figure for an ideal of material incarnation and the ground of an analogy between writing and painting: "Je voudrais écrire comme un peintre. Je voudrais écrire comme peindre" (I would like to write like a painter. I would like to write as if painting).[7]

The idea here of a painterly writing is not at all that of mere description. It is rather the idea of a performatively embodying writing that will close the gap between words and things, signs and sensations, body and soul. This uncannily recalls, though in a very different register, the project of Balzac's Frenhofer to put onto canvas "God's secret." It also confirms the importance of the painterly analogy in the deep structure of thinking and fantasizing about realism, not simply as imperative to look but also, and more radically, as desire for embodiment. For painting or the visual arts generally are the closest we get to (the illusion of) an art of embodiment, above all when their object is the body, human flesh itself. Cixous thinks of Cézanne as she meditates on the theme of "God's portrait"; Cézanne was obsessed with Frenhofer; Frenhofer in turn is obsessed with Titian; and it is Titian's way with flesh and blood that inspired the astonishing remark by his contemporary Dolce: "It is to me as if Titian in painting this body has used flesh to make his colours."[8] This both reverses and abolishes the normal view of signification and representation as a system of substitutions; it thinks not of paint substituting for blood but of blood being paint. One could scarcely imagine a more dramatic statement of the idea of art as a making incarnate, as body, pure and simple.

Does all this then serve to confirm the stubbornly enduring life of the idea of realism, along with its incurable complicities with metaphysical essentialism and foundationalism? Or are there still further possibilities within the idea to be retrieved and explored? Raymond Williams, for example, also insisted on a relation between the body, language, and knowledge, specifically knowledge of the social and its articulations as active experience. This web of relations enters decisively into his account of both the novel and the drama in the nineteenth and twentieth centuries, where the categories of the body and of knowledge converge in the complex existential and historical weave that Williams named the

"structure of feeling." From within this structure, the plots of literary realism are identified as forms that actively make possible certain kinds of understanding of the social world. In this respect Williams is close to Bakhtin as well as to Lukács and against Foucault (or, rather, a polemically simplified version of Foucault). Knowledge is not so much knowledge that incarcerates in the prevailing forms of the symbolic order as knowledge of *what* incarcerates in that order. It gives us ways of understanding that order. It works by making connections that are otherwise hidden from view in the mystificatory moves of ideology (for example, the knowledge of the city made possible by the plots of Dickens's novels).

The connecting energies of realism may well be a value to hold on to in the continuing debate, in counterpoint to the fashionable emphases on dispersal and fragmentation. This notion may also help us make sense of Williams's otherwise curious remark, to which I referred earlier, about reading Freud as a realist novel. For it is worth remembering, against the grain of those (often very persuasive) readings of Freud as protomodernist—all laterality, textual expansion, digression, and tangle—that the word "connection" is a very powerful one in the Freudian narrative and analytical lexicon (it appears literally dozens of time in the Dora story). Thus, if psychoanalysis is to be one of the paradigms of a questioning of the realist paradigm, then a veritable Pandora's box is opened, out of which tumble all sorts of intractable and intriguing paradoxes. The stress on connection in Williams might also help us reconnect with Auerbach. Auerbach writes constantly of the connecting energies of literature and of the cognitive power such energies generate. The cognitive moreover goes with the recognitive, the scene of recognition. Williams places recognition at the very heart of his account of literature in *The Long Revolution*. Recognition, Aristotle's *anagnorisis*, is at the very beginning of the theory of mimesis, and, as noted earlier, it is at the very beginning of Auerbach's book, in the opening discussion of Homer. Going back to where, conceptually speaking, Auerbach began may be a way, for us, of beginning again.

9

Visuality and Narrative

THE MOMENT OF HISTORY PAINTING

The theory of narrative has been at once enriched by a set of distinctions and burdened by a degree of terminological confusion over the principal terms of these distinctions. I refer to the distinction drawn by Henry James between "telling" and "showing" and the cognate distinction proposed by Georg Lukács between "describing" and "telling" (*beschreiben* and *erzählen*). The potential confusion arises by virtue of the different meanings and values that respectively attach here to the notion of telling. For James it is a negative value (narrative should show, dramatize, rather then tell or narrate). For Lukács, on the other hand, telling is the sine qua non of great narrative, as opposed to the merely inert, mechanical procedure of describing (this, for example, is the ground of Lukács's evaluative distinction between realism and naturalism or, in proper-name shorthand, between Balzac and Zola). The confusion is awkward (but that is all it is) because what James understands by "showing" is in fact broadly what Lukács understands by "telling." What the Jamesian and Lukácsian conceptions have in common is that both converge on a notion of the typical, a version of narrative that embodies what the philosophers call the type-token relation. The narrative instance is a token that stands synecdochically for a larger whole, that discloses the whole by showing a par-

ticular as a concrete demonstration. From there it is but a step, though an analogical one, to construing narrative showing on the model of point-ing, a form of deixis or ostensive definition. It is as if narrative is offering an example, a *paradeigma*, and inviting us to look at it on the assumption that it will lead us toward, point to, the larger class or pattern of which it is an example. It is thus exemplary in the double sense that now attends the notion of the paradigm: an instance but, as a representative, typical instance, a model. Something of the force of the analogy is moreover caught when Barthes, in a passing remark in *S/Z*, compares the metonymic order of narrative to the pointing finger of ostension.[1]

These various notions thus evoke the power of visual analogies in thinking about narrative. But what if we consider the matter the other way round: not, as in the previous chapter, the visual grounding of narra-tive but the place of narrative in the visual, in a medium, that is, literally geared to showing? Where painting is concerned, this crucially implicates the more particular question of history painting. History painting is by definition linked to narrative. Yet the relation in question is in fact impos-sibly aporetic. The aporia turns on a paradox bound up with the found-ing category of narrative representation in the standard theory of history painting: the significant moment (variously addressed in the theoretical writings of, among others, Bellori, LeBrun, de Piles, Shaftesbury, Richardson, Winckelmann, Lessing, Diderot, and Falconet). To speak of the moment of history painting is potentially to speak of many things, to move between several levels of reference and meaning. One is external, the moment of history painting in the historical sense, though here the meaning will oscillate between singular and plural—the plural designat-ing the history of history painting as a series of moments (periods), the singular designating rather the idea of a privileged moment, the high point, the period when the cultural conditions most favorable to the genre are in place. Another level is internal and concerns the moment *in* history painting, the moment of action (or inaction) selected for repre-sentation. This already involves a theoretical ambiguity: the moment of representation is also a moment of presentation, given to the spectator in the present of viewing. It is an ambiguity that dovetails with a much larg-er distinction in the general theory of painting, between what have been called the rhetorical and the philosophical conceptions of painting, the former—especially dominant in painting theory of seventeenth- and eighteenth-century France—committed to a view of painting as per-suading the spectator by means of illusion (thus notionally confusing rep-

resentation with presentation, the illusion of presence).[2] On the other hand, there is the related question, still within this internal sense of the term "moment," of whether the moment represented is properly a temporal category at all, with various implications concerning the vexed issue of how history painting stands to narrative and, by extension, the whole sphere of temporality and particularity (in the tradition of the discrimination of the arts according to time and space). By definition, the moment is particular, but in the received theories of history painting it was paradoxically called on to divest itself of particularity, functioning as an ideal moment, outside time and expressive of the universal.

I want to consider the problematic of the moment in history painting, and its complex relation to narrative, by way of an example from painting in the Napoleonic period. Such painting is notoriously an attempt to adapt the inherited conceptions and idioms of history painting to the requirements of propaganda and especially to the demands of the war machine during the imperial campaigns. More specifically, I want to look at one painting, perhaps the most famous Napoleonic battle painting, Gros's *La Bataille d'Eylau*. On one reading, the painting stands in a non-problematic relation to narrative and its defining moment. That moment is of course incarnated in the figure of Napoleon on horseback visiting the battlefield on the day after the carnage and raising his arm as if in a gesture of benediction. Napoleon's arm points, though to exactly what is not fully clear: either to the troops, both French and foreign, in an encompassing embrace of fraternal mercy, or toward the heavens, as if to evoke the compassion and blessing of a higher authority. Either way, the significance of the raised arm is to elevate. The painting is in fact saturated with pointing gestures, notably the arms and hands turned toward the figure of Napoleon, saluting, imploring, acknowledging (or rather enacting, literally pointing to a source of meaning).

This we might describe as a form of deixis. Louis Marin has given us a version of pictorial deixis, turning on the presence in the picture of a figure who, often in the form of a pointing gesture, is witness to its central action and the meaning of that action.[3] In these terms we should also note an additional figure in Gros's painting who points: Percy, the chief surgeon, absent from the original sketch, appears in the final painting, where, while he contemplates Napoleon, he indicates with his dropped left hand the work of his subordinate, the army doctor bandaging the knee of a wounded Lithuanian, who in turn salutes Napoleon while swearing an oath of fealty. This network of gestures provides a grid, bind-

ing the composition around Napoleon as the bringer of a cure for the horrors of war, strictly comparable with the literally binding activities of his corps of army doctors ministering to the wounds of the enemy. Taken together, these details suggest a fantasy of incorporation: bodies, maimed and suffering, turn toward the emperor, drawn to the charismatic body, indeed into the body, source and terminus of a circuit of communication suggestive of community in the midst of anarchy, even of religious communion defined as an act of redemptive healing, and of incorporation of the enemy into the body of empire. Gros's picture thus simultaneously satisfies the needs of propaganda and the formal criteria of history painting as classically conceived: the moment it depicts gathers into itself a range of meanings that are abstracted out of mere narrative contingency (mere anecdote) and impelled toward a point of transcendence.

Yet it is doubtful if this centripetal dynamic can be said to govern everything in the painting, especially the action of its foreground dimension. Nearly all commentators on *Eylau* (from the time of its first exhibition in 1808 to our own times) have gravitated toward the extraordinary activity of the foreground plane, its vast and scattered imagery of dying and mutilated bodies. The terms in which the foreground of *Eylau* relates to (or rather clashes with) the notionally dominant schema of the painting are what I want briefly to examine, with a view to saying something more general about the aporia of history painting's relation to narrative and why it is in the Napoleonic period, under a very particular set of political and cultural conditions, that this aporia becomes peculiarly visible. The counterforces at work in this painting—its centrifugal energies pulling against its centripetal tension—have something to do with the sheer size of the painting. Scanning it takes time, and there are things in it, a number of details, that are difficult to decipher visually (for example, which bits of body belong to whom or who is lying trampled under the horses). For the moment, however, one might settle provisionally on a particular detail. For, even as one files past quickly (as the visitor in the Louvre these days typically tends to do), one's eye might be caught by an eye in the picture, not the strangely abstracted look of Napoleon but the gaze of the Prussian in the bottom right-hand corner, held by the doctor intent on treating the soldier's wounds.

What this gaze might be taken to signify is something to which I shall return. My present point is less interpretive than analytical and methodological. For to start with a detail, especially with this detail, is both to make a move (routinely unremarkable) and yet to raise a question, a fun-

damental question, about the character of Gros's painting. The move is a standard one, the adoption of a kind of synecdochic shorthand, using the detail as an anticipatory marker for a more general claim or argument about the picture; indeed there is an important sense in which the whole of my argument can be made to converge on the implications of this one detail. The question, however, is whether those implications are themselves subject to the logic of synecdoche, whether the picture itself, in its own mode of composition, corresponds to the same order of representation as the move of the discursive argument about the picture.

Normally we would expect this to be so. The detail is an art-historical convention, selected and enlarged in reproduction for the purpose of analyzing and illustrating some typical pattern or property of the picture as a whole.[4] The detail has representative value; it is to the economy of visual representation what synecdoche is to writing and discourse.[5] Yet it is not obvious that this detail is of this sort, whereby part stands for whole, or rather whether it is of the sort that introduces a moment of excess and disturbance, that escapes the net, dislocates the frame. As far as I know, the critical and scholarly literature makes no mention of the soldier's eyes (as distinct from other foreground details, crucially the bodies and corpses in the center foreground). And if it has been unremarked it is presumably because it has been perceived as unremarkable, seen as fully absorbed into what appears to be the dominant semantic and moral atmosphere of the picture: kneeling alongside one of the surgeons, the soldier with his gaze is easily assimilated into the generalized (and officially sponsored) meaning of Napoleon's role as healer; the soldier's eye invites a movement of the viewer's eye, such that we can read the figure of the Prussian soldier across a diagonal leading back to the figure of Napoleon, the gaze of the latter subordinating the former to the intended message of beneficent delivery from the pain and horror of war.

Yet if, as synecdoche, the detail solicits and guides the eye, in what direction is the viewer in fact sent across the massive canvas: diagonally to Napoleon, horizontally to the pile of bodies, or perhaps even out of the picture altogether, beyond the frame toward the viewer him- or herself? If this is a synecdoche promising access to some larger pattern, it is a troubled and troubling one. For when one thinks one has done with it, a question nevertheless remains: What exactly is the soldier looking at? Or more exactly what is it that he sees with his eyes and what is that one sees *in* his eyes? The first question in itself is banal. The soldier seems to be looking into the face of another soldier, wounded or perhaps already

dead, whom the viewer sees only from the back. This is banal in that there are of course thousands of paintings that stage a scene in which a figure sees something that the viewer does not see. The question, however, transcends the commonplace, moving into a different register altogether by virtue of the fact that, although the Prussian soldier seems to be looking at the other soldier, this is not certain. One reason it is not certain has to do with the nature of his gaze; it is exorbitant, in the literal sense of leaving the immediate field of focused vision (there is something wildly unfocused about the eye here). Moreover it acquires its exorbitant character in part because of its structural and compositional contrast with the whole network of looks and gazes organized in the picture as a whole. Whatever it is that the viewer sees in his eyes, it is not visible in the eyes of most of the other figures, above all in the eyes of Napoleon, rapt in Christlike compassion or mystically turned toward contemplation of a world-historical future.

The soldier's gaze is worth commenting on for a variety of reasons, not least because it marks an important difference between the finished picture and the preparatory competition sketch. In the latter both eyes are shown and depicted as open wide in accordance with the theatrical code of Horror; moreover in the sketch it is unambiguously clear that he is looking into the soldier's face that the viewer does not see. In the finished picture most of this has gone: here the left eye has been partly shaded out, and the remaining right eye, though preternaturally bright, is no longer governed by the wide-eyed theatrical rhetoric of the sketch. Its look is far more abstracted, no longer in clear focus on any particular object; it is very possibly an eye turned inward, "exorbitant" in the sense of deranged, haunted by trauma and possibly insanity. These claims about the Prussian soldier can be satisfactorily addressed only in an extended account of the painting. But for now it is possible to say that a detail that raises doubts about both what the subject is seeing and what viewers think they are seeing is a detail that perforce opens on to a wider problematic of vision and viewing, that it is less an efficiently legible synecdoche than a point of indeterminacy, lending itself to multiple readings while guaranteeing none, in short, a detail that does not so much help organize a pattern as engender, in Georges Didi-Huberman's arresting expression, a "fiasco of iconography."[6] The fiasco of iconography? This is a strong description, as distinct from the familiar art-historical cliché of Gros as transition from the neoclassical to the romantic. It is not that the cliché is false but that it is tired and, by dint of repetition, fails to register the powerfully disrup-

tive energies of Gros's painting, the alliance of transition with crisis. The cliché mentions elements—the new priority given to color, the more flexible gestural economy—that are indeed important, but Gros's use of color, the whole question of color, does not involve only techniques of realism or freedom of individual imagination. Rather it is enlisted in a narrative of crisis and—for the high conservative imagination (where "conservative" means, among other things and paradoxically, the older civic-republican idea of history painting)—a narrative of cultural decline; in this argument, color does not so much brighten vision as darken it, draining from the canvas the kinds of meaning history painting was supposed to put there.

Yet to talk of fiasco may seem not only excessively strong but also anachronistic, importing backward from the pressure of our own critical concerns. There is of course an important sense in which this is inevitable; the project of recovering the past exclusively from the point of view of the past is the pipe dream of those observers who have forgotten that they too are historical beings. On the other hand, I want to maintain that the processes in question are immanent in the picture and, just as important, in the historical period during which the picture was produced. On the battlefield of *Eylau*, if not dead then gravely wounded, is a certain culture of the iconographic. Iconography can be understood here broadly as a stock and a code: a painterly repertoire of motifs, allusions, and quotations and a code for the production of meanings (in Didi-Huberman's words, a "naming of the image by the reading of a sense" [99]). Art-historical scholarship has often pretended not to notice this disruptive way with the iconographic; Gros's supposed sources are duly and dutifully listed (for example, Michelangelo, Raphael, Rubens) and then fed into the code allegedly programming the meaning of the picture.

In this particular case, the code and its meanings are political. The painting of *Eylau*, from its submission as a competition sketch to the commissioning of the final article, was subject to one of the most carefully monitored and controlled of the public *concours*. The finished painting was a *succès fou* when exhibited in the 1808 Salon, although many of the reviews were in fact mixed (the Salon criticism is one of the barometers for testing the claim that the disturbances effected by the picture are historically grounded and not merely the product of anachronistic back-projection; nearly all the reservations revolve around what I shall be calling an anxiety of the foreground). Napoleon himself was delighted with the painting and, to show his appreciation, engineered a characteristic bit

of Napoleonic theater: after distributing accolades and honors to some of
the other painters showing in the exhibition, he started to make his exit,
when, as if from an afterthought, he turned on his heel, walked briskly
back to a disconsolate Gros, and, with great fuss, pinned his own medal
of the Légion d'Honneur on the coat of the painter (Gros has left us an
oil sketch of the event).[7] It is no wonder, then, that the painting is so often
read according to the standard iconographic protocols; everything about
the circumstances of its making and much in the context of its reception
suggest that it demands to be read in this way.

Accordingly, the various pictorial sources and allusions (Michelangelo,
Raphael, Rubens, etc.) contribute to the construction and transmission
of a unified political message; they invest contemporary history with aes-
thetic and moral grandeur and thus participate not only in commemo-
rating a battle (one of the bloodiest of the Napoleonic campaigns) but
also, and more profoundly, in legitimating Napoleonic power and rule.
But not only do the so-called sources invest the subject of the painting
with certain meanings; they also say something about the painting itself,
something about its status *as* painting. It is not just that Napoleon is being
implicitly compared to, say, Michelangelo's Christ but that Gros's paint-
ing is comparing itself to Michelangelo's painting. The sources function
both as signs of Napoleonic rule and as signs of the picture's identity as
history painting; they help legitimate the picture as well as its subject. Yet
it is in this self-legitimating dimension of the image that Gros's complex
relation to the iconographic tradition is revealed.[8] For the way the signs
behave suggests something close to a form of bricolage, they appear as so
many raids on the canon, a form of plunder, cognate perhaps with
Napoleon's looting of the museums of Europe and above all resembling
the structure of Napoleonic propaganda itself, a series of opportunistic
appropriations. They bring us to the verge of a very complicated relation
indeed, that concerns not just the painting of politics but also the politics
of painting, grasped as an ensemble of mediations, some external (the
conditions of commission and so on) but, more importantly, those of the
internal dynamic of the picture itself, its own terms of painterly practice.

We can gain some initial sense of what this involves by momentarily
leaving Gros and turning to a painting by one of his contemporaries,
Ingres's *Bonaparte, premier consul* (it is important that the example is from
Ingres, the fiercest champion of the continuing relevance of the grand
style in modern conditions). Ingres's painting of the first consul—of
Bonaparte rather than Napoleon and thus of the most confidently expan-

sive phase of the legend of the defender of the Revolution—was the product of an official commission for a portrait to be given to the city of Liège; the document beneath Bonaparte's right hand is a decree authorizing payment to Liège of 300,000 francs for the rebuilding of a section of the city that had been destroyed by Austrian artillery. It is an image—one among many—of Bonaparte the statesman, wielding the pen rather than the sword, signing treaties, drafting constitutions, bringing the liberating and reparative energies of modernity to the wreckage inflicted by Europe's traditionalist and reactionary foe, the tyrant Austria.

In several respects, however, the image is extremely odd, notably the presence of elements that relate awkwardly to the intended connotation of emancipatory modernity. For Ingres has chosen to surround the figure of Bonaparte the modern statesman with various motifs taken from the idiom of late medieval Gothic and in particular from the work of the fifteenth-century Flemish painter Van Eyck (specifically the Gothic notations of cathedral and environs seen through the window behind Bonaparte). To list these notations is again to do nothing more than follow the protocols of iconographic source hunting. The important question concerns what they are doing there; what, so to speak, is the legitimacy of a Van Eyckized representation of Bonaparte. One very interesting answer to this question is Norman Bryson's account of these echoes of Van Eyck as a tissue of quotations, but quotations with a difference: the Van Eyckian motifs enter the picture in a way that destabilizes the normal internal hierarchy whereby the quoted image is subordinated to the authority of the quoting image.[9] What we have here is not so much the use of late medieval iconography to heighten an essentially modern image but rather the reverse: a stylization of a modern image that projects it back into a remote past, almost as if, through the window, the painting is being evacuated of its specifically modern frames of reference, as if painted from a position of studied indifference to the demands of the contemporary historical moment. In short, the Van Eyckian motifs produce an effect of strangeness, of estrangement from the present, the dynamic forward march of history of which Bonaparte is the principal agent.

Politically, we can see why this peculiar combination of elements might have been attempted. If as first consul Bonaparte was a military despot, he liked to see himself, and to be seen, as an enlightened one, at once exporting *lumière* to the dark continents of ignorance while at the same time tolerantly respecting the indigenous culture of conquered

peoples (the most flagrant instance of this impossible combination was the Egyptian expedition).[10] Thus, the signs of Flemishness that Ingres puts into a portrait of Bonaparte officially commissioned for the citizens of Liège can read as bearing a distinct political message: Bonaparte, the protector of the new Belgium, is also connected with its cultural heritage. Enveloped by the quotations from Van Eyck, Bonaparte poses no threat to the cultural heritage of Belgium; on the contrary, the connotation of the picture is that he is the legitimate inheritor of the tradition of late medieval Christendom, the site of a fusion of traditional and modern, an image of both change and continuity.

Except of course that the fusion doesn't actually work. The connotation is fake, and the picture seems in some way to know this or at least to register it. This is less a fusion than a confusion. Quoted and quoting images fail to harmonize; the relation of foreground and background is essentially one of dissonance; the eye of the viewer moves from one to the other as across a hiatus; the spatial relations of body, furniture, and floor do not add up ("all the right angles have been distorted by about ten degrees").[11] And if, as Bryson suggests, this painting has the air of a somewhat distanced stylistic experiment that doesn't quite come off, then arguably one reason it doesn't is the intrinsic implausibility of the political demands being made on the picture. More generally, it gives us terms for thinking about the relations of politics and painting beyond the reductive ones of either classical background analysis or the simpler forms of *Ideologiekritik*. The relations constitute a two-way track; active in the painting (as manifest content), the political is also in the activity of the painting, its formal work *as* painting. The awkwardness of matter, of political meanings, is also the awkwardness of their registration, in the manner of composition, in the means as well as the message.

This, one might say, is opportunism become opportunity, the occasion of a new way with history painting. It brings me back to the case of Gros. David famously wrote to Gros from exile in Brussels: "Vous n'avez pas encore fait ce qu'on appelle un vrai tableau d'histoire" (You have not yet made what we call a true history painting).[12] It is a claim partly fueled by the bitterness of exile, but it also records something that is at once true and false. David, while generally supportive of Gros's endeavors during his tenure as "Premier peintre de l'Empereur," also knew that Gros's work marked an important departure from his own. Gros himself knew it too; indeed it caused him so much confusion in later life, renouncing and denouncing the very emancipation from the Davidian legacy his own

earlier work had done so much to bring about, that it contributed to his suicide (he was found dead in a pond outside Paris). Gros's way with history painting is post-Davidian but not simply as its reinvention or displacement; it is history painting as *problem*, created in and as a moment of instability and uncertainty, in the cracks and fault lines of the genre.

Gros's picture constitutes an unstable force field. An obvious contrast is with David's *Horaces*, an image contradictory and divided but held in that terrifying and tragic tension from which History speaks its name (in the form of an oath of allegiance). David's painting is thoroughly synecdochic, in the sense that its details are inseparable from a drive to abstraction and totality.[13] The image offers itself to be read whole, in a complex, dialectical reading, to be sure, bound up with the emergence of a new public sphere of debate, but with an implicit confidence in its ability to seize and represent history. Gros makes an opportunity of the unavailability to him of that confidence. His great painting is born of the confusions of the Napoleonic age, of the postrevolutionary crisis of legitimation, but is not reducible to mere symptoms of that crisis; rather, it converts the symptoms into visual statements the regime could not have recognized (that Gros himself perhaps could not have recognized) while demanding new recognitions.

"Fiasco," in this context, means the end of the settled iconographies of power. This can be clarified further by means of one last comparison: the analogy of imperial rule and imperial art with the reign of Louis XIV. Michael Levey has been the most eloquent spokesman for this analogy.[14] Yet, though attractive, it is also superficial. Unlike seventeenth-century Flemish and Spanish court painting, which pulls toward genre, retreat from the public stage into the privacy of domestic and family life, French painting under Louis XIV was mobilized in support of the proposition "l'Etat, c'est moi." But, as Louis Marin showed, for painting to take this proposition seriously, it had to conceive its images of regal power as not mere representation (belonging to the fallen realm of arbitrary and challengeable signs) but, via a juridical appropriation of the theology of the Eucharist, as embodiment, fully natural, unmediated, present rather than represented; the king's body (or rather one of his two bodies, the essential as distinct from the contingent) is the incarnation of the divine, and the king's portrait is its embodiment in the material of paint. In the terms of Felibien's account, the portrait of the king *is* the king.[15]

Napoleon's yes-men made several attempts to evoke the aura of Louis's Versailles. But the uncertainties and the blind spots in the fabrication of

Napoleonic legitimacy meant that there was no real basis for this. Napoleon's body may be proffered in these terms, wrapped in emblems of the sacred, but always without conviction (or at least this sort of conviction), for the reason that the historical grounds of the assumption and justification of power had changed irreversibly. We can date this from what Antoine de Baecque has called "la défaite du corps du roi" in late-eighteenth-century political theory and popular discourse.[16] Despite the manufactured nostalgias of the politicians and the functionaries, Napoleon is absolutely modern, his dilemmas of power and legitimacy are modern,[17] and so too are the more interesting of their pictorial representations.

One way of focusing this intersection of the artistic and the political with regard to the issue of legitimacy is by posing Napoleon as at once the problematical subject and the problematical object of the relevant transitive verb "to represent." Napoleonic painting turns on the relations of two questions built from the respective political and artistic meanings of that verb: what does Napoleon represent politically, and how was one to represent Napoleon artistically? The difficulty of giving secure answers to both these questions is the historical context for an account of the work of Gros and more generally of the fate of history painting at the beginning of the nineteenth century. It is in this sense that one can speak of fiasco and of Gros's Prussian soldier in the bottom right-hand corner as a paradoxical synecdoche, a moment of radical heterogeneity, a centrifugal countertendency to whatever centripetal forces bind the image (like the surgeons in the picture binding wounds).

Joshua Reynolds argued—in its most general form it is a more or less representative view for the period as a whole—that painting in the grand style, and notably history painting, depended on the attention of the spectator not being "divided" through a sundering of main figure and subordinate detail united within a hierarchically ordered compositional system.[18] Gros's soldier effects just such a division of attention. Another way of putting this would be to ask how the soldier relates to the moment of history painting, in both the epochal and compositional senses of the term. Is it that the moment of history painting has come and gone, burst by the pressures of the Napoleonic moment? And is it that the soldier compromises the moment in the picture, its ostensibly defining moment, its notional center, the moment highlighted by its title: Napoleon visiting the field of battle (or more accurately—a point of some considerable significance—Napoleon visiting the field *after* the battle)? As I have

shown, the choice of the moment (the synecdochic moment) to be rep-resented lay at the very heart of the canonical theory of history painting, as the compositional foundation stone of the claims of history painting to high moral and cultural value. Damage the moment, and you accord-ingly damage the whole edifice. This, I would maintain, is at the center of Gros's way with the vocabularies and assumptions of history painting, though the manner of my demonstration of this, through the example of the detail, is itself impossibly paradoxical, in retaining for the purposes of my own argument the very synecdochic mode whose role in the econ-omy of Gros's painting I have questioned. But, then, there's really noth-ing that can be done about that.

10

Literature, Painting, Metaphor

MATISSE/PROUST

Proust famously defined literature as translation, in the sense of the representation of one set of terms by another.[1] Literary art as translation in Proust can be understood in a variety of contexts: extratextual (the privileged sensations of *A la recherche* as *signes* that it is the task of the writer to decode); intertextual (*A la recherche* as the rivalrous rewriting of Balzac's *Comédie humaine* or Saint-Simon's *Mémoires*); and interartistic (the literary work sustaining complex transactional relations to the other arts, notably music, sculpture, and painting).

The relation with painting is the one that concerns me here, though not in the terms normally found in Proust criticism and scholarship (Proust's interest—largely mediated through the creation of his fictional painter, Elstir—in Turner, Manet, and Monet).[2] I want rather to suggest a relation with Matisse (and especially the paintings of the fauve period). "Relation" is, however, a term that can both generate and conceal a great deal of methodological confusion. Indeed it would be fair to say that, despite growing interest in the topic, the intellectual foundations of inquiry into literature and the visual arts are still far from being reliably constituted (the word "relations" is either too reductive or too vacuous to be of much help here). The juxtaposition of Proust and Matisse is cer-

tainly arbitrary, but perhaps no less so than other, more standard juxtapositions, though this will be of little comfort to those for whom "relations" basically means "influence." My suggestion that it might be interesting to align Proust and Matisse has nothing whatsoever to do with claims of influence. There is no evidence that Proust and Matisse were even acquainted with one another's work.

If there are grounds for comparing them, they derive rather from more general currents of literary and cultural history, specifically commonalities within the space of early high modernism, above all the modernist commitment to techniques of defamiliarization directed at regimes of representation with a view to scrambling fixed identities, of both objects and people. My contention is that, in these terms, Proust's literary practice, at once mirroring and mirrored by the work of Elstir, more closely resembles the painterly practice of Matisse than that of the nineteenth-century predecessors with whom he is so frequently compared. Both are radical defamiliarizers whose work consistently produces ambiguous identity statements, the principal means in the production of these ambiguated identities being a certain essentially modernist use of metaphor. Metaphor then is posed here with a double reference: as a rhetorical device deployed to rework given orders of representation but also as a mode of translatability whereby painting and literature of a certain kind can be seen as metaphorically convertible one to the other. Elstir, as I shall show, is the nodal point for this movement across the boundaries of the arts.

One does not customarily think of disturbance in connection with Matisse. He is notoriously associated with a conception of painting not as disorientation or estrangement but as soothing balm for the mind troubled or exhausted by the pressures of modernity, most notoriously in the remark he made about his dream of "an art of balance, purity and serenity" that would be "devoid of troubling or depressing subject matter" and, in the most apparently fatuous moment of this collection of remarks, an art that would produce "a soothing, calming influence on the mind, something like a good armchair that provides relaxation from physical fatigue." It can be seen immediately how those claims give hostages to fortune: Matisse as cultural purveyor of aesthetic narcotics to a pleasure-seeking bourgeoisie, whose paintings, such as the picture based on a Baudelaire poem, *Luxe, calme et volupté*, were themselves a commodity offered to a society or social group jaded by the pursuit and consumption of other commodities (similar criticisms were of course also made of

Proust, aesthete and snob, sharing and endorsing the values of those who haunted the hotels, beaches, and casinos of the seaside resorts and spas of the leisured classes).

This view of Matisse is entirely misleading, and in approaching his more experimental work we should basically disregard the infamous analogy between viewing pictures and relaxing in a comfortable armchair. Matisse does of course deal in paradisiac and utopian landscapes of pleasure, but they are very peculiarly constructed. Take the crucial question of the construction of space. Everyone agrees that line drawing in the pictures of the fauve period is extremely odd, that traditional lines and planes of perspective, depth, and recession are either disregarded or actively scrambled. Matisse is much more interested in composing with blocks and patches of color; pictorial space is built primarily from the distribution of these *pans* (and we should remember how important the notion of the *pan*, the block or patch of color, is to Proust, notably in connection with the famous patch of yellow in Vermeer's *View from Delft*).

"Construisez avec des rapports de couleur" (Construct with relations of color), Matisse said, in remarks collected by Sarah Stein.[3] The relations in question—the "rapports de couleur"—are described by Matisse as subject-object relations, the capacity of an object world to resonate, mainly through the mediation of color, into a subjectivity, which is then projected back out into the external world in a manner that reorders its spatial configurations: "J'ai à peindre un intérieur: j'ai devant moi une armoire, elle me donne une sensation de rouge bien vivant, et je pose un rouge qui me satisfait" (I am to paint an interior: I have before me a cupboard, it provides me with a lively sensation of redness, and I apply a red that satifies me). There is a similar remark on the painting of interiors, or more precisely and more interestingly (for a reason I shall shortly specify) the painting of interiors and exteriors: "Si j'ai pu réunir dans mon tableau ce qui est extérieur, par exemple la mer, et l'intérieur, c'est que l'atmosphère du paysage et celle de ma chambre ne font qu'un. . . . Je n'ai pas à rapprocher l'intérieur et l'extérieur, les deux sont réunis dans ma sensation" (If I have been able to unite in my painting what is exterior, for example, the sea, and the interior, this is because the atmosphere of the landscape and that of my room, are but one. . . . I do not have to compare interior and exterior, the two are united in my sensation).

Here is the relevant spatial relation, a relation that defamiliarizes normal constructions of space by ambiguating, even abolishing the distinction between inside and outside; interior and exterior are brought

together, even fused, through the subjective impression ("dans ma sensa-tion") characteristically rendered in a certain arrangement of colors. Consider, for example, the extraordinary painting *The Blue Window.* It ostensibly represents a view from inside a room through a window to an outside. But that naturalistic interpretation is in fact a reconstruction that goes very much against the grain of the way the picture itself actually functions. First, normal relations of perspective are troubled by a distur-bance in the economy of vertical and horizontal. The picture surface seems uniformly flat, unidimensional, everything in the vertical. But what should one make of the band of dark blue toward the left frame? It is a vertical stripe, but logically, given that there is an object on it, it would have to be a ledge or a shelf, thus in the horizontal plane. But then the stripe continues beyond the window—another edge, boundary, or frame—into the outside, where it clearly cannot be a ledge or a shelf. Or what of the horizontal stripe of dark blue, notionally the base of the win-dow, thus the point demarcating inside and outside space? This doesn't really work either, since the more or less equivalent squares of blue (the patches of lighter blue) above and below the dark blue stripe are also in the same vertical plane, although in a naturalistic logic, the so-called inside square or patch of blue would have to be in the horizontal (as a table on which objects are placed), while the outside would be both hor-izontal and vertical (as an early night sky receding in the distance and dropping down to the plane of the earth).

We thus already see a scrambling of the relations of inside and outside and the strategic role of color in producing this effect. The painting is dominated by shades of blue, one of the functions of which is to create a set of color rhymes that raise questions as to where one thing ends and another begins. Take, for instance, the strange treelike object outside the window. I say "outside," but that in fact is not entirely clear. One of the blue balloonlike components of this strange treelike object actually seems to be inside the room, not least by virtue of its being connected to ver-tical black lines that in one aspect seem to be the mark or notation of a tree trunk but also run spatially into the lamp inside the room, while the other black vertical seems to run behind the almost indecipherable yel-low object on the table into the window frame and could arguably be a window railing or a bar. In other words, there is a dislocation of spatial relations that also defamiliarizes objects and raises questions as to identi-ties (what these objects in fact are). Finally, in the ambiguous interstitial zones where things are supposed to end and others begin, there is the

whole question of the frame: it is no accident that Matisse returns again and again to window scenes, since they are perfect for staging questions of framing, questions that engage not only relations in the object world but also of course in the painting world, the whole drama of the frame or the border of the picture that Derrida so brilliantly analyzed in his discussion of Kant's *parergon* in *La vérité en peinture*.

Most of Matisse's other paintings of this period share the same scenes, techniques, strategies, and questions. In *The Piano Lesson*, for example, there is once again a room, this time with a boy playing the piano close to what seems to be an open window. Once more relations of inside and outside are strangely articulated. What visual reading do we give to the patch of green? If naturalistically it is to be tracked horizontally as a garden border, that reading is challenged by the compositional reality of the patch of green as a triangular patch slapped like a vertical geometric shape hard against the vertical frame of the window. And what of the two great patches of blue gray? The patch on the left runs from top to bottom, interrupted only by the green, but where one section belongs to an outside (but what outside? a vertical wall perhaps, but that would be inconsistent with the allegedly horizontal green), and one section belongs to the inside, the section of wall beneath the window. But what about the blue-gray patch on the right? What on earth does that represent? Is it recessive into the depth of space, an extension of the room, with the boy's mother or music teacher sitting on a stool? If so, it is most bizarrely composed. Or is it in fact precisely a composition, a painting on a wall, echoing, rhyming, with the other artistic artifact, the reclining female form at the bottom left? Is this a case of *mise en abîme*, pictures within pictures, as in the famous case of Matisse's painting of his studio, where the walls are covered with shorthand notations of Matisse's own pictures? Or rather is it a subtler form of *mise en abîme*, not just pictures within pictures but statements of ambiguity, of uncertain object identity (here a painting or a real-life woman) that would be a perfect reflection of the whole activity of Matisse's more provocative paintings as extended exercises in loosening and equivocating our perceptual grip on the world?

From these questions about Matisse I will now turn to Proust. It is a commonplace of Proust criticism that his great novel is above all a systematic reordering of time-space relations in function of certain privileged sensations and impressions (usually mediated by the mechanism of memory). There is a connection between this literary project and the account given within the novel of Proust's painter figure, Elstir. Proust's

work is a reflection on the work, the conditions of its own birth and emergence. This is staged and thematized in a variety of ways, mainly through the narrator's commentary on the coming-into-being of his own narrative, in the extended metatextual sequences of the last volume, *Le Temps retrouvé*. But it is also thematized more indirectly through the emblematic artist figures of *A la recherche*: the composer Vinteuil, the novelist Bergotte, and of course the painter Elstir.

Elstir is above all remembered by the narrator for the extraordinary shock—an experience of defamiliarization at once amazing and exhilarating—furnished by the seascape paintings at Balbec. The most striking feature of these paintings is the way they blur and in some cases reverse spatial relations and demarcations, with corresponding identity confusions in the object world or the natural world. What most catches the narrator's attention is Elstir's practice of painting the sea as if it were the land and the land as if it were the sea:

> Sometimes, at my window in the hotel at Balbec, in the morning when Françoise undid the blankets that shut out the light, or in the evening when I was waiting until it was time to go out with Saint-Loup, I had been led by some effect of the sunlight to mistake what was only a darker stretch of sea for a distant coastline, or to gaze delightedly at a belt of liquid azure without knowing whether it belonged to sea or sky. But presently my reason would re-establish between the elements the distinction which my first impression had abolished. . . . But the rare moments in which we see nature as she is, poetically, were those from which Elstir's work was created. One of the metaphors that occurred most frequently in the seascapes which surrounded him here was precisely that which, comparing land with sea, suppressed all demarcation between them. . . . It was, for instance, for a metaphor of this sort—in a picture of the harbour of Carquethuit, a picture which he had finished only a few days earlier and which I stood looking at for a long time—that Elstir had prepared the mind of the spectator by employing, for the little town, only marine terms, and urban terms for the sea. . . . On the beach in the foreground the painter had contrived that the eye should discover no fixed boundary, no absolute line of demarcation between land and sea.[4]

There is much to be said—that has already been said[5]—about this passage. Among other things, it uncannily resembles the description that I have given of Matisse (it may of course be the case, given the vicious circularities that inform discussion of the relations between literature and the visual arts, that the description is inflected by my knowledge of Proust's Elstir). Something else, however, will be clear from this passage: it also invites a comparison with Proust's own writing, that is, the writing of Elstir is a model, a microcosm, another *mise en abîme* of Proustian writing in general. This indeed is already indicated by the passage itself in at least two respects: first, the fact that it begins with the narrator's transcription of his own perceptions prior to describing Elstir's seascapes, a transcription that is a pure mirror image of Elstir's pictorial method ("I had been led by some effect of the sunlight to mistake what was only a darker stretch of sea for a distant coastline, or to gaze delightedly at a belt of liquid azure without knowing whether it belonged to sea or sky"). This is also significant in terms of some proposed comparison with Matisse, not only because the looking-through-a-window scene here recalls the very many window scenes of Matisse, in which one looks out of a window on to a seascape, but also for the more general reason that it involves the question of borders and framing, of the frontiers defining where things begin and where they end. The terms of the comparison thus invoke not just a comparison between the real-life painter Matisse and the fictional painter Elstir but also a comparison between the latter and Proust, Elstir as analogue for Proust's own writing practice understood as a frontier-abolishing enterprise, bringing things together across space and time in a different configuration.

This in turn connects with the second element of the passage, namely, its emphasis on Elstir's painterly practice as a form of metaphorical representation ("One of the metaphors that occurred most frequently in the seascapes which surrounded him," "It was, for instance, for a metaphor of this sort"). "Metaphor" thus appears twice in the account of Elstir's paintings. Metaphor is of course Proust's primary literary device for the reconfiguration of the space-time world: things separated in physical or mental space are joined across the divide, the frontier, of discursive logic or social habit by the connection-generating force of metaphor. Metaphor is transgressive of boundaries; objects and experiences that occupy different points in space and time are brought together in a manner that defamiliarizes both.

The defamiliarizing power of Proustian metaphor has paradoxically

become the most familiar aspect of his writing, and there is probably very little to be added to this topic in critical discussion. What I want to do is to take Proust's theory and practice of metaphor back into the question of painting, first by way of Elstir and then by way of Matisse. If Elstir's paintings are an analogue, a metaphor, for writing, this is in part because painting is seen by Proust as itself a metaphorical activity. Metaphor, in this connection, is a way of renaming things: Elstir's paintings reorder the world by, as it were, removing primary names from things and giving them new, metaphorical names or by giving names to things otherwise unnamed or unnameable (a painterly equivalent of the rhetorical process known as catachresis):

> Naturally enough, what he had in his studio were almost all seascapes done here at Balbec. But I was able to discern from these that the charm of each of them lay in a sort of metamorphosis of the objects represented, analogous to what in poetry we call metaphor, and that, if God the Father had created things by naming them, it was by taking away their names or giving them other names that Elstir created them anew. The names which designate things correspond invariably to an intellectual notion, alien to our true impressions, and compelling us to eliminate from them everything that is not in keeping with that notion.

This conception of painting as metaphorical might take us back to the example of Matisse, in particular to what earlier I called Matisse's color rhymes. I have already discussed how Matisse construes painting as a relational activity. Louis Aragon reported Matisse as having said: "Je ne peins pas les choses, je ne peins que les rapports entre les choses" (I do not paint things, I paint only the relations between things). These relations are essentially metaphorical, relations of resemblance and similitude, mediated above all by color correspondences. Recall the remark by Matisse: "Construisez avec des rapports de couleurs, proches et éloignés" (Construct with relations of color, close and distant). This echoes Proust in a number of respects. First, it recalls the famous "petit pan de jaune" in Vermeer's *View from Delft* that obsesses the dying novelist Bergotte, the patch of yellow that transcends simple representational considerations (the side of a wall catching the sunlight in the Dutch townscape) to resonate into a whole network of subject-object relations. Second, it recalls the account of Elstir's work as a metaphorical transformation of object

identities and spatial boundaries. The parallel can be further extended. Matisse blurs inside-outside relations and vertical-horizontal ones. His procedure has a very direct echo in *A la recherche* when the narrator remarks (in *Du côté de Guermantes*) on an effect of light that makes us take a brilliantly lit arc of a wall (in the vertical axis) for "a long bright street beginning a few feet away from us." Elstir actively reverses equivalent relations, painting the sea as land and vice versa. This corresponds to another figure in rhetoric: the figure of chiasmus, the function of which is to reverse the terms of an antithesis, to redistribute terms across the divide of an opposition. Chiasmus and metaphor often work together in the project of a general unsettling of given orders of representation. This can be particularly disturbing in the case of constructions of human identity, especially across the barrier of sexual and gender identities. It is indeed one of the grounds on which conservative opinion in traditional accounts of rhetoric is so suspicious of metaphor; in these accounts metaphor is often represented, paradoxically enough, by way of a metaphor, in the figure of the daubed and alluring Harlot, encouraging illicit couplings, where couplings are to be understood in both the sexual and the semantic senses, bringing together things that should, on the stern view of rational discourse or social convention, be kept apart. From the harlot to the transvestite and the so-called invert is then but a step (a very Proustian step), where metaphor will be an object of suspicion for the conservative imagination insofar as the energies that animate it and that it in turn vivifies are those of gender-crossing, and identity-scattering, desire.

Here are terms for a more extended comparison among Matisse, Proust, and Elstir. Matisse, for example, links the relational activity of painting, its metaphorical structure, to desire. The remark quoted earlier ("Je ne peins pas les choses, je ne peins que les rapports entre les choses") is further elaborated in the following specification of the relational activity in question: "Le rapport, c'est la parenté entre les choses . . . le rapport, c'est l'amour, oui, l'amour" (Relation is the kinship between things . . . relation is love, yes, love). This is much more than the usual emphasis on the landscape of pleasure in Matisse (Matisse the purveyor of soothing paradisiac images, notably involving the resurrection of stereotyped versions of femininity). It is certainly true that Matisse adores the decorative and the domestic, places them center stage, though even here it is arguable that it is precisely in placing them center stage, rescuing them from the marginal and devalued position they normally occupy in rela-

tion to the stereotype of femininity that he displaces the traditional hier-
archy. The point I want rather to stress here is that in several of Matisse's
pictures desire, sexuality, and the body are highly fluid, indeterminate,
ambiguous categories. Crucially they are often androgynous; painting
works yet again to blur identities and cross frontiers, this time crossing the
male/female, masculine/feminine divide. Consider here the 1910 paint-
ing *Music*, with its androgynous figures in the representation of a primi-
tive, primordial scene, a scene of origins in which what is staged is the
mystery of sexual difference.

Proust has several passages in the *Recherche* devoted to the theme of
primordial androgyny in connection with his meditations on the subjects
of homosexuality, bisexuality, and transvestism (notably of course in the
presentations of Charlus and the motif of the "homme-femme"). This too
finds an echo in the paintings of Elstir, specifically in the painting that so
intrigues the narrator, the painting of the young Odette as actress *Miss
Sacripant*:

> It was—this water-colour—the portrait of a young woman,
> by no means beautiful but of a curious type, in a close-fitting
> hat not unlike a bowler, trimmed with a ribbon of cerise silk;
> in one of her mittened hands was a lighted cigarette, while
> the other held at knee-level a sort of broadbrimmed garden
> hat, no more than a screen of plaited straw to keep off the sun.
> . . . The ambiguous character of the person whose portrait
> now confronted me arose, without my understanding it, from
> the fact that it was a young actress of an earlier generation half
> dressed up as a man. But the bowler beneath which the hair
> was fluffy but short, the velvet jacket, without lapels, opening
> over a white shirt-front, made me hesitate as to the period of
> the clothes and the sex of the model, so that I did not know
> exactly what I had before my eyes, except that it was a most
> luminous piece of painting. . . . Above all one felt that Elstir,
> heedless of any impression of immorality that might be given
> by the transvestite costume worn by a young actress . . . , had
> on the contrary fastened upon this equivocal aspect as on an
> aesthetic element which deserved to be brought into promi-
> nence, and which he had done everything in his power to
> emphasise. Along the line of the face, the latent sex seemed to
> be on the point of confessing itself to be that of a somewhat

boyish girl, then vanished, and reappeared further on with a suggestion rather of an effeminate, vicious and pensive youth, then fled once more and remained elusive.

This is portraiture as pure chiasmus, and Proust's writing of Elstir's picture obeys the same chiastic/metaphorical logic, the figure in question described as now like a man disguised as a woman, now like a woman disguised as a man, toing and froing across the border of sexual difference, the text affirming difference but at the same time ambiguating it, posing identity as in perpetual flight, as *insaisissable*. It is also no accident of course if the narrator's discovery of this picture is embedded in the narrative of his first encounters with Albertine, for the narrator the ambivalent, bisexual creature par excellence. More important still than the thematic connection between picture and narrative is the connection between pictorial method and literary method. If Elstir's metaphorical renaming of identities touches questions of forbidden desire and problematic sexual identity, so too does metaphor in Proust. Desire, the polymorphous energies of the desiring imagination, is commonly the motor of metaphorical textual expansion in *A la recherche*. It is desire that sets in motion one of the earliest and most famous metaphorical sequences in the text, the oft-cited hawthorns passage in *Du côté de chez Swann*, when the narrator first meets Gilberte, a sequence moreover whose metaphorical development takes us proleptically to the sea, to Balbec and the "jeunes filles en fleurs," of whom the most important will be Albertine. The latter in turn become, in *A l'ombre des jeunes filles en fleurs*, the occasion for a veritable riot of metaphor centered on the scattering of identity predicates across the group of girls. The whole thing culminates in yet another analogical return to painting, this time in the comparison of the band of girls on the Balbec beach with the paintings of Carpaccio, thus anticipating the descriptions of the Carpaccio paintings in the later Venice section of *A la recherche* (Carpaccio being, as Malcolm Bowie has shown, a key site for the exercise of the metaphor-laden desiring imagination). Painting and novel, text and image, thus inflect each other, are metaphors for each other; the girls are like Carpaccio, Carpaccio is like the girls.

For Proust's novel this sort of transaction has many consequences. Perhaps the most important is the question it puts to that founding convention of narrative, the convention of character. We speak easily of Proust's characters, but perhaps too easily. Character implies fixity, a seiz-

able identity or essence. But the destabilizing movements of Proustian metaphor, crossing boundaries, redistributing predicates, imply the exact opposite. And indeed the questioning of character becomes explicit in both *A l'ombre des jeunes filles en fleurs* and *La Prisonnière*. Whatever the girls are, they are not characters; characters, according to the narrator, are what we perceive people as being when we lose interest in them, become indifferent, when desire has lost its capacity for mobile metaphorical transformation:

> I do not say that a day will not come when, even to these luminous girls, we shall assign sharply defined characters, but that will be because they have ceased to interest us, because their entry upon the scene will no longer be, for our heart, the apparition which it expected to be different and which, each time, leaves it overwhelmed by fresh incarnations. Their immobility will come from our indifference to them, which will deliver them up to the judgment of our intelligence. . . . So that, from the false judgment of our intelligence, which comes into play only when we have lost interest, there will emerge well-defined, stable characters of girls.

Another way of putting this is to return to a motif I mentioned in connection with Matisse and say that Proust's people are not characters to the extent that they cannot be put inside a frame. I also mentioned Derrida's reflections on the problematic of the frame, Kant's *parergon*. Derrida's question, via Kant's philosophy, concerns the status of the frame, whether it belongs or does not belong to the picture, whether it is inside or outside and what the implications of that might be for viewing and interpreting pictures. Let me conclude with another Derridean reference, this time in respect of the topic of metaphor. In his essay on metaphor, "La mythologie blanche," Derrida directs our attention to a peculiar feature of ancient Greek thought, designated by the Greek term *kurios*.[6] The term carries two sets of meanings, originally to do with being master of the *oikos*, with the rights of a head of the household over his property, especially over his wife, the woman as property; later, in Aristotle, it becomes a term in the philosophy of language designating proper meaning, the literal sense as opposed to figurative or metaphorical sense. *Kurios* thus evokes a link between the juridico-economic and the linguistic-rhetorical, related to notions of the proper and property (what belongs where, to what, and to whom). It is a term indicating a source and sys-

tem of authority and control, be it over the body and desire (specifically of the woman) or over the realm of meaning. It is then perhaps no wonder that, in the narrative itself, Elstir gets agitated when, on the appearance of his wife as he shows his ambiguous picture *Miss Sacripant* to the narrator, he moves immediately both to hide the picture and to deny "impropriety" in his own relations with the subject of the picture. Elstir smells trouble, and trouble is exactly what both text and image are about.

11

English Proust

Much of the last volume of Proust's *A la recherche du temps perdu* is devoted to life in Paris during the First World War. Proust, the least chauvinistic of writers imaginable, is nevertheless so moved by patriotic sentiment as to transgress the convention that keeps a fictional world separate from its author:

> In this book in which there is not a single incident which is not fictitious, not a single character who is a real person in disguise . . . I owe it to the credit of my country to say that only the millionaire cousins of Françoise who came out of retirement to help their niece when she was left without support, only they are real people who exist. And persuaded as I am that I shall not offend their modesty, for the reason that they will never read this book, it is both with childish pleasure and with a profound emotion that, being unable to record the names of so many others who undoubtedly acted in the same way, to all of whom France owes her survival, I transcribe here the real name of this family: they are called—and what name could be more French?—Larivière.[1]

This passage is likely to astonish us for a number of reasons, but principally for showing us a writer, famed for his advocacy of the aesthetic solution to the problem of living, so relaxed about the rules of the relevant literary language game. For who on earth is speaking here? Strictly speaking it is the fictional narrator; in fact it is of course Marcel Proust. But this opens on to an impossibility: if the Larivières are the only real people in the book and none of the others is "a real person in disguise," then how can Françoise the fictional character have relatives in real life? The confusion here between fiction and life is both casual and radical (it is moreover compounded by the fact that the name Larivière is not only very French but also very literary, the name of one of the most decent characters in the history of the French novel, Dr. Larivière of *Madame Bovary*).

This confusion of levels or identities also occurs elsewhere in the novel. The best-known instance is the moment when Albertine calls the narrator by his first name (one of only two occasions on which this happens): "Then she would find her tongue and say: 'My-' or 'My darling-' followed by my Christian name, which, if we give the narrator the same name as the author of this book, would be 'My Marcel,' or 'My darling Marcel.' " In this spectacle of the narrator stepping outside the confines of the fictional world to speak of his own author, confusion in the mind of the reader becomes a veritable spin. And then what are we to make of the narrator's curious references to himself as the teller of Swann's story? First, there is the apostrophe, in *The Captive*, to the dead Swann: "My dear Charles Swann. . . . It is because he whom you must have regarded as a young idiot has made you the hero of one of his novels that people are beginning to speak of you again." Second, there is the even stranger moment (again from *The Captive*) of Françoise stumbling on the "manuscript" sketch of a "story" about Swann among the narrator's papers: "On one occasion I found Françoise, armed with a huge pair of spectacles, rummaging through my papers and replacing among them a sheet on which I had jotted down a story about Swann and his inability to do without Odette." If this is an allusion to *Swann in Love*, then in what "story" do we find ourselves; what here is "fact" and what "fiction"? The whole business finally collapses into pure playful disingenuousness, when, in *Sodom and Gomorrah*, the reader is imagined addressing the narrator (but logically it must in fact be the author): "It is a pity that, young as you were (or as your hero was if he isn't you)."

All this suggests that the passage about the Larivières raises at least two

of the questions that must greatly preoccupy and perplex the translator of Proust. First, Proust's patriotism, the emphasis on "my country" (in counterpoint to the themes of exile and homelessness that recur throughout the whole of *A la recherche*), engages the nature of his prose as well as his sentiments; as Walter Benjamin said, in one of the finest essays ever written on *A la recherche*, Proust's language is inseparable from his "intransigent French spirit." It is a language with roots reaching deep into the history of French prose from Montaigne through Saint-Simon and La Rochefoucauld to Chateaubriand (there is, for instance, scarcely a Proustian maxim that one can read without hearing the tone and rhythm of the seventeenth-century *moralistes*). This feature of the writing, the sense of the text as gaining sustenance from the rich soil of the French literary past, is intimately connected to the conservative side of Proust's imagination, its "vegetative" aspect (if Proust famously compared his book to a cathedral, he also compared it to a tree). The soil often does not readily permit cross-Channel transplants. In more ideological register, it can also create certain other difficulties. While Proust, the Jew and passionate Dreyfusard, had no truck with the crude blood-and-soil slogans of the contemporary nationalists, he did write some remarkably silly and at times disturbing pages on the subject of heredity (in this weird concoction of cultural and biological determinism, we are all programmed to revert to "type," such that the Marquis de Saint-Loup on the battlefield atavistically incarnates the "memory of his race," while the appearance of "avarice" in the middle-aged Gilberte de Saint-Loup, née Swann, prompts the alarmingly fatuous observation "what Jewish strain influenced Gilberte in this?").

The second question raised by the Larivière passage is initially quite different but in fact overlaps with the first. However strong the commitments behind Proust's conservatively French manner, his world remains nevertheless chronically unstable, notably around questions of identity (indeed the French literary tradition in Proust may be in part a stylistic defense mechanism for dealing with that instability). The fluid relations among hero, narrator, and author, fiction and reality, narrative and narration, past and present, reveal a subject in a state of flux and raise from the word go an issue for the translator. The question of how to translate the peculiarly constructed opening sentence of *A la recherche* ("Longtemps, je me suis couché de bonne heure") has of course become something of a party game. To my knowledge, there are now five versions currently on offer in English. Scott Moncrieff renders it as "For a long time I used to

go to bed early." Kilmartin reproduced this in his revised translation, but Enright, in his revision of Kilmartin, altered "used to go" to "would go." In addition, James Grieve's *Swann's Way* offers the refreshingly simple "Time was when I always went to bed early," while Richard Howard proposes going into print with "Time and again, I have gone to bed early."

One can argue the toss indefinitely over the respective strengths of these different renderings. Grieve's "Time was" and Howard's "Time and again" have the merit of beginning with the capitalized word on which the novel also ends, thus tracing a textual circle that mirrors the circular character so often assumed by Proustian time. On the other hand, "Time was" is a bit too colloquial for this notoriously indeterminate narrative beginning, while "Time and again" carries an unwarranted implication of the compulsive. Similarly, while "used to go" and "would go" correspond rather to a French imperfect, Howard's boldly literal "have gone" takes on board the implied imbrication of past narrated and present speaking of Proust's perfect tense; on the other hand, in French (but not in English) the perfect tense is also routinely the spoken representation of what in written narrative takes the preterite.

This grammatical difference already suggests certain incommensurabilities between the systems of French and English. There is, however, a further detail of the opening sentence that none of the five versions captures and that is directly related to the texts's restless shuttling between identities. The movement of Proust's novel can be described as the attempt to close the gap between hero and narrator, to join the two, like the two ways, Swann's Way and the Guermantes Way, which are discovered by the narrator in later life to connect up. The novel is based on a subject internally split and dispersed through time. It is therefore significant that its opening sentence should turn not on a transitive or an intransitive verb, but on a reflexive ("je/me"). Proust's grammar thus gives us a subject split into nominative and accusative, both speaker and spoken, and the book this sentence inaugurates is a many-thousand-page detour through that gap. Unsurprisingly, none of the English versions tries to do anything with this ("I took myself to bed" might just do, especially in connection with the semi-invalid side of the narrator's condition, but it has connotations that the French reflexive does not have).

Here we encounter the translator's problem at the outer limits of the representable (grammatical differences would be joined at this limit by paranomasia, where inevitably Proust's wordplay, or rather that of his

characters, for the most part produces defeat, the translator forced to include the original French in parentheses). Within these limits, however, there is a wide range of more local and contingent constraints. The most elementary concern the varying editions of the French text the translators have worked with, the publishing history of the original being in turn bound up with the story of Proust's own working practices in the cork-lined room, which produced that notoriously tangled because constantly expanded web of manuscript, typescript, and proof (in the wonderful German film *Celeste* the notebooks with their endlessly intercalated pages are shown as opening out like a fan or concertina). The original version ran to about half a million words; the final version to around a million and a quarter.

The work of the scholars (research on the *Recherche*, incidentally one of the senses of the title that, like the double meaning of "perdu"—"lost" and "wasted"—is also untranslatable) on Proust's additions to manuscript, typescript, and proof governs the history of French editions and relatedly that of English translations. Scott Moncrieff worked from the first Gallimard edition (which, with some exaggeration, Samuel Beckett described in his early essay on Proust as "abominable"); Terence Kilmartin worked from the far more reliable Pléiade edition of 1954, while D. J. Enright, taking over from Kilmartin (prevented by illness from undertaking his projected revision of his own revision of Scott Moncrieff), worked from the recently issued second Pléiade edition. The latter, however, though of great importance to Proust scholars, will not make much difference for the general reader where the main text is concerned. By far and away the bulk of new material incorporated by the second Pléiade consists of selections, placed in appendixes, from Proust's sketches. Some of this material is reproduced in the Enright edition, and some of it is good to have; for example, in the addenda for *The Guermantes Way*, we find a marvelous parody of one of Proust's great themes in the improbable mouth of Oriane de Guermantes: "That is why life is so horrible, since nobody can understand anybody else."

Yet a serious account of English translations of Proust will not turn decisively on the history of text and publication in France. One must emphasize this, principally because it is easy to fall prey to a Whig theory of the fortunes of Proust translation. This is a theory also encouraged to some extent by the translators themselves. Kilmartin offers his version not just as a series of changes and additions in the light of textual information unavailable to Scott Moncrieff but also as a "revision" of Scott

Moncrieff in the sense of correcting and improving aspects of the latter's translation of the same French text, while Enright's endeavors are billed as a "re-revision." In many respects this is an entirely proper description of what is on offer (though Enright's changes to Kilmartin's English, while often felicitous, are not that extensive, encouraging the suspicion that this supposedly new Proust is as much a publisher's wheeze as anything else). There was of course much to be corrected in Scott Moncrieff, notably the egregious howlers. The most famous example was Albertine's *me faire casser le pot*: Scott Moncrieff translated it literally and thus meaninglessly but also bizarrely since from the context he must have understood its reference to a sexual practice. But there are far more basic errors in Scott Moncrieff; perhaps the worst, in this novel about time, is the confusion between *temps* and *fois*, whereby Swann's "il y a a combien de temps?" in his questioning of Odette about her lesbian past comes out, unbelievably, as "how many times?"

On the other hand, while paying tribute to Scott Moncrieff (after all the true hero of the story), both Kilmartin and Enright can also be a little condescending toward him, as if he were some kind of dated Edwardian old duffer. Certainly if it is a matter of simply correcting errors, then this cuts more than one way. For example, Kilmartin criticizes Scott Moncrieff's grip on Proust's syntax, but this can be a case of the pot calling the kettle black. If Scott Moncrieff "wrenches his syntax into oddly unEnglish shapes," at least he doesn't put a plural subject with a singular verb as Kilmartin does ("the coldness and rudeness of their children has passed unnoticed"). Or take the saga, more or less endless, of the misplaced "only." Perhaps Kilmartin took the view that modern English usage renders such considerations merely pedantic. But if so, there can surely be little excuse for getting your syntactic knickers in a twist around a sentence that gets it wrong in one clause and right in the next ("We can only be faithful to what we remember and we remember only what we have known") and no excuse at all for the laxness with one of Proust's most famous maxims: "One only loves that in which one pursues the inaccessible, one only loves what one does not possess"; rhythm and emphasis here imperatively require the placing of "only" after "loves."

This kind of accounting exercise could go on indefinitely. More importantly, simply entering debits and credits in the accuracy ledger bypasses the deeper and more interesting questions of Proust in English. These require us to address the body of English translations as a whole in terms of the kinds of assumptions made about the nature of Proust's style

and the sort of English most appropriate to that style. A starting point here is Kilmartin's preface. Kilmartin describes Proust's style as basically "natural" and "unaffected." This must be the oddest view of Proust's style ever. While stripping out some of Scott Moncrieff's period purple was obviously desirable in order to restore more of Proust's unrelenting lucidity, the notion that Proust's vastly elaborated figurative and syntactic structures are aptly described as "natural" gives hostages to fortune too numerous to mention. In any case, there is no such thing as *a* Proust style; there are many styles and many voices, just as behind the narrating "je" there are multiple selves.

Kilmartin's view of Proust's style (or what he sometimes calls "tone") is of course related to the issue of how best Proust might travel into English. In this connection he proposes the following hypothesis as the basis of a working model: "The main problem with Scott Moncrieff's version is a matter of tone. A translator ought constantly to be asking himself: 'How would the author put this if he were writing in English?' " If this is the determining question, we are unlikely to be staying for an answer. Although at first glance the hypothesis looks like a reasonable benchmark, it is in fact quite demented. Perhaps we can make some sense of the notion of what Proust would have written had he written in English by translating it into how an English writer, of roughly the same period, background, and outlook, might have written. But this also is a somewhat murky notion, and in any case, if this is the rule of thumb, Kilmartin's own practice as translator often breaches, sometimes happily, sometimes disastrously, precisely that rule. The plot thickens considerably when we turn to Enright. For if Kilmartin rounds on Scott Moncrieff for translating literally where "English equivalents" should have been used, Enright takes him to task for exactly the opposite, objecting, for example, to translating a character's use of the idiom "partir à l'anglaise" as "taking French leave" on the grounds that it is absurd to have French speakers speak to one another of "French leave." Indeed it is, unless of course they happen to be speaking English.

It will be clear that the further one goes into this question, the more one finds that behind the murkiness there lurks a potential madness (the kind of lunacy that all translators must at times feel close to). It will also be clear that the relevant assumptions about translation also involve cultural choices and values, such that the issue is not simply the representation of Proust in English but the production of an English Proust. In this regard, the story once again begins with Scott Moncrieff, not just as

translator but as initiator of a volume of essays on the occasion of Proust's death, *Marcel Proust: An English Tribute.* As a case study in the production of an English Proust, this is a fascinating document in the cultural history of early-twentieth-century English literary taste. It is also somewhat discouraging, at times so lowering as to take the temperature down to minus. In the first place, the guest list of contributors is conspicuous by those who declined Scott Moncrieff's invitation (they include "Mrs Virginia Woolf, Miss Rebecca West . . . Mr Aldous Huxley, and that most reluctant writer, Mr. E. M. Forster"). This may have been in part because, as one contributor notes, Proust "has an outlook on life which is bound to be unsympathetic to a good many Englishmen." Another contributor—Arnold Bennett—encourages such a view, remarking on the "effrontery" of Proust not having "given himself the trouble of learning to 'write' in the large sense." For the rest—apart from a small number of often brilliant pieces, notably an essay by Catherine Carswell on Proust's women as always presented in terms of "the effect they have upon the men that love them"—we have the all-too-familiar Proust of cakes, lime-blossom tea, and hawthorns ("when I met him as a reader [he] filled my plate with one delicious fruit and sweet and cake after another").

English Proust comes out of this discourse (a summarizing marker might be the recurrence in these essays of the word "charm"). Kilmartin's claim is, in certain respects rightly, that Scott Moncrieff's translation is complicit with this and that sharpening the edge of the prose requires wiping it clean of the detritus of the English teatime. On the other hand, just how clean is something of an open question. Take the vexed issue of the title. Rarely can the question of a title have stirred such a hornets' nest (or created, so to speak, such a storm in a teacup). As reported in the New York press, there was some kerfuffle between publishers over who originally thought of using *In Search of Lost Time* to replace Scott Moncrieff's pretty but useless Shakespeare quote, *Remembrance of Things Past.* Richard Howard signaled his intention long ago to use the new title for the scheduled Farrar, Strauss, and Giroux translation. Kilmartin informed us that he wanted to use *In Search of Lost Time* for the 1981 Chatto publication but was overruled. This little quarrel proves only that the spirit of capitalism is alive and well in corporate publishing. The truly intriguing element of the story, at least as reported in the *New York Post*, is that, according to his wife, Enright actually wanted to retain the Scott Moncrieff title when Chatto this time decided to respect Kilmartin's original wishes: "It was a grand phrase, and it's what it's known as. That's my husband's position as

an English reader and as an Englishman for whom Shakespeare is quite important."

If this report is true, it would seem that a certain kind of English nostalgia is also alive and well. While being in or on the verge of sleep ("Perhaps some of the greatest masterpieces were written while yawning") is one of the privileged states of *A la recherche du temps perdu*, it is doubtful that Proust would have relished association with the prolonged English postimperial trance (as is well known, he took vigorous exception to Scott Moncrieff's title). Among other things, the English Proust of the nostalgia market is a class Proust, and the relevant assumptions in part social assumptions. Proust's own social vision is itself a problematical affair, starting with the meanings of the words "social" and "society" in his text: they are generally restricted to life in the aristocratic salon and dining room. Within the restricted definition, Proust supplies a merciless anatomy of a dying world, not just as, in the familiar emphasis, dissection of snobbery but in making the crucial connection between the manners of the snob and, in Benjamin's words, the symptoms of a "class everywhere pledged to camouflage its material basis." Proust deepens the convention of the novel of manners by placing the obsession with the petty rituals of rank and etiquette in the distinctively modern context of the abstracted, sterile world of consumption severed from production. This is one reason why we hardly ever see the world of the working class, other than as immediate appendages to the upper classes (domestic servants, hotel staff, casino operators, and shop girls, the latter as use value for sexually deprived men of means, including the narrator). If we do not see the world of industrial work, that is because its invisibility is part of the point. On the other hand, Proust's fastidiousness can degenerate into fussiness and fascination, and after some of the more extended stretches of prose *chez les Guermantes* it may well be with a sigh of relief that we find even the narrator himself giving up: "I should never get to the end of it if I began to describe all the different types of drawing room."

A translation must of course respect the assumptions of the original. But there can be no brief for making matters worse. English Proust often does just that from Scott Moncrieff through to Enright. Consider the case of *Maman* (where after all Proust's narrative in many ways both begins and ends). In the sociolinguistics of French, *Maman* is not marked for class. English "Mamma," however, is very strongly marked for class, especially the pronunciation implied by the double *mm* (James Grieve, in his translation of *Du côté de chez Swann* at least tried to weaken this with

the spelling "Mama"). "Mamma" makes one wince and transforms Combray into a Laura-Ashleyfied English nursery and the dilemmas of the neurasthenically oedipal boy into the problems of a little Lord Fauntleroy, best dealt with by a vigorous spanking at a suitably brutal public school (to take an alternative example, could one imagine that great oedipal lover, Jean-Jacques Rousseau, who freely addressed Mme de Warens as "Maman," calling her "Mamma"?). If revision is the name of the game, why did neither Kilmartin nor Enright do something about this?

One reason appears to be that their attachment to cute Proust is occasionally even stronger than Scott Moncrieff's. For example, the question of mother is also related to the question of George Sand. When Maman, in the famous good-night–kiss scene, reads *François le Champi* to her agitated son, the latter is calmed by the presence in Sand's text of "des expressions tombées en désuétude et redevenues imagées." Scott Moncrieff's translation of "redevenues imagées" is uselessly but harmlessly literal ("returned as imagery"). The phrase of course connotes both visual and rhetorical meanings (something like "metaphorical color"). Kilmartin and Enright render it as "quaint and picturesque" (a bit rich then for Enright to accuse Scott Moncrieff of being "quaint"). This is cakes-and-strawberries Proust to surplus requirement; we do not need it. Nor do we need the lamentably sentimental "damsel" for Proust's *fillette* designating the Parisian laundry girl whom the narrator fancies (Scott Moncrieff simply has "girl").

What we need—and indeed at their best what we get from all three translators—is Proust out of the nursery and on the wild side. For example, he is one of the great explorers not only of the multiplicities of human sexuality but also of the complex and shifting relation between sexuality and speech. There are many challenges here to the translator, above all perhaps in capturing the manic rhythms of the discourse of Charlus at once concealing and revealing his homosexuality in the polite society of the salon. Charlus's speech is an extraordinary mix of the exquisite, the demotic, and the camp. How one stays faithful to this in English is by no means obvious. Scott Moncrieff was on the whole very successful here. Kilmartin interestingly throws caution to the winds, abandoning his hypothesis about what Proust might have written had he been writing in English in favor of a series of hit-and-run, though sometimes hit-and-miss, raids on late-twentieth-century slang. When this goes wrong, it can go badly wrong. Charlus, for instance, bids farewell in the

street to the narrator with the colloquial "à la revoyure"; the point of the expression is that it is both popular and precious (as is much of the speech of Françoise). Kilmartin renders it as "so long," which suggests that Charlus has wandered into a Damon Runyon story and is exiting from a Manhattan dive (something like "tood-a-loo" might do, with its connotations of both popular usage and upper-class affectation).

The problem becomes even more acute in connection with Charlus's use of sexual demotic. It is surely inconsistent with Kilmartin's hypothesis concerning what Proust himself might have written in English to translate *petits truqueurs* (male prostitutes who engage in blackmail) as "rent boys"; the latter is certainly an "English equivalent" but nearly a hundred years too late for Proust, thus raising questions as to what model of linguistic and cultural relevance Kilmartin had in mind in advancing his hypothesis (there is consequently an unintended irony in the narrator's remark: "I did not know the meaning of this slang expression 'rent boys' "). As for *mômes* coming out as "a bit of brown," this really does miss the point of Charlus's tortured verbal behavior. This is not just a lapse of literary judgment but a category mistake. Even as Charlus's incredible tirades shift into semi-delirious overdrive, "a bit of brown" is wrong for Charlus in the Guermantes or even the Verdurin salon, not so much because it is anachronistic but because it is excessive; it would be to go too far in his high-wire act of slumming it with socially unavowable desires while lording it with his social self-image: Charlus skates on ice dangerously but also skillfully, though beneath the ice madness always threatens. But if anachronistic camping of the text can produce misreadings, all is forgiven when, on leaving the Verdurins, Charlus is to be found eyeing young soldiers on the train. "Ce n'est plus un chemin de fer où nous sommes," remarks the sculptor, Ski, in a hideous pun, "c'est un funiculeur." Scott Moncrieff does not appear to have noticed the obscene deformation of *funiculaire*, though perhaps he thought the more attentive reader might have caught *cul* in "funicular." Kilmartin comes up with another anachronism, but one so brilliantly inventive and appropriate to both occasion and character that all other considerations evaporate: "This isn't a puffer-train, it's a poofter-train."

This is emphatically translation joining original on the wilder side. It is of course no accident that it should be in connection with the languages of sexuality. Desire is Proust's greatest theme and the most active motor of his text. In terms of his characters' fate, it is also the motor of catastrophe. All Proust's lovers are psychopaths, teleologically as well as

psychologically; the "way the psychopathological universe is constructed," muses the narrator in connection with his love for Albertine, is "disastrous," because whatever you do is destined to go wrong, not just routinely yet contingently, but invariably. However you play it, the outcome is necessarily and absolutely awful. In this most non-Aristotelian of novels, the narrative of Proustian love is to some extent rigorously Aristotelian in that if its beginning is arbitrary and its middle wayward, its end is wholly preordained. One of the main achievements of Proust's translators is to have caught the mix of intolerable suffering, monstrous egocentricity, and high comedy in this baleful view of human intimacy. Albertine casually, inadvertently reveals the truth behind the lies:"I felt as though I were in a town that had been razed to the ground, where not a house remained standing, where the bare soil was merely heaped with rubble." The extended metaphor is to be read at various levels, appropriately powerful for the intensity of subjective disorder but also sufficiently detached to reveal it as self-indulgently theatrical and not a little comical. It is of a piece with the whole final sequence of *Sodom and Gomorrah,* where the emotional disaster visited on the narrator by Albertine's disclosure of her previous friendship with Mlle Vinteuil is both extraordinarily poignant and hilariously funny.

It is perhaps no surprise that it is in this area that Kilmartin in particular excels, since he himself stresses the importance of Proust's humor, in particular his fabulous gift for mimicry, pastiche, and parody. What also needs stressing is the extent to which the comedy is self-referential and the parody self-parody. Many of the grand structuring themes and devices of *A la recherche* are seen through this magnifying lens. Brichot's endlessly tedious etymologies mirror the narrator's obsession with the "magic" of names. Albertine's occasionally breathless syntax leaves the narrator struggling with her sentences in a manner not dissimilar to the way the narrator leaves the reader with his:"Awaiting the conclusion, I found it hard to remember the beginning."There is a marvelous moment in one of the Doncières sequences when Saint-Loup and the narrator get lost in the fog on their way to a restaurant. In context, the detour before "finding our way and reaching safe haven" serves as a miniallegory of Proust's book itself, as the tale of a prolonged fog-bound detour on the road to the discovery of the artistic vocation, for a few pages earlier we find the narrator musing on the great topic of *Le temps retrouvé* (the "detour of many wasted years"), with the hint of an imminent illumination beyond the waste. But as the text trembles on the verge of epiphany, the whole

episode is then ironically placed when, some pages later in the restaurant, the fatuous prince de Foix makes polite conversation with a stranger who has also lost his way: "Losing your way isn't so bad; the trouble is in finding it again." Losing and refinding one's way (within the narrative, within the sentence) are exactly the drama of reading *A la recherche*. Could it then be that the absurd prince de Foix is the novel's best critic?

Above all there are those gems of ironic *mise en abîme* refracting back a skeptical view of what one would have thought to be untouchable in Proust: metaphor. Metaphor is not only Proust's principal literary device for rescuing experience from the ravages of time; it is also thematized and discussed, notably in *Le Temps retrouvé*, with a reverence at times close to mystic awe. But the reflexive register can also take a quite different forms, when, for example, it is displaced onto the ridiculous Cottard and his "insatiable" passion for "figures of speech" or when M. de Guermantes attacks the narrator's article in *Le Figaro* for its "turgid metaphors as in the antiquated prose of Chateaubriand." Or take the self-effacingly downbeat conclusion to the narrator's extended analogy between living with Albertine and living with a madman: "But all this is *only* a comparison" (my italics). Coming from Proust, that "only" give many hostages to fortune. Above all perhaps, there is Albertine's outrageously baroque speech on the subject of ice cream: "Those mountains of ice at the Ritz sometimes suggest Monte Rosa, and indeed, if it's a lemon ice, I don't object to its not having a monumental shape, it being irregular, abrupt, like one of Elstir's mountains." Try as the narrator might to distinguish Albertine's ludicrous speech from the use of figures in his own writing ("her eagerness to employ in speech images . . . which seemed to me to be reserved for another, more sacred use"), with the injection of Elstir into the discourse and thus of the narrator's typical analogical movement from nature to art and back again, the dividing line has been compromised; like both ice cream and language in Albertine's mouth, there is here a sense of structures melting, collapsing.

This may have some relation with one of the novel's very last metaphors, where the theme of a life in time is dizzily spatialized: the narrator, "perched on its giddy summit," is seized with a "feeling of vertigo." In the next paragraph—the final one of the book—this image of heights is transferred to the aged and tottering duc de Guermantes, figured as walking on "living stilts" from which one must inevitably "fall." The clownish metaphor of stilts is a comic transformation of the metaphor of altitude (so highly prized by the narrator in connection with Stendhal).

But it is arguably also a parody of metaphor *tout court*, the prop, the crux of Proust's work, what holds the whole thing up.

The novel thus ends with a stress on frailty and fragility, not only of the human body but of all human enterprises, including perhaps that which this finale otherwise celebrates, the great work of metaphorical art the hero–narrator will undertake. These last sentences combine exhilaration and comedy with the melancholy contemplation of decay and death and implicate both Proust and us as, coming to the end, we look back over a work of writing and reading (Proust himself calls the writing a form of "translation": "The function and task of a writer are those of a translator"). In his foreword, Enright speaks of the "melancholy" nature of his own task as translator. He is referring of course to the sad circumstances in which he took over from Kilmartin. There is more, however, to the relation between melancholy and translation. Benjamin links melancholy to the modern condition of exile and homelessness. Proust belongs here; if all paradises are paradises lost, there can be no homecoming. For all his talk of "my country," he knows, as does his narrator, that "the artist is a native of an unknown country" and that, for all his corresponding talk of buildings, cathedrals, and foundations, his book is like those of Bergotte, irritably described by that superpatriot Norpois as having "no foundation" (and as "altogether lacking in virility"). Benjamin also links the condition of melancholy and exile to the displacement of the symbol by allegory: the symbol is the prelapsarian, paradisiac mode of expression; allegory is on the side of the sign and its endless interpretability. For some entirely incomprehensible reason Kilmartin and Enright translate *signes* in the famous passage about the work of art as the deciphering of a "livre intérieur de signes inconnus" as "symbols." Although Proust does use the term *symbole* elsewhere, it is crucial to translate as "sign" here, precisely because of Proust's own emphasis on art *as* "translation."

Melancholy, however, is not the end of the story. Melancholy can become mourning, and mourning is accorded an altogether upbeat metaphorical value by Proust, specifically in connection with his own literary medium: "Certain novels are like great but temporary bereavements, abolishing habit, bringing us back into contact with the reality of life." This joins with the more active senses that Proust gives to both desire and suffering. They enable as well as disable, above all as powerful generators of text. The narrator writes that "to seek happiness in the satisfaction of a desire of the mind was as naive as to attempt to reach the horizon by walking straight ahead." If this is a formulation of the futility of

desire, it is also the case that the writing of desire in Proust remains productively true to this insight, moving sideways, laterally, either as the vibrant intellectual curiosity of the tentacular speculative sentence, with its proliferating interpretive hypotheses, or as the restless pleasure of polymorphous metaphorical elaboration traveling, for example, across the collective body of the "jeunes filles en fleurs," gleefully scattering predicates and identities with transgressive abandon.

We have also to remember that, if mourning and desire go together as creative forces, the habit-abolishing "bereavement" that novels give us is only "temporary," just as elsewhere we are told of "the almost hypnotic suggestion of a good book which, like all such influences, has very transient effects." Habit reasserts itself, dulls the wits, consigns to oblivion. The process has to be started over again; even after we fall off the stilts, we must keep on the move. This too has implications for translation, not only in the banal sense of requiring new ones from time to time but also in the deeper sense of what it means to make and remake an English Proust. The prospects are encouraging. There is, for example, a remarkable text by the poet, Tom Raworth. It is best to read this text after reading the last paragraph of *A la recherche*. As, with the duc de Guermantes, we totter through that last long sentence landing for the last time on the word "Time," we would do well to proceed immediately to Raworth, where we can start again not only by going from end to beginning but also from bottom to top. The text is called "Proust from the Bottom Up," in a collection of poems with the apposite title *Tottering State*. It takes the key passage from *Le Temps retrouvé* about literature as deciphering of the "book of unknown signs" and rewrites it, irreverently and literally, from bottom to top, while at the same time redistributing its elements in willful disregard of normal syntax and sense (it begins with "not traced by us is the only book that really belongs to us" and ends with "if i tried to read them no-one could help me with").

We make of this splintered Proust what we will, but, within the extended sense of the term, it is entirely reasonable to see it as a form of translation, as creative translation around the Proustian themes of interpretation and decipherability, forgetting and remembering, losing one's way and refinding it (though what negotiable way is opened up here remains moot). The more general point is that English Proust can mean many things. It also of course means, for the time being, Irish Proust (for example, Beckett making hay with the hawthorns in *Molloy* or being impeccably Irish in the early essay on Proust with the truly memorable

line, "Proust had a bad memory") and American Proust. Where the latter
is concerned, we still eagerly await the new Richard Howard translation.
It promises to be a more freewheeling affair altogether. This is very good
news, for it is especially in the United States that a certain English cult of
Proust is treated with the contempt it deserves. It is probably only in *The
New Yorker* that we would find a cartoon depicting a woman addressing a
salesman in a bookstore with the caption: "I want something to get even
for that new translation of Proust he gave me last year."

This points the way to the happy end of the madeleine as cultural
fetish and to other kinds of alignment, for example, since I have spoken
of stilts and falling, with Bob Dylan's view of the artist: "She's nobody's
child, the law can't touch her at all / she never stumbles, she got no place
to fall" (Elstir, who paints the sea as land and the land as sea, would have
liked her: "She can take the dark out of the night-time and paint
the day time black"). And while I'm at it, I hope Howard won't think it
excessively presumptuous of me to ask that he begin with the great
Proustian theme of names by doing something about the persistence, his-
torically understandable in Scott Moncrieff but inexcusable in Kilmartin
and Enright, of "Christian name" for *prénom*. This might just do for
"Palamède," Charlus's "Christian name" mentioned in connection with
"this or that Podestà or Prince of the Church." But having Jewish Swann
describe "Odette" as a "Christian name," or Lady Rufus Israels address
Swann's daughter, Gilberte, "by her Christian name" not only has noth-
ing to do with Proust's French but also implies that the Church of
England has had a hand in the translation. A more informal and ecu-
menical Proust in English will need to put us on first-name terms with
prénom. For if—to return yet again to a point of departure—the com-
plexities of the fictional language game render the narrator somewhat
coy over his own first name, it is unthinkable that Proust the author
would have approved of Marcel's being represented as his "Christian
name." If this, in an all-too-familiar view of translation as representation,
is to count as an English equivalent, the one thing it is not is an equiva-
lent in any way remotely adequate to the work of the writer whom
Harold Bloom has described, provocatively but rightly, as "our truest
modern multiculturalist."

Notes

Unless otherwise indicated, all translations are my own.

1. THE TRIANGLE OF REPRESENTATION

1. W. J. T. Mitchell, "Representation," *Critical Terms for Literary Study*, ed. Frank Lentricchia and Thomas McLaughlin (Chicago, 1990).

2. See Stephen Halliwell, *The Poetics of Aristotle* (London, 1987), 192.

3. The requirement of honesty concerning the partial and contingent origins of representation does not as such follow from the pragmatist position; indeed it might be crucial to the pragmatic effectiveness of a representation that these origins be concealed. This echoes the old argument in utilitarianism as to whether the utilitarian grounds of action should, for good utilitarian reasons, be concealed from the majority of human agents; antifoundationalist pragmatism has delivered no satisfactory answer to this question.

4. Jacques Derrida, "Sending: On Representation," *Social Research* 49, no. 2 (summer 1982): 296–326.

5. Representation as standing-for has been further specified analytically by way of two kinds of standing-for: "descriptive representation," based on a relation of resemblance (thus potentially overlapping with representation as simulacrum

or imitative model), and "symbolic representation," based on arbitrary relation, on agreements as to "x" standing for "y," rather than on perceived natural resemblances. See H. F. Pitkin, *The Concept of Representation* (Berkeley, 1967). The distinction is misleading, however, given, at least in the history of aesthetic thought, the association of the symbol with the nonarbitrary, the presence in the symbol of the symbolized, which takes us close to the notion of embodiment (as in the Eucharist). A better term perhaps would be "semiotic representation," based on a principle of pure substitution. In many cases of course the descriptive and the semiotic are mixed. According to Ernst Gombrich, the "first" representation (historically fantasized as a conceptual ground for representation in general) is just such a mix (in his terms, of the imitative and the functional). Gombrich's famous example is the child's use of the broomstick as a hobbyhorse, in his *Meditations on a Hobby-Horse* (London, 1963).

6. Cited in Pitkin, *The Concept of Representation*, 60–61.

7. Raymond Williams, *Keywords* (London, 1983), 269.

8. See below, chapter 7.

9. See below, chapter 8.

10. Roland Barthes, "Diderot, Brecht, Eisenstein," in *Revue d'esthétique* (Paris, 1973), 185. Translation by Stephen Heath.

11. Cited in Pitkin, *The Concept of Representation*, 62.

12. Ibid., 63–65.

13. On this aspect of representation, the thinking of Raymond Williams remains exemplary. See chapter 3, below.

14. Roland Barthes, *Leçon* (Paris, 1978), 14.

15. Even Derrida, who has taken us further than most with the invitation to conceive of "thinking altogether differently" (that is, beyond "all possible representation"), concedes that "it is difficult to conceive anything at all beyond representation" ("Sending," 326).

16. For an interesting attempt to build bridges between scientific realism and literary realism, see George Levine, "Scientific Realism and Literary Representation," *Raritan* 10 (1991): 18–39. See also idem, ed., *Realism and Representation: Essays on the Problem of Realism in Relation to Science, Literature, and Culture* (Madison, 1993).

17. For a passionate, if controversial, statement of the power of literary representation, especially so-called strong representations, to make or alter consciousness, see Harold Bloom, *The Western Canon: The Books and School of the Ages* (New York, 1994). The exemplary figure for Bloom (Shakespeare) is defined again and again in terms of representation. I take it that Bloom prefers representation to, say, rhetoric because in the case of the former considerations of power are inseparable from considerations of truth.

18. On the heuristic power of literary fiction, see Paul Ricoeur, *Time and Narrative* (Chicago, 1984).

19. Bernard Williams, "*The Women of Trachis*: Fictions, Pessimism, Ethics," in *The Greeks and Us*, ed. Robert B. Loude and Paul Schollmeier (Chicago, 1996), 49–50

20. Ibid., 52.

2. BLURRED IDENTITIES: REPRESENTING MODERN LIFE

1. T. J. Clark, *The Painting of Modern Life: Paris in the Art of Manet and His Followers* (London, 1985).

3. FOUNDATIONS AND BEGINNINGS: RAYMOND WILLIAMS AND THE GROUNDS OF CULTURAL THEORY

1. Raymond Williams, *Marxism and Literature* (Oxford, 1977), 11.

2. Catherine Gallagher has raised the important theoretical issue of abstraction in an argument questioning the relation, even implied identity, of terms in the expression "cultural materialism." Gallagher queries, even breaks, the relation between the cultural and the material in the form, roughly, of the following argument: if culture belongs to the domain of signification ("signifying practices," as Williams says), then it necessarily partakes of abstraction (her example is that of money, which she rightly accuses Williams of having misunderstood, in confusing materiality and signification). Abstraction, however, is exactly what recurringly, from *Culture and Society* to *Marxism and Literature*, aroused Williams's hostility, perhaps because of the Leavisite residues of organicist thinking subsequently glossed as a Marxist materialism. It is certainly true that the whole place of abstraction in Williams's thinking requires a lot of sorting out. See Catherine Gallagher, "Raymond Williams and Cultural Studies," in *Cultural Materialism: Essays on Raymond Williams*, ed. Christopher Prendergast (Minneapolis, 1995).

3. Williams, *Marxism and Literature*, 19, 31. While the meaning of "indissoluble" is fairly clear here, it does sit somewhat uneasily with the figure of "solution," being "in solution" (in the liquid sense), that Williams deploys in both *The Long Revolution* and *Culture* to represent the idea of lived social process.

4. Raymond Williams, *Towards 2000* (London, 1983), 263.

5. Against this arguable parochialism, one must emphasize Williams's committed internationalism, not just as political solidarities but also in the very form of his own intellectual life, especially from the period of *Marxism and Literature* onward. In the introduction to the latter, Williams situates and defines his own sense of intellectual "at-homeness" in terms of the crossing of boundaries on a grand scale: "I had opportunities to extend my discussions in Italy, in Scandinavia, in France, in North America, and in Germany, and with visitors from Hungary,

Yugoslavia, and the Soviet Union. This book is the result of that period of discussion, in an international context in which I have had the sense, for the first time in my life, of belonging to a sphere and dimension of work in which I could feel at home" (4).

6. Given the persistence of the generalized (and underinformed) image of Williams as caught up in regressive nostalgias for earlier social forms, we should note that the refusal of the "projection of simple communities" is a constant emphasis from *Culture and Society* onward. It is thus important to remind ourselves that the "reach for complexity" is there from the beginning and that, among other things, the attempted imagining of an alternative social order involves acceptance of specialization, division of labor, and technology. Consider, for example, the passages in the chapter on T. S. Eliot in *Culture and Society* that reject "merely a form of the regressive longing for a simpler non-industrial society" and advance the claim that "in any form of society towards which we are likely to move, it now seems clear that there must be . . . a very complex system of specialized developments. . . . A culture in common, in our own day, will not be the simple all-in-all society of old dream. It will be a very complex organisation, requiring continual adjustment and redrawing. At root, the feeling of solidarity is the only conceivable element of stabilization in so difficult an organisation. But in its issue it will have to be continually redefined, and there will be many attempts to enlist old feelings in the service of an emerging sectional interest. The emphasis that I wish to place here is that this first difficulty—the compatibility of increasing specialization with a genuinely common culture—is only soluble in a context of material community and by the full democratic process." What such compatibility might look like, in more precisely specified terms, remains of course one of the great open questions, in both Williams's work and elsewhere. The merit of Williams's contribution is at least to have kept the question in play, as distinct from submitting to prevailing forms of complexity as inevitable, natural, and permanent (the reductio of which is the absurd end-of-history thesis).

7. "A Hundred Years of Culture and Anarchy," in *Problems in Materialism and Culture* (London, 1980). This neglected text is a devastatingly severe *political* placing of Arnold's argument about culture in the context of the 1866 Hyde Park demonstrations that so disturbed Arnold in the first of the lectures that became *Culture and Anarchy*.

4. CIRCULATING REPRESENTATIONS: NEW HISTORICISM AND THE POETICS OF CULTURE

1. Graham Bradshaw, *Misrepresentations: Shakespeare and the Materialists* (Ithaca, 1993).

2. Stephen Greenblatt, "Towards a Poetics of Culture," *New Historicism*, ed. H. Aram Veseer (London, 1989).

3. For a brilliant account of Beckett's wrecking of the circuits of exchange, see Stanley Cavell, "Ending the Waiting Game: A Reading of Beckett's *Endgame*," in *Must We Mean What We Say* (New York, 1969).

4. James Tully, "The Pen Is a Mighty Sword," in *Meaning and Context: Quentin Skinner and His Critics*, ed. James Tully (Cambridge, 1988), 9.

5. Brook Thomas provides an interesting account of the ways in which Greenblatt destabilizes the conventional text/context opposition in *New Historicism and Other Old-Fashioned Topics* (New Jersey, 1991), 38–39. But Thomas also points out that Greenblatt's selection of texts and social practices restores the very model of context he sought to dislodge, thus reinscribing his argument in the hermeneutic circle (48).

6. Catherine Gallagher also gives an account of New Historicism both within and against Marxism; see her "Marxism and the New Historicism," in *New Historicism,* ed. Veseer, 37–48.

7. For a discussion of Said's thinking in relation to these matters, see chapter 6, below.

8. Stephen Greenblatt, "Resonance and Wonder," in *Literary Theory Today*, ed. Peter Collier and Helga Gyer-Ryan (Cambridge, 1990), 76.

9. An earlier version of Greenblatt's paper that appeared in *The Aims of Representation: Subject Text/History*, ed. Murray Krieger (New York, 1987), carried the far more restricted title "Capitalist Culture and the Circulatory System." He might have added that his choice of illustrative examples entailed an even tighter restriction of his title to U.S. capitalism. We are certainly a long way here from a poetics of "culture" *tout court*.

10. Walter Cohen, "Political Criticism of Shakespeare," in *Shakespeare Reproduced: The Text in History and Ideology*, ed. Jean E. Howard and Marion F. O'Connor (New York and London, 1987), 33; Greenblatt, "Resonance and Wonder," 60.

11. It seems, however, that more recently New Historicist attention has settled on the more prosaic topics of bread and potatoes (and the ideological representations of the communities that consume them).

12. In Greenblatt's *Shakespearean Negotiations: The Circulation of Social Energy in Renaissance England* (Oxford, 1990), the key term is "energy," but energy, "social" energy, is described as "power, charisma, sexual excitement, collective dreams, wonder, desire, anxiety, religious awe, free-floating intensities of experience" (19). This may or may not be an accurate account of the social-psychic economy of Elizabethan England, but it also uncannily recalls the terms, banal to a degree, of a certain late-twentieth-century discourse of thrill; what is strikingly absent from this inventory of social energy are the energies of work and production, without which no society is even conceivable.

5. REPRESENTING (FORGETTING) THE PAST:
PAUL DE MAN, FASCISM, AND DECONSTRUCTION

1. Paul de Man (summarizing his interpretation of Rousseau), "The Rhetoric of Blindness: Jacques Derrida's Reading of Rousseau," in *Blindness and Insight* (Minneapolis, 1983), 140.

2. Geoffrey Hartman, "Paul de Man, Fascism, and Deconstruction: Blindness and Insight," *New Republic*, March 7, 1988.

3. Paul de Man, "Les Juifs dans la littérature actuelle," *Le Soir*, March 4, 1941, 10.

4. This essay was written before the appearance of Jacques Derrida's article, "Like the Sound of the Sea Deep Within a Shell: Paul de Man's War," *Critical Inquiry*, spring 1988. A belatedly added footnote is clearly not the place to address in detail the range of complex argument presented in Derrida's piece. I do, however, feel it necessary to register my disagreement with him over the crucial question of how to interpret the article "Les Juifs dans la littérature actuelle" (and in particular the context, significance, and implications of the phrase "*antisémitisme vulgaire*"). Derrida remarks that the phrase is irreducibly ambiguous between the two senses I have noted (either anti-Semitism as such is "vulgar," or there are two kinds of anti-Semitism, the "vulgar" and the "distinguished"). Derrida also says that, if it was the former de Man intended ("a possibility I will never exclude"), then "he could not say so clearly in this context." That is the crux of the difference between Derrida and myself. Whereas Derrida sees the context as placing limits on what, in other respects, he in fact reads as an "anti-conformist" statement with regard to prevailing anti-Semitic notions, I see the context as fatally compromising, or at least I cannot see how a document of this sort can reasonably be described as anti-conformist when the context prevents it from being clear on the one point that is vital to the anticonformist stance. Furthermore, there is, as I see it, no sense whatsoever in which the one explicit and unambiguous argument of the article concerning the Jews—namely, that Western literature has healthily resisted contamination by Jewish influence—could be seen as anticonformist. It simply registers a disagreement with those who hold to the opposite view, but a disagreement within a shared universe of discourse (the dominant assumption of which is that Jews are indeed an alien presence in Western culture, whether or not they have succeeded in contaminating it). I am moreover perplexed by what strikes me as inconsistent observations in Derrida's text. In respect of the most disturbing moment in de Man's article (when he refers to a "solution to the Jewish problem" in terms of "the creation of a Jewish colony isolated from Europe"), Derrida speaks of the "*unpardonable* violence and confusion of these sentences" (Derrida's italics). Yet he also says that he does "not understand" these references to a "solution" and a "Jewish colony." If he does not understand them, why are the sentences in which they appear "*unpardonable*" (as

distinct from being that on which judgment should be suspended until the references are understood)? And, if they are unpardonable, do they not undermine the claim that the article is anticonformist (in the sense of anticonformist that counts, as more than simply a disagreement within the prevailing discourse of anti-Semitism)? Finally, "unpardonable" is a word that, as far as I can recall, has not been used in any of the published remarks on the affair that I have read. It is a very strong, perhaps the strongest possible, term of condemnation available in the language. For someone who like Derrida weighs his words and those of others with great care, I take it that he is fully alert to the massive weight of this word. What are the implications, then, for the rest of his article of a view that describes the relevant sentences as being beyond pardon? These are issues that will have to be taken up in more detail elsewhere.

5. Cited in Jon Wiener, "Deconstructing de Man," *The Nation*, January 9, 1988.

6. Stephen Heath, "Literary Theory, Etc.," *Comparative Criticism* 9 (1988): 301.

7. Bernard Williams, *Ethics and the Limits of Philosophy* (London, 1985).

6. REPRESENTING OTHER CULTURES: EDWARD SAID

1. This essay originally appeared, in French and in a slightly different form, in *Critique*, December 1996.

2. Fernand Braudel, *La Méditerranée et le monde méditerranéen à l'époque de Philippe 11* (Paris, 1966), 29–34.

3. Russell Jacoby, *The Last Intellectuals: American Culture in the Age of Academe* (New York, 1987).

4. Edward Said, *Orientalism* (New York, 1978), 326.

5. Edward Said, *Beginnings: Intention and Method* (New York, 1975), 227–75.

6. Edward Said, *Culture and Imperialism* (London, 1993).

7. See Peter Winch, "The Idea of a Social Science," in *Rationality*, ed. Bryan Wilson (Oxford, 1974), 1–17.

8. For a clear account of these three positions (which are called, respectively, "the natural science model, the incorrigibility model, and the interpretative view"), see Charles Taylor, "Understanding and Ethnocentricity," in *Philosophy and the Human sciences*, Philosophical Papers 2 (Cambridge, 1985), 116–33. Taylor himself argues persuasively the merits of the third position.

9. Bernard Williams, *Making Sense of Humanity* (Cambridge, 1995), 139.

10. James Clifford, "On *Orientalism*," in *The Predicament of Culture: Twentieth-Century Ethnography, Literature, and Art* (Cambridge, Mass., 1988), 255–76.

11. Edward Said, "Postface," *Orientalism*, 2d ed. (London, 1996), 331.

12. Nietzsche's view is described by Said as "perhaps too nihilistic" (*Orientalism* [1978], 203).

13. See Stephen Heath, "The Politics of Genre," in *Issues in World Literature*, ed. Mary Ann Caws (New York, 1994), 33–43. The cultural politics of the transmission of the genre of the novel to Africa has been beautifully dramatized by M. aM. Ngal in his novel (*sic*) *Giambatista Viko* (Paris, 1984).

14. I am speaking here of *Orientalism*. In *Beginnings*, Said shows precisely the requisite kind of analytical expertise, above all in connection with the poetry of Hopkins.

15. Ernest Gellner, "The Mightier Pen?" *Times Literary Supplement*, 19 February 1993, 3–4.

16. Ernest Gellner, *Plough, Sword and Book: The Structure of Human History* (London, 1988).

17. On Montaigne and the Other, see Michel de Certeau, *Heterologies: Discourse on the Other* (Manchester, 1986), and Tzvetan Todorov, *Nous et les autres: La réflexion française sur la diversité humaine* (Paris, 1989). On Joyce, see Franco Moretti, *Modern Epic* (London, 1996).

18. Said, *Culture and Imperialism*, 246.

19. See the remarkable article by Timothy Reiss, "Mapping Identities: Literature, Nationalism, Colonialism," *American Literary History* 4, no. 4 (winter 1992): 649–77. The problematic in question has been neatly summarized by Jürgen Habermas: "I cast about, sometimes here, sometimes there, for traces of a reason that writes without effacing separation, that binds without unnaming difference, that points out the common and the shared among strangers, without depriving the other of otherness" (*The Past as Future* [Lincoln, Nebr., 1994], 119–20).

20. Diderot appears but rarely in Said's writings. In *Orientalism* he is associated with the creation of the encyclopedic "typologies" that allegedly found the more alarming typifications (or stereotypifications) of nineteenth-century orientalism (*Orientalism* [1978], 119). In *The World, the Text, and the Critic* (Cambridge, Mass., 1983), on the other hand, Diderot appears in a far more favorable light (122, 142).

21. Said, *The World, the Text and the Critic*, 24.

22. Denis Diderot, *Pensées philosophiques*, in *Oeuvres philosophiques* (Paris, 1964), 39.

23. See Edward Said, "Lost Between War and Peace," *London Review of Books*, 5 September 1996, 14.

24. Diderot, *Pensées philosophiques*, 28.

7. REPRESENTATION OR EMBODIMENT? WALTER BENJAMIN AND
THE POLITICS OF *CORRESPONDANCES*

1. Susan Handelman, *Fragments of Redemption: Jewish Thought and Literary Theory in Benjamin, Scholem, and Levinas* (Bloomington, Ind., 1991), 139.

2. On Benjamin's relation to the history of German thought, see Andrew Bowie, *From Romanticism to Critical Theory: The Philosophy of German Literary Theory* (London, 1997), 193–237.

3. Paul Ricoeur, *Lectures on Ideology and Utopia* (New York, 1986), 81; Louis Althusser and Etienne Balibar, *Lire le Capital* (Paris, 1965), II:170. On the opposition in Hegel of *Vorstellung* and *Darstellung*, the latter on the side of art as that which "bodies forth," as "embodying," and as "presentation," see Charles Taylor, *Hegel* (Cambridge, 1975), 471-72; see also Andrezej Warminski, "Pre-positional By-play," *Glyph* 3 (1978): 105–106.

4. Michael Sprinker, *Imaginary Relations: Aesthetics and Ideology in the Theory of Historical Materialism* (London, 1987), 290; Friedrich Schiller, *On the Aesthetic Education of Man*, ed. and trans. Elizabeth M. Wilkinson and L. M. Willoughby (Oxford, 1982), cxiv.

5. Martin Heidegger, *The Question Concerning Technology: Basic Writings*, ed. David Farrell Krell (San Francisco, 1977), 302, 309.

6. Hans-Jost Frey, "On Presentation," in *Walter Benjamin: Theoretical Questions*, ed. David S. Ferris (Stanford, 1996).

7. Walter Benjamin, *Das Passagen-Werk: Gesammelte Schriften* (Frankfurt-am-Main, 1982), I:471.

8. Walter Benjamin, "Some Motifs in Baudelaire," *Charles Baudelaire: A Lyric Poet in the Era of High Capitalism* (London, 1973), 139. In this essay, Benjamin defines "experience" in the senses associated with the German word *Erfahrung* as follows: "Where there is experience in the strict sense of the word, certain elements of the individual past combine with the material of the collective past" (113).

9. Michael Jennings, *Dialectical Images: Walter Benjamin's Theory of Literary Criticism* (Ithaca, N.Y., 1978), 85. Scholem, however, categorically asserted that Benjamin's theory of language was riven with an unresolved contradiction between the mystico-magical and the skeptical materialist conceptions; see Gershom Scholem, *Walter Benjamin: The Story of a Friendship* (Philadelphia, 1981), 209.

10. Walter Benjamin, "On Language as Such and on the Language of Man," in *Reflections* (New York, 1978), 316–17.

11. See Lloyd Spencer, "Allegory in the World of the Commodity: The Importance of *Central Park*," *New German Critique*, no. 34 (winter 1985): 63.

12. See Susan Buck-Morss, *The Dialectics of Seeing: Walter Benjamin and the Arcades Project* (Cambridge, Mass., 1989), 168

13. Buck-Morss, *The Dialectics of Seeing*, 81.

14. Conventionally, interpreters of Benjamin distinguish between the so-called good symbol (the theological variety) and the bad symbol, basically a secularized simulacrum of the real thing (see Jennings, *Dialectical Images*, 167). It is unclear, however, what the grounds of this distinction could be, unless one takes

"theology" literally here, which would in turn require taking literally all the associated religious concepts, crucially, of Origin and Fall. Susan Handelman has argued that, in so far as the symbol in Benjamin is indebted to Judaic thought, it has nothing to do with ideas of embodiment and consubstantiation. According to Handelman, this is what distinguishes the Judaic theory of Names from the Christian doctrine of Incarnation: "the 'symbolic' character does not mean any immediate fusion with a transcendent object, or any organic, natural, and instantaneous connection between particular and general, or symbol and symbolized. . . . In sum, there is no ontologizing of the symbolic" (*Fragments of Redemption*, 139–40).

15. Paul de Man, *The Rhetoric of Romanticism* (New York, 1984), 249.

16. Walter Benjamin, *Central Park*, in *New German Critique*, no. 34 (winter 1985): 20.

17. Pierre Klossowski, "Between Marx and Fourier," in *On Walter Benjamin: Critical Essays and Recollections*, ed. Gary Smith (Cambridge, Mass., 1991), 367–70.

18. Joseph de Maistre, *Essai sur le principe générateur des constitutions politiques et des autres institutions humaines* (Paris, 1814; reprint, Strasbourg, 1959), 87.

19. Joseph de Maistre was not, however, a romantic pantheist. His theory of the divinely authorized Word is consistent with the Christian doctrine of Revelation, and the notion of the living word of God is not the same as the pantheist notion of Nature as a language of embodiment, embodying transcendental ideas. Nor, for that matter, was Hamann's doctrine any different; see Taylor, *Hegel*, 27 n.

20. Joseph de Maistre, *Considérations sur la France actuelle* (Paris, 1852), 48.

21. I am of course referring here to the relation between de Maistre's linguistic theory and his prescriptive politics. On the purely descriptive or analytical level, de Maistre's account of the relation between secular modernity and violence is profound. This in turn suggests that the nature of Baudelaire's interest in de Maistre requires a far more complex unpacking than I have been able to give here. Its broader context would be that of the whole tradition of radical-right European cultural critique of modernity, a tradition producing forms of thought that are alarming and dangerous but also, from a diagnostic point of view, often deep. This presumably would explain why a critic of the left such as Raymond Williams was so drawn to them, in at least their English varieties.

22. The appropriation of Joseph de Maistre by the twentieth-century extreme right is reflected in the appalling little book by the Action Française sympathizer Paul Courcoural that aligns the ideas of de Maistre with those of Charles Maurras: *Les idées politiques de Joseph de Maistre et la doctrine de Maurras* (La Rochelle, 1929). Given the anti-Semitism of Action Française, there is perhaps a bitter irony in the fact that Benjamin also encountered theocratic fantasies and related notions of a magical language of revelation in the work of the Jewish thinker Oskar Goldberg (who proposed a numerological reading of the Torah

and, as Scholem summarized it, a "restoration of the magic bond between God and His people"). Scholem tells us that "Benjamin felt such a strong antipathy towards him that on one occasion he was physically incapable of grasping the hand Goldberg had extended in greeting" (*Walter Benjamin*, 97). Scholem himself boldly suggests a convergence of the ideology of Nazism and Goldberg's fantastical speculations via a reference to Thomas Mann's *Doctor Faustus* ("There Goldberg appears as the scholar Dr Chaim Breisacher, a kind of metaphysical super-Nazi who presents his magical racial theory largely in Goldberg's own words" [98]).

23. For some suggestions on the authoritarian in Benjamin and its potential relations with the thought of Carl Schmitt, see Rainer Rochlitz, *Le désenchantement de l'art: La philosophie de Walter Benjamin* (Paris, 1992), 271.

8. GOD'S SECRET: REFLECTIONS ON REALISM

1. A version of this paper was given at a conference organized by the University of Groningen in 1996 to commemorate the fiftieth anniversary of the publication of Auerbach's *Mimesis: The Representation of Reality in Western Literature.*

2. Erich Auerbach, *Mimesis: The Representation of Reality in Western Literature* (New York, 1957), 484, 490–91.

3. On the visual grounding of the epistemology of literary representations, see Jacques Derrida, "The Double Session": "[Painting] functions as a pure indicator of the essence of a thought or discourse defined as image, representation, repetition. If *logos* is first and foremost a faithful image of the *eidos* (the figure of intelligible visibility) of what is, then it arises as a sort of primary painting, profound and invisible. . . . Hence it [painting] can reveal the essential picturality, the representativity, of *logos*" (*A Derrida Reader: Between the Blinds*, ed. Peggy Kamuf [New York, 1991], 175, 176). This in turn leads to the notion of "writing-painting.."

4. Auerbach, *Mimesis*, 415.

5. Roland Barthes, "Diderot, Brecht, Eisenstein," in *Revue d'esthétique*, (Paris, 1973), 185. See chapter 1 for a more extended discussion of this model.

6. See the remarkable study by Janet Beizer, *Ventriloquized Bodies: Narratives of Hysteria in Nineteenth-Century France* (Ithaca, 1994).

7. Hélène Cixous, *Entre l'écriture* (Paris, 1986), 171. Another writer who has been tempted by the idea of a founding relation between writing, the body, and vision is Paul Auster in the autobiographical text *The Invention of Solitude* (London, 1988). Commenting on an encounter with Francis Ponge, Auster claims he "realized that for Ponge there was no division between the work of writing and the work of seeing. For no word can be written without first having been

seen, and before it finds its way to the page it must first have been part of the body, a physical presence" (138). But this converts a truism or two into a major fallacy, writing out of writing precisely what wrecks the fantasy of embodiment and presence, namely, the temporality of writing. Moreover, in the priority granted to the visual (as a site of pure presence), it also neglects the temporality of vision itself. Later in his book Auster turns to the question of painting: Van Gogh's *Bedroom* is "not a representation of solitude, it is the substance of solitude itself." This confuses a statement about a rhetorical effect with a statement about an ontological reality, a confusion perhaps to be explained by the categorical, and radically misleading, formulation: "Paintings. The collapse of time in images" (144). Such a notion of a fall out of time into an epiphany of pure presence is heavy with religious implication; it comes as no surprise perhaps that we find Auster quoting Pascal's *Memorial* (137). And from there it is but a step to Cixous's talk of God.

 8. Cited in Georges Didi-Huberman, *La peinture incarnée* (Paris, 1985), 21.

9. VISUALITY AND NARRATIVE: THE MOMENT OF HISTORY PAINTING

 1. I discuss this constellation of concepts and analogies in *The Order of Mimesis* (Cambridge, 1986), 32–36.

 2. The distinction between the rhetorical and the philosophical theories of painting is John Barrell's, the former aiming at illusion ("to deceive the eye") and the latter refusing illusionistic device in favor of a more abstract appeal to the mind. For the purposes of my own argument, however, I wish to collapse the distinction, arguing that both the relevant theories are rhetorical, insofar as both are causal theories concerned with methods of persuasion and the effects of painting on the viewer. Barrell himself in fact concedes the point; see *The Political Theory of Painting from Reynolds to Hazlitt* (New Haven, 1986), 85. On pictorial representation as presentation in connection with the writings of de Piles, see Jacqueline Lichtenstein, *The Eloquence of Color: Rhetoric and Painting in the French Classical Age* (Berkeley, 1993), 179.

 3. Louis Marin, *De la représentation* (Paris, 1994), 323.

 4. See Daniel Arasse, *Le Detail* (Paris, 1992).

 5. The classic statement of this view within Napoleonic art theory is Quatremère de Quincy's: "Pour que dans ce genre une partie puisse signifier le tout, il faut que le génie de l'art lui communique une valeur d'expression, qui empêche qu'on ne la prenne pour une partie détachée" (In order that in this genre a part may signify a whole, it is necessary that the genius of art communicate to it an expressive value that ensures that we do not take it for an isolated part) (*Essai sur l'idéal dans des applications pratiques aux oeuvres de l'imitation propres des arts du dessin* [Paris, 1837], 199).

6. Georges Didi-Huberman, *La peinture incarnée* (Paris, 1985), 99.

7. Charles Zieseniss, "Napoléon au Salon de 1808," *Bulletin de la société de l'histoire de l'art français* (1971): 205–15

8. On the relation between the iconographic and the political in David and Gros, see the interesting remarks of Alexander Fygis-Walker, *The Uses of Iconography Around 1804* (M.Phil. diss., Courtauld Institute of Art, University of London, 1984), 37.

9. Norman Bryson, *Tradition and Desire: From David to Delacroix* (Cambridge, 1984), 104.

10. See Andrew Martin, *The Knowledge of Ignorance* (Cambridge, 1985), 81–100.

11. Bryson, *Tradition and Desire*, 106.

12. Cited in Jules David, *Le peintre Louis David, 1748–1825* (Paris, 1881–1882), 1:572. On the other hand, it is worth recalling Gros's official self-description, in the contract drawn up for the decoration of the Pantheon ceiling: "Je soussigné, Antoine-Jean Gros, peintre d'histoire" (cited in J. Delestre, *Gros: Sa vie et ses ouvrages* [Paris, 1867], 156).

13. See Norman Bryson, "Representing the Real: Gros' Paintings of Napoleon," *History of the Human Sciences* 1, no. 1 (May 1988): 89.

14. Michael Levey, *Painting at Court* (New York, 1971), 174.

15. Louis Marin, *Le portrait du roi* (Paris, 1981), 251–60.

16. Antoine de Baecque, *Le corps de l'histoire: Métaphores et politique (1770–1800)* (Paris, 1993), 45–85.

17. "Il [Napoleon] a fait la France moderne" (Hippolyte Taine, *Les origines de la France contemporaine: Le régime moderne* [Paris, 1891–1894], 1:4).

18. Cited in John Barrell, *The Political Theory of Painting from Reynolds to Hazlitt* (New Haven, 1986), 101.

10. LITERATURE, PAINTING, METAPHOR: MATISSE/PROUST

1. Derrida poses the question of translation as part of the general problematic of representation, notably with regard to the terms (specifically French and German in his examples) for representation itself, as a circular logic of substitution whereby it is undecidable whether "représentation" represents *Vorstellung* or vice versa; see "Sending: On Representation," *Social Research* 49, no. 2 (summer 1982): 297).

2. Juliette Monnin-Hornung, *Proust et la peinture* (Geneva, 1951).

3. In Dominique Fourcade, *Henri Matisse: Ecrits et propos sur l'art* (Paris, 1972).

4. Marcel Proust, *In Search of Lost Time*, trans. Terence Kilmartin and D. J. Enright, 6 vols. (London, 1992).

5. See the interesting, if heterodox, arguments of Vincent Descombes, *Proust: Philosophy of the Novel* (Stanford, 1992), 262–63.

6. Jacques Derrida, "White Mythology: Metaphor in the Text of Philosophy," in *Margins of Philosophy* (Chicago, 1982), 247 ff.

II. ENGLISH PROUST

1. All quotations from Proust in English are from *In Search of Lost Time*, trans. Terence Kilmartin and D. J. Enright, 6 vols. (London, 1992).

Index